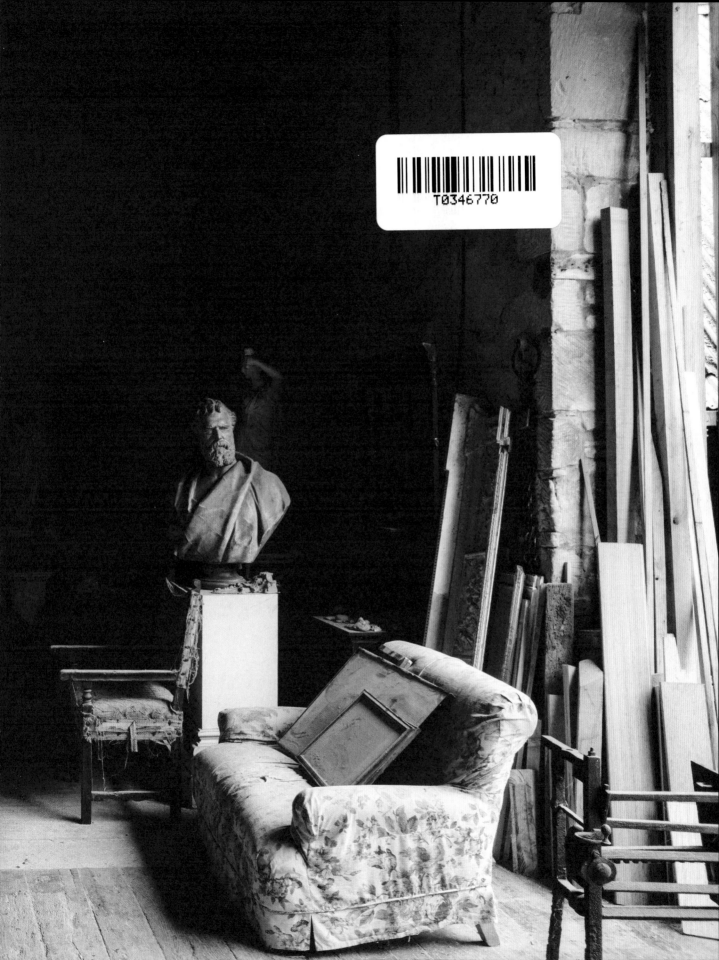

SACRED SPACES

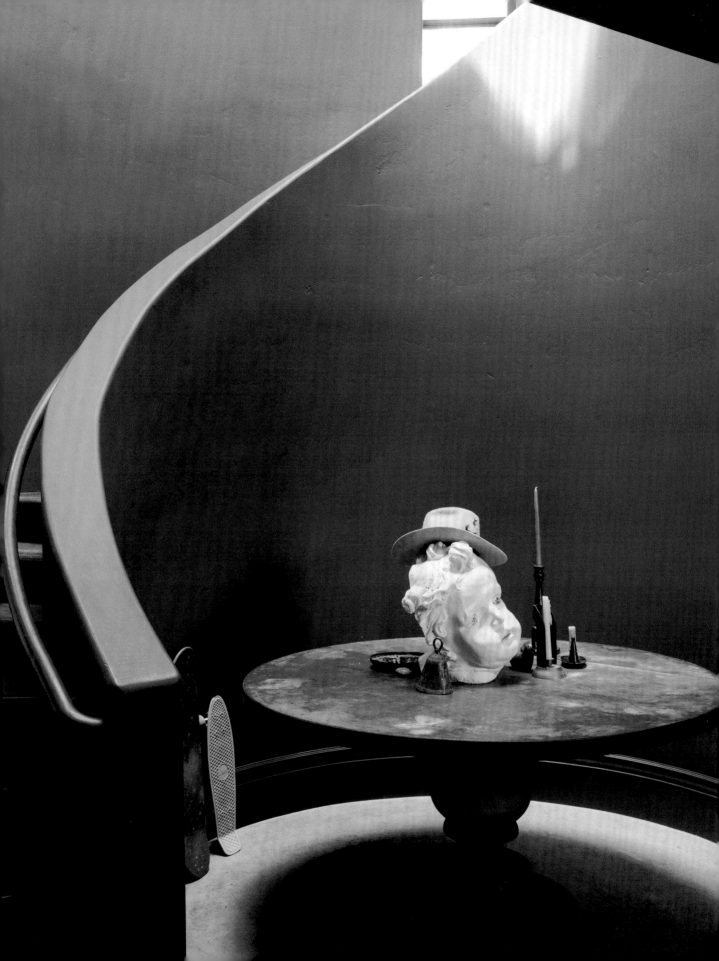

SACRED SPACES

EVERYDAY PEOPLE AND THE BEAUTIFUL HOMES CREATED OUT OF THEIR TRIALS, HEALING, AND VICTORIES

CARLEY SUMMERS

CONVERGENT

NEW YORK

Published in the United States by Convergent Books,
an imprint of Random House, a division of
Penguin Random House LLC, New York.

CONVERGENT BOOKS is a registered trademark and its C colophon
is a trademark of Penguin Random House LLC.

All photographs are by the author, with the exception of
pages 256 and 262, copyright © by Christina Cernik.
Used by permission. All rights reserved.

LIBRARY OF CONGRESS CATALOGING-IN-PUBLICATION DATA
NAMES: Summers, Carley, author.
TITLE: Sacred spaces / Carley Summers.
DESCRIPTION: New York: Convergent, 2023
IDENTIFIERS: LCCN 2022036796 (print) | LCCN 2022036797 (ebook) |
ISBN 9780593241004 (hardcover) | ISBN 9780593241011 (ebook) |
SUBJECTS: LCSH: Interior decoration—Psychological aspects. |
Interior decoration—Pictorial works.
CLASSIFICATION: LCC NK2113 .S845 2023 (print) | LCC NK2113 (ebook) |
DDC 747.022/2—dc23/eng/20220805
LC record available at https://lccn.loc.gov/2022036796

Printed in China on acid-free paper

crownpublishing.com

2 4 6 8 9 7 5 3 1

FIRST EDITION

Book design by Barbara M. Bachman

To my precious husband, Jon Summers,

our son, Max Alexander Summers,

and our family.

This is for them and the legacy our family will carry—

the importance of welcoming every story to the table.

CONTENTS

PHOTOGRAPHY, ART, AND DESIGN HAVE BEEN PASSIONS OF MINE SINCE I WAS A young girl, though it took a long and winding road to get to where I am now. Today, they are not only my career path, but also a part of my soul.

Getting serious about photography and design ten years ago became a vehicle that God used to give me a space to share my story with others. I don't say that lightly. The path I was on when I was a teen was fraught with one calamity after another, starting with the great tragedy of my life: being raped at eighteen, followed by two DUIs, nights in jail, emergency room visits from drug accidents, and rehab twice. I was broken and in need of a home. And eventually I was able to make a home that became a sacred space, a place of healing and restoration.

I have been sober for more than ten years, and yet I would never have thought that after those dark nights of the soul, I would be a respected photographer and designer writing this book today. The odds were certainly stacked against me. But those moments did not define me. And today, I have become a trusted voice in the home category with an audience that looks to me for inspiration, hope, and home design that represents safety, tranquility, and redemption.

Within these pages you'll meet sixteen remarkable people from around the globe, and hear their stories of beauty, trials, and victories that prove the power of what a true home can offer—a space to be known, held, kept safe, and seen as fully human and fully loved.

Sacred Spaces moves beyond the traditional beautiful design book, and unearths the true

INTRODUCTION

depth behind each home: the brokenness, the hurt, and the healing that took place to get these homeowners where they are today, and how their sacred spaces have set them free.

We would be ignorant to think we cannot learn from those who are different from us—every story deserves a seat at the table. Every story has worth and value. Our stories are what link us together—exposing our humanity. *Sacred Spaces* shares not only each homeowner's story, but also their testimony: their spiritual perspective on their life story. I will be sharing my own trials and how those once-negative moments have turned into my testimony that I happily offer to give someone else hope.

I have trekked all over the world to meet and document the people and their homes that are featured here in *Sacred Spaces*. Their stories undid me in the best possible ways, as I learned where they came from and how they arrived at who they are today. I have never felt more honored than when I was welcomed into their homes and they shared their stories with me. These homes hold the spirit of their struggles as well as their healing. Like me, they created homes that protect them and nourish them—truly sacred spaces.

My hope is that as you read through these pages and view these beautiful homes, you will find yourself in these stories and spaces shared, and will be inspired to create something sacred for yourself. No matter what your story is, no matter your ethnicity or religion or background, you deserve a sacred space of your own.

SACRED
SPACES

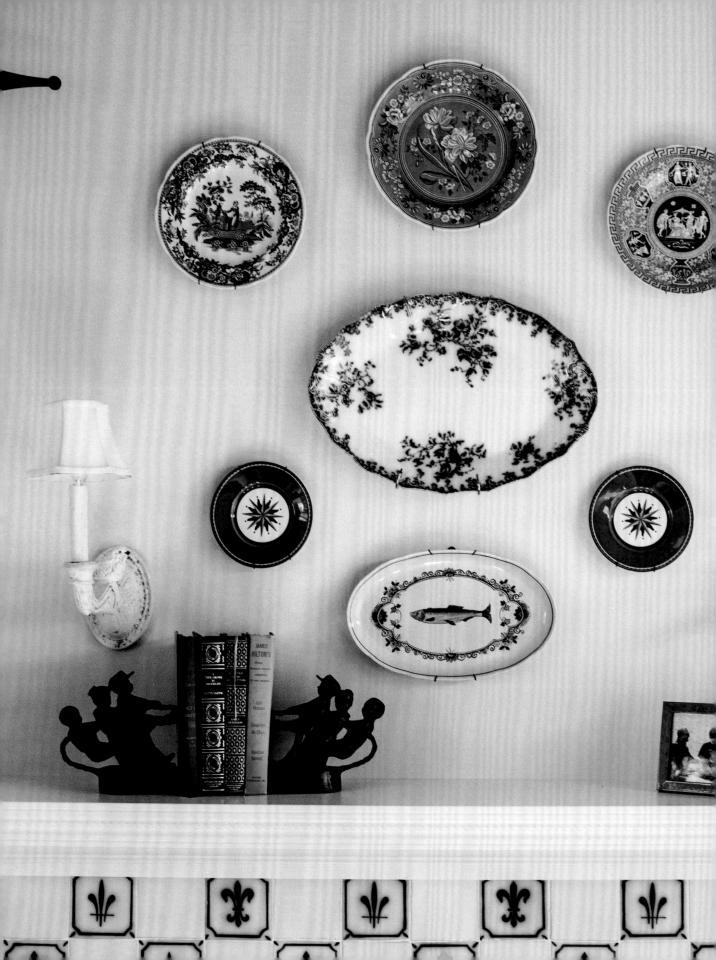

THE FOUNDATIONAL HOME

STORIES FROM

FRANCESCA GENTILLI, EDDIE ROSS,

AND PAGE AMAN,

WHO HAVE CREATED A SOLID FOUNDATION

FOR A LASTING LEGACY.

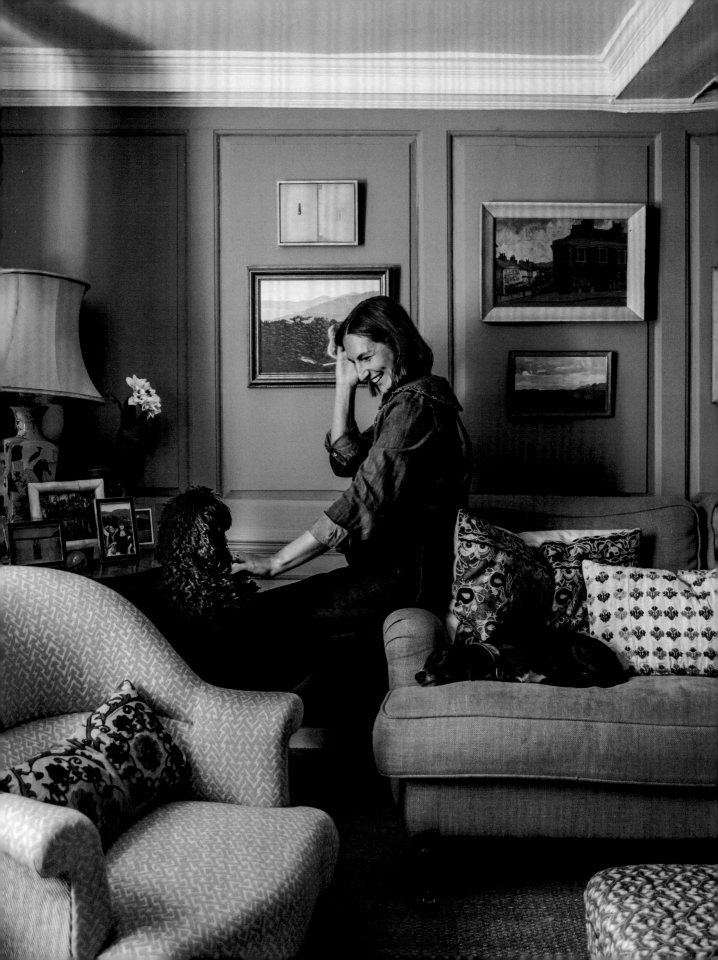

FRANCESCA GENTILLI

PASSED DOWN THROUGH MULTIPLE GENERATIONS, THE COZY FAMILY FARMHOUSE Francesca and her husband, Alex, live in is nestled in the old English town of Weston, a village belonging to the northern district of Hertfordshire. Just an hour north of London, the setting of their quaint home is breathtaking, overlooking a vast field of sunflowers, completely indicative of the inhabitants' sunny and cheerful demeanor. Their home is just minutes from Alex's office, where he works to carry on his family legacy as a sustainable farmer. Francesca and Alex beautifully renovated and restored their historic gem, and their love for each other and their home is abundantly evident. Francesca's passion for travel is showcased throughout the house: various textiles from around the world grace the rooms, and her family legacy lives on through the beautiful furniture displayed in the living room. Like many, Francesca struggled to find her inner calling, but on a spontaneous trip to India, she found her purpose through procuring beautiful rugs and textiles from rich cultures around the globe. When I think of my time with Francesca, I think of innocence and purity of heart. I met her during my travels overseas, and the moment we first struck up a conversation, I knew there was something so special about her. Her heart is genuine and she has such a contagious joy about her. While we strolled through the countryside near her home and chatted about life, I felt at peace with her. I felt safe, which is also the way I felt in her home. She has created a sanctuary for her family, and her story is just beginning. I know you will feel the sweetness of her home as you dive into her story and beautiful space.

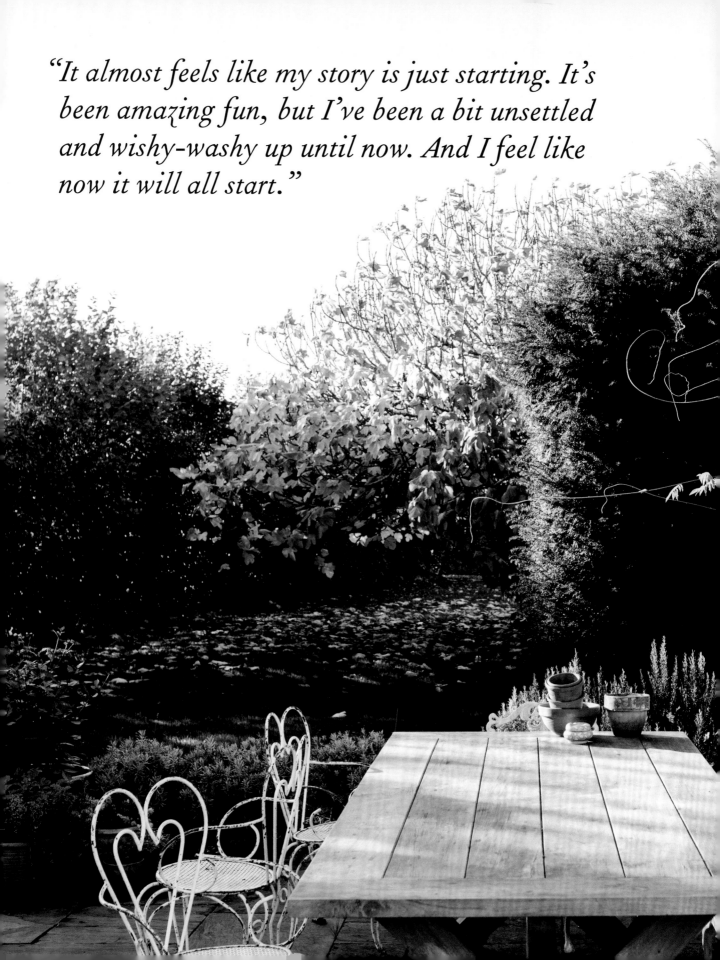

"It almost feels like my story is just starting. It's been amazing fun, but I've been a bit unsettled and wishy-washy up until now. And I feel like now it will all start."

Your story . . . Go!

FRANCESCA: I grew up on a farm in the middle of no-where, in Hambleden, a village in Oxfordshire. Our farm sat on a hill on the edge of the village, where I led a very sheltered childhood. It was mainly an arable farm, but we always kept some sheep. And I remember one of the sheep rejected its baby. I asked my father and Jack, the shepherd, if I could have it—if it could be mine. After much deliberation, they said yes. So Woolie and I became great friends. She would hang out in the field with all of the other sheep, but I would read her stories from my storybook and sneak her digestive biscuits and feed her carrots. We hung out loads. My snacks were probably not very good for her diet, but we were friends.

My mom always said I was born with my bags packed. As a child, I begged her to go to boarding school. She didn't want me to go, but I thought the idea of having a big

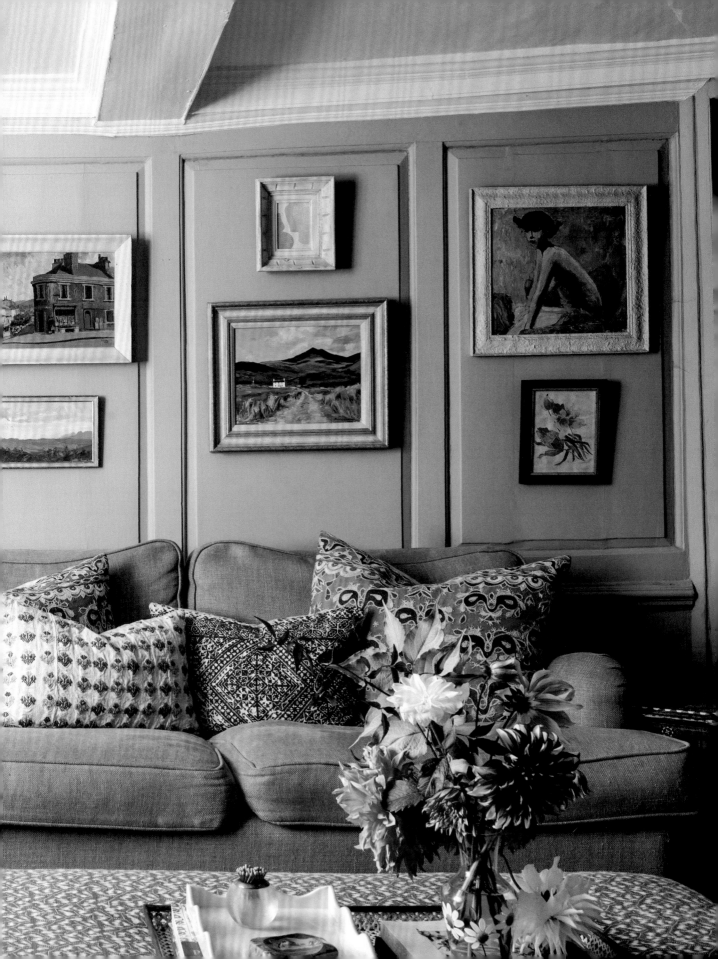

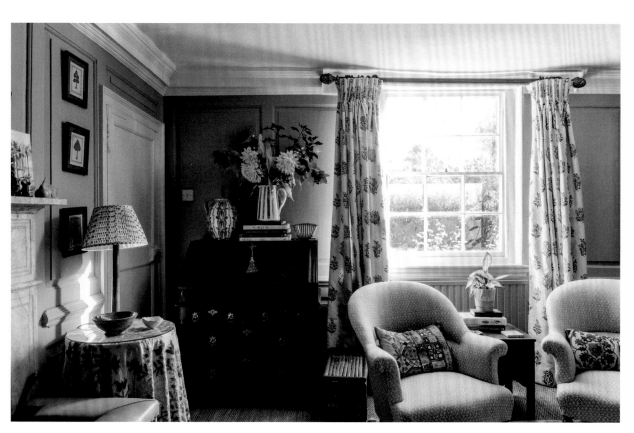

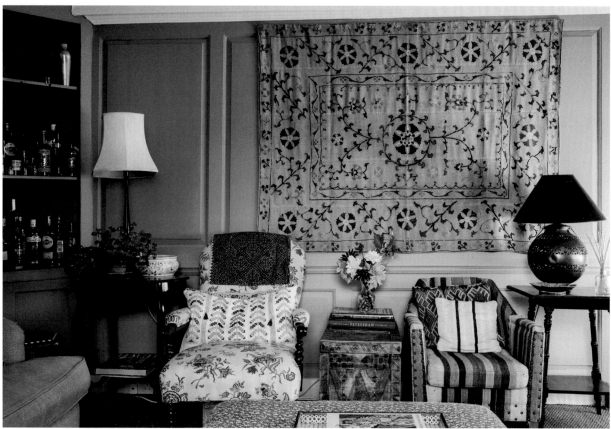

sleepover with all of my friends, five days a week, was the coolest thing ever. She thought it was cruel. But I got my way, and never looked back.

After school, I got my first proper job, where I worked in catering. I really like working. I like to earn my own money. I didn't get an allowance or any money from my parents, which made me want to own my own way. I would work on and off in a catering company, doing little canapés, which is really artistic and fiddly and lovely. But then I got my first exciting job at age nineteen and I went to work in the French Caribbean. I didn't know anyone, but I just went and did it. The jobs were quite average, but I felt like I was going to study French at university.

CARLEY: What kind of work was it?

FRANCESCA: Just working in a fashion boutique. And so, I'd hang out and talk to everyone who came in. And then the second year there I helped launch a Greek bar-restaurant. I was a terrible waitress. I dropped all the glasses. I literally would go around with lots of trays and drop them all. But for some reason, they kept me. That really wasn't my calling, but it was cool to be in the Caribbean islands. I was doing that while all of my friends were at university. I never did university. And part of me really regrets it because they all had so much fun there. They probably didn't learn that much, but they had a lot of fun. I kind of feel like I missed out on that experience. But if I had gone, then I probably wouldn't be where I am now, because it would have taken me down a different route.

CARLEY: You'd probably be working at an office in London somewhere.

FRANCESCA: Ah, no way, no way, no way. I could never be in an office in London. The idea of being hemmed in isn't ideal.

CARLEY: So, travel has always been really big for you?

FRANCESCA: Travel has always been really big. As soon as I did that job in the Caribbean, I kind of got the bug to just pack up and go and try new places. But I didn't travel as much as I do now. In my twenties, I kind of floated around doing all sorts of jobs, not really feeling fulfilled, but just doing them because they paid the bills. I did a lot of kitchen work, cooking and things like that. And I worked in fashion wholesale, which was soul destroying. Our office was in a basement, but the boss was four floors up. She'd call me and say, "Francesca, can you come up here?" I'd run to the top of the building, and when I'd get there, she'd say, "Can you go and get me a cappuccino?" I would think, *You could've just asked me on the phone.* She was

such a gal, but she was also a family friend. So I had to be careful about how I reacted. And I realized I absolutely hated it.

Then I started my business in 2013, and that was when I found my groove and when I started traveling loads. For the first time, I was really enjoying what I was doing. And I kind of fell into it, not really realizing where it was taking me. But for the first time, it just felt right. It felt like I had finally found a good direction, in an industry that I wanted to be in because it offered a perfect mix of being creative and selling things. I'm good at selling things—I like selling things and talking to people.

CARLEY: So now you've come back full circle.

FRANCESCA: Yeah. Full circle, living back on a farm with my husband, Alex. We don't really know where we met, but it was in the haze of the university era at a party somewhere.

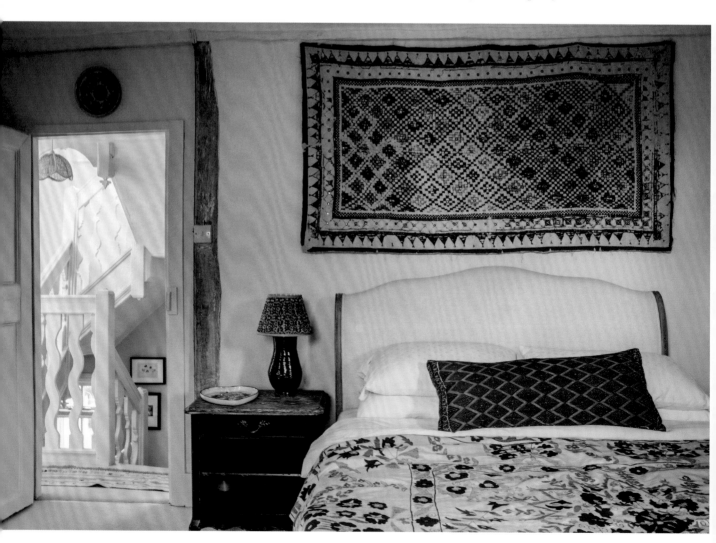

"Having spent my adolescent years not really knowing where I was going to be or what I was going to do, that was a bit of a trial, because that was me not knowing what I wanted out of life and feeling really unsettled."

We stayed friends for a very long time. And then we went on holiday together with other friends. One thing led to another, and we ended up being together. From there, things moved quite quickly, and we married within two years—because when you know, you know. And we had known each other for so long. There was none of that getting to know him and finding out if he was a good guy, because I already knew. And that's kind of where we are now.

CARLEY: With two babies on the way!

FRANCESCA: With two babies on the way! So yeah, it almost feels like my story is just starting. It's been amazing fun, but I've been a bit unsettled and wishy-washy up until now. And I feel like now it will all start.

CARLEY: You have a foundation.

FRANCESCA: Yep, exactly.

If you had one pivotal point that changed the direction of your life, what would that be?

FRANCESCA: It may sound like a cliché, but a really important moment in my life was one of my first trips to India, where I was introduced to beautiful and bold uses of color. There

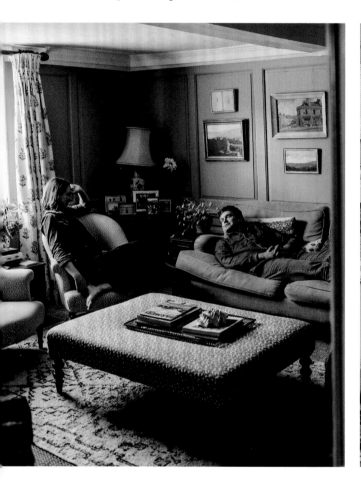
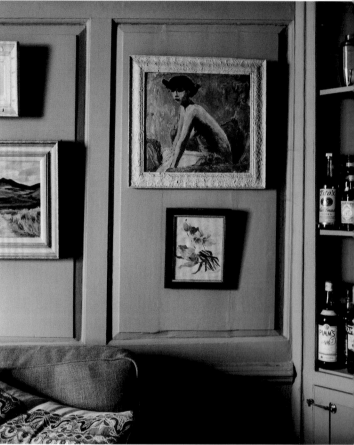

were no rules, and everything seemed to go harmoniously. It was also where I founded my business. I was on the hunt for a rug for my own home when I stumbled across this teeny tiny little shop that had rugs stacked up floor to ceiling. I was in there for hours and hours and hours, chatting to the guy who owns the shop, who I still work with today. And after copious amounts of chai tea, I decided to buy ten rugs, take them home with me, and just see what happened—because I had never really seen rugs like that before. When I got home, I sold them all within a week.

It's then I realized, *Ah, I'm onto something here.* So, I went back to India to start developing my own designs and my own colors, and that's how it all started. Up until then, I was a little bit lost with what to do with my life, struggling to feel settled. I spent years floating around and never fully finding my feet. Everything I was doing kind of felt temporary up until that point.

I'm very lucky now to travel with work. And even though sometimes it feels like I'm here, there, and everywhere, I've never felt more grounded and secure in what I'm doing, because it all just clicks, and it feels right, which is why India was a big pivotal point for me in starting my business, because that's when I finally found something I could stick with. It's been almost ten years now, the longest I've ever kept a job.

CARLEY: Same. I love it.

How are your trials and victories represented in your home?

CARLEY: You were saying that you were a bit lost, but you don't feel lost here. And so, a trial in your life back then was trying to figure out your purpose, what you were supposed to do. What was your passion? Who were you going to marry? And now, having a home come full circle to a place that you love, a place of security, seems like a real victory.

FRANCESCA: That's exactly it. Being surrounded by beautiful textiles that are so representative of me, is a victory. I love being surrounded by, as Alex would say, "pretty things." It sounds really superficial, but I do love being surrounded by the pretty things in life. It's a victory because it's all from my business, where I found myself a bit more.

Having spent my adolescent years not really knowing where I was going to be or what I was going to do, that was a bit of a trial, because that was me not knowing what I wanted out of life and feeling really unsettled.

And then I got to come full circle, marrying a farmer, moving back to the farm, being super happy and secure in my home. That's the victory: suddenly having found my feet, feeling really settled, feeling really comfortable and secure and happy.

CARLEY: What do you think was the largest trial of your life? Or maybe your biggest trial is yet to come, with your twins on the way?

FRANCESCA: Yeah. That might be a lot of trial and victory. The next few months are going to be the biggest trial. The next couple of years will be the hardest, but they will also be the most rewarding. There will be emotions I've never felt before—just a totally new chapter.

What does freedom *mean in the setting of your home?*

FRANCESCA: I do think that self-expression in a home is incredibly important. Being able to walk into a home and get quite a good feeling for what someone is about—just by walking into their home and hanging out in their room—is really special.

CARLEY: And having the freedom of knowing the place isn't going anywhere.

FRANCESCA: This place isn't going anywhere. This is our home. This is where we feel safe and secure, and able to be exactly who we are. Home is where barriers get taken down and you're just you. You're not trying to be something someone else wants you to be. You're just able to be totally and completely you.

CARLEY: And that's what is sacred about your home?

FRANCESCA: Exactly.

Where is your sacred space in your home, the place you find the most peace?

FRANCESCA: Well, I'm in it right now, in our sitting room, on the sofa. I don't have a cup of tea right now, but normally I sit in here with a cup of tea, with the dogs and with Alex, with the fireplace roaring, and a candle lit. We don't have a TV in here, so we like just *being*.

What does your personal meditation or quiet time in your home look like? How do you get away from the worries of the world?

FRANCESCA: Mine would be very similar to my sacred little space in my home. It's always with a cup of tea while sitting here. I love this room. I love being here. I make a cup of tea, light a fire, and light a candle.

CARLEY: I love it. There's a ritual.

FRANCESCA: Yeah, I make sure it's cozy and the lighting is just right. Another thing I do is take the dogs for a walk. I walk in the woods, walk in the fields with the two ratbags, and leave the phone behind. That's a really good meditation for me.

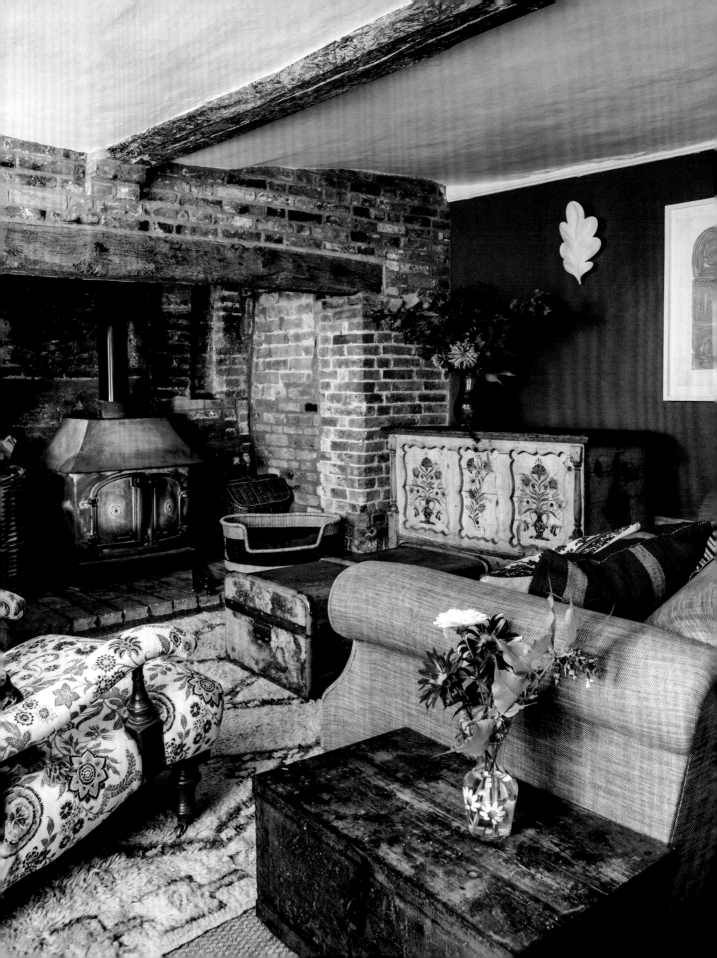

If there is one part of your story that you think would set another free, what is it?

FRANCESCA: Perhaps the fact that I'm thirty-three years old. I'm not young, and I feel like my story is only just beginning. Maybe that can resonate with other people. You don't need a big story. You can look forward to the story that's about to unfold.

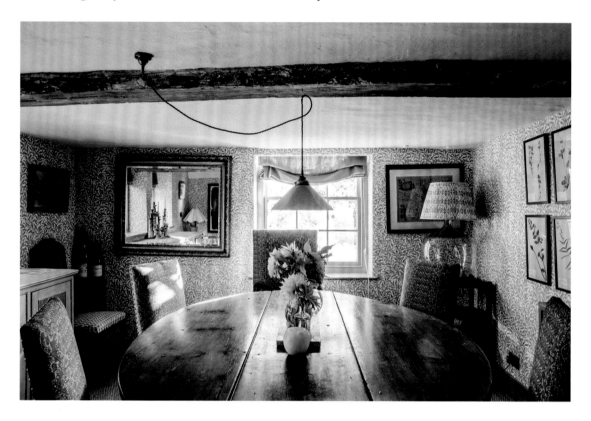

"And then I got to come full circle, marrying a farmer, moving back to the farm, being super happy and secure in my home. That's the victory: suddenly having found my feet, feeling really settled, feeling really comfortable and secure and happy."

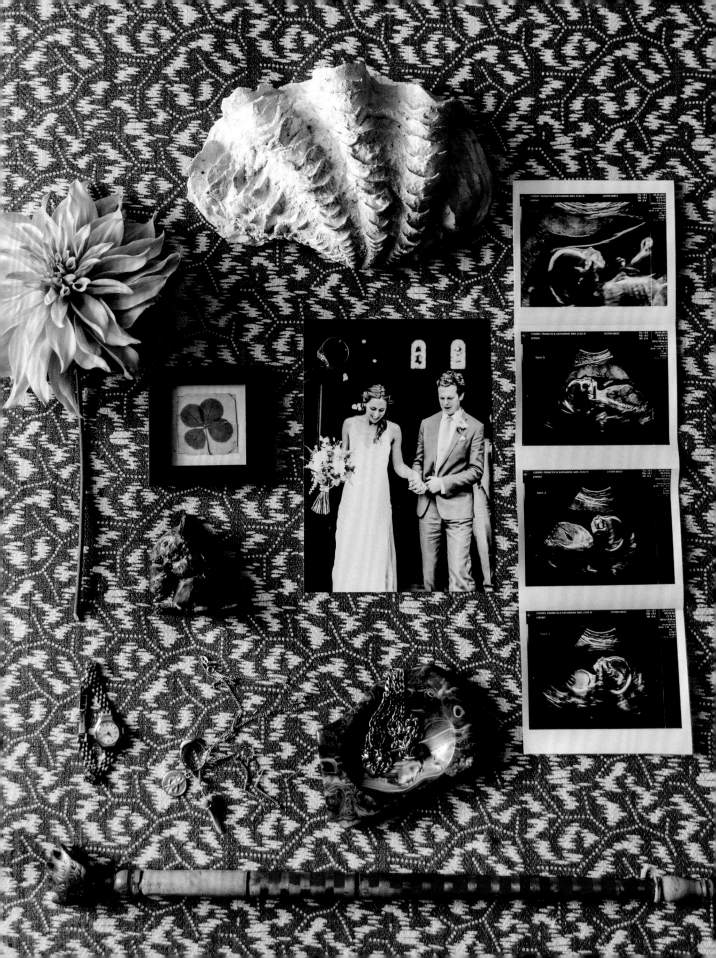

EDDIE ROSS

I HAVE NEVER LAUGHED SO HARD IN MY LIFE THAN DURING MY TIME WITH EDDIE and his partner, Jaithan. Their beautiful historic home is situated in Wayne, Pennsylvania, just outside of Philadelphia. Eddie is a style icon, having worked with some of the biggest names in the design industry, while paving his own way with his unique talents. Eddie and Jaithan own and operate Maximalist Studios, a place where creatives can bring their visions to life. Eddie tastefully incorporates traditional elements, eclectic charm, and unexpected objects into his home to create a chic, masculine space. Eddie and Jaithan both have an essence about them that makes me feel at home, accepted, and like I've been a close friend of theirs for years. Their home is peaceful and a true reflection of who they are: kind, generous, and full of life. As light poured into their kitchen, I casually snapped pictures of their morning routine, while they were laughing and dancing. We told stories of our childhoods and talked about what true faith looks like. As we sat in their sunroom near the end of my visit, they asked, "Do you have to leave?" Honestly, friends, this is what it's all about. I felt so at home, so myself, that I didn't want to leave. That is truly a sacred space.

Your story . . . Go!

EDDIE: My grandparents built a house on a property in Greenwich, Connecticut, that they received as a wedding present from my grandfather's parents. When my parents got married,

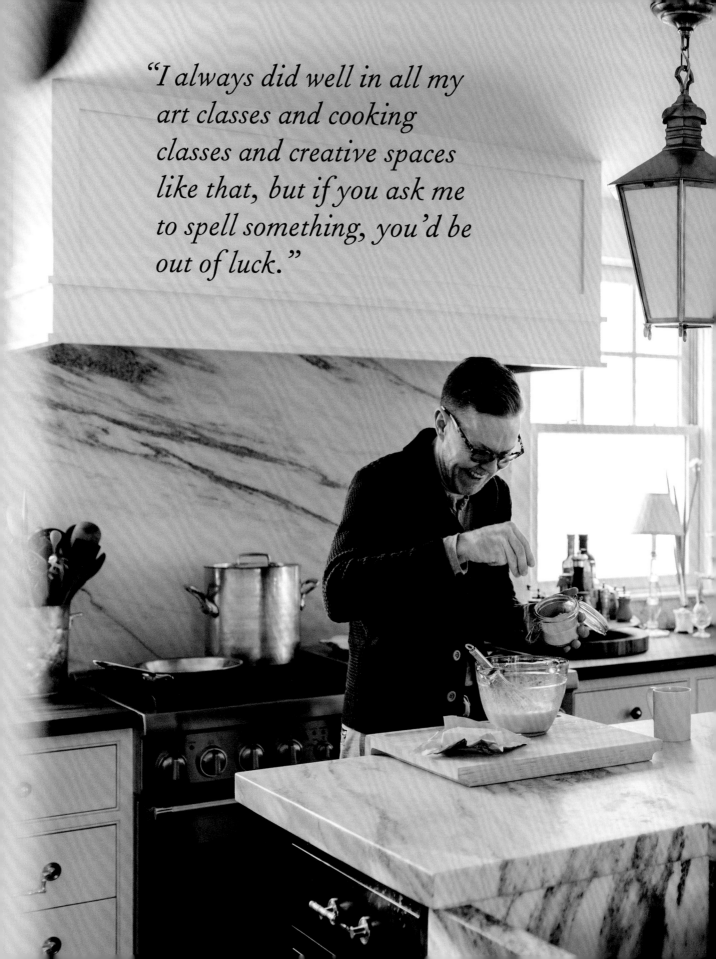

"*I always did well in all my art classes and cooking classes and creative spaces like that, but if you ask me to spell something, you'd be out of luck.*"

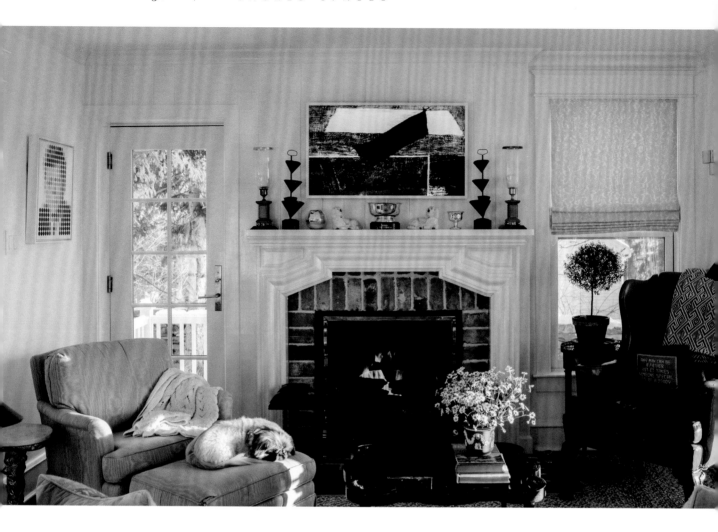

they bought the house from my grandparents, then built an in-law apartment, so we all lived together. My parents had built-in babysitters, with my grandparents there. I have three brothers, so it was kind of crazy, too.

My grandmother had great taste, which may be where I got mine from. My mother's taste was lost somewhere, but she has a good heart and she's a good cook. I always did well in all my art classes and cooking classes and creative spaces like that, but if you ask me to spell something, you'd be out of luck.

In high school, I started working for a caterer, often servicing clients in their fancy Greenwich homes. I didn't really have a lot of friends in school. I was kind of like a little dork and super pudgy. So working and being creative is where I found my safe place.

When I started working for the catering company, I was going into all these beautiful homes as a server, wearing my fancy penguin suit, and seeing all these different styles and thinking, *Oh my God, one day I want to live like this.* That's how I got the decorating bug.

And so I went to culinary school after that, got my first apartment, and realized, "Oh my gosh, I can't afford to live like these people I see." So that's when the thrifting and getting-really-scrappy-without-it-looking-scrappy came into play. I think that's been my whole thing, from entertaining to decorating, to where we are now: save and splurge on how to achieve a look that's eclectic, affordable, and what makes Jaithan and me feel comfortable where we are. Jaithan grew up in a completely different way. He was the son of two doctors who belonged to the clubs, who went on fancy vacations, whose mother had an interior designer—all of it.

CARLEY: It's like a juxtaposition.

EDDIE: It's a total juxtaposition of two worlds coming together.

CARLEY: You said earlier that you found yourself within work.

EDDIE: Yes. And I always had older friends because when I was working, everyone treated me like there was nothing ever wrong with me, since I was different from most kids. I was always treated like I was almost even better, more talented than everyone else, because my coworkers and clients were like, "Wait, how are you sixteen and you know how to do this?" I would say, "Well, I read *Martha Stewart Living* and I watch Martha Stewart and I love Martha Stewart, and one day I'm going to work for her."

CARLEY: And then you did work with Martha.

EDDIE: Yes, I did.

CARLEY: You've had an incredible career. I look around your house, and I see how the knowledge that you've gained from your life experience is so invested in your home.

EDDIE: It is. And I also think one of the most challenging and most educational experiences I had was when I was renting a home, because when you're renting, it's not yours, but you want it to be yours, and so you have to find ways to make it yours without making any permanent changes.

This house you see here is ours and we can do anything we want to it. But the renovation of this house almost broke us in so many ways. It almost broke us financially, mentally, and it almost broke our relationship, especially because we work together and live together. We were renovating a house in a place where we didn't know many people, while simultaneously building a business.

And it was one of the most challenging things, especially when working with architects who were trying to push their design and their style—like wanting to take a 1923 center-hall colonial and turn it into an open floor plan. We had to push back and say, "No!" So we found

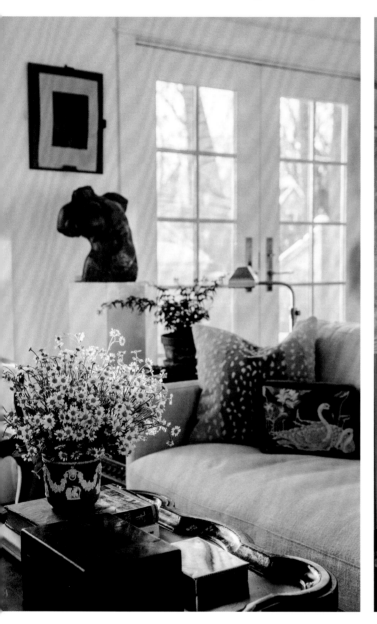
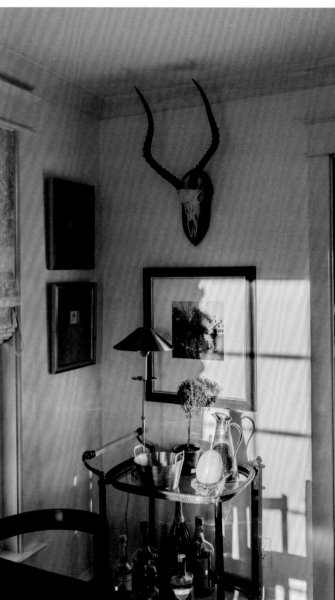

ourselves fighting with so many people over what we wanted for our house, asking ourselves, *Why is this so hard?*

But after it was all done, we could look around and breathe and still see all the things we loved. And now we have this space where it is like our own refuge/retreat.

CARLEY: It feels that way.

EDDIE: That's what the whole goal was, and why we did this house in a neutral palette. But I also wanted it to be timeless; that's what I think the key was.

CARLEY: You accomplished it.

EDDIE: You know what I will say? Going from being "Eddie, the senior decorating editor at *Martha Stewart Living*" or "Eddie, the East Coast editor at *Better Homes and Gardens*" to having no title at all and feeling lost was a huge hit to my identity. After all of that success in my career and then going to nothing, I remember thinking, *What will be next for me?* But now, having this house and our company, Maximalist Studios, and flourishing in areas I never thought I would, is truly a dream come true.

If you had one pivotal point that changed the direction of your life, what would that be?

EDDIE: It was when I went to culinary school and I found myself hating my life, hating cooking for work. I had enjoyed cooking, then suddenly, when it was full-time, it wasn't enjoyable anymore. I loved decorating and going to flea markets and stuff like that, and people would say, "Well, you're not a decorator. How are you going to do that?" And I would say, "I don't know, but I'm going to figure it out." Then one day, I was fired from Martha Stewart's TV and food department, and I took a job at Food Network, where I was hired ironically as an associate design director, which was so great. I was living in Greenwich at that time, and I was renting this little guest house cottage. My friend Hannah's sister-in-law was a decorating editor for a magazine called *Classic American Homes*. She came over one day and saw my cottage—how I decorated it—and said, "Have you ever thought of decorating editing for work?"

I said, "Well, yeah, I love that." And she said, "I know you have all this experience, but you'd be starting off as an assistant." And I said, "That's fine." So while I was still working at Food Network I took my first styling job, styling and decorating for *Classic American Homes*. You know, I faked it till I made it. I'll never forget.

When I quit my job at Food Network, 9/11 happened right after, and I couldn't get another job anywhere. I was like, "Oh my God, what did I do?" I had a car payment, and I had my rent to pay. But that was a pivotal point when I realized I needed to work in design.

Shortly after, I started doing window designs for a store in Westport, Connecticut. My

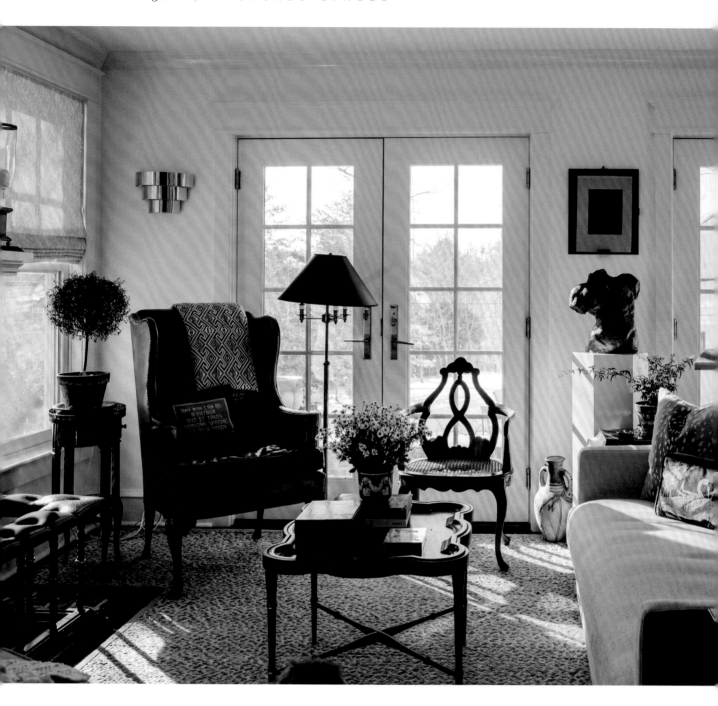

first styling credit in a magazine happened shortly afterward, and that's when my career in design sort of took off.

CARLEY: How did your family respond to you going off and working in a creative field? Were they supportive?

EDDIE: They didn't understand it. But then suddenly, when I started getting on TV, they were almost basking in the glory of what I was doing.

How are your trials and victories represented in your home?

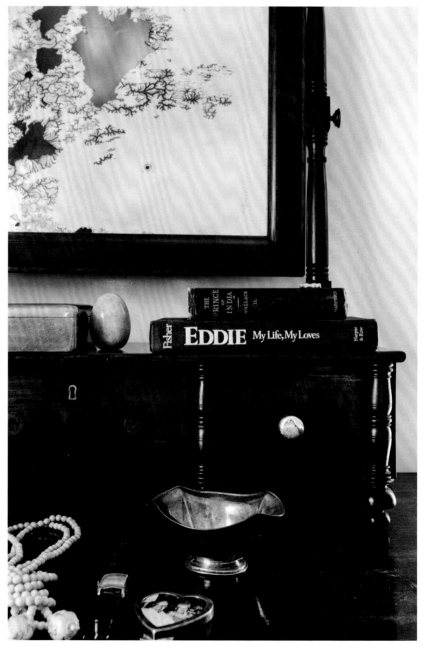

EDDIE: Well, I always knew I was creative, and I definitely wasn't like the other kids. I never felt like I had a home, because the house I lived in never felt like me. I would always laugh and say I felt like I was swapped at birth by accident, because I felt like I belonged in a mansion in the country. My home just didn't feel right to me; it was loud, chaotic, messy. My parents were so young when they had my brothers and me. I mean, I was raised by kids.

I always wanted a place that was calm and felt like me. I wanted everything around me to feel like it had something special to offer and had a story. My grandparents had that same sensibility and loved antiques. I share that same love. I would rather find something that's old and built well or buy something that's new and built well and more expensive than buy something that's inexpensive and built poorly or has no character. But my parents wanted everything to be new. So I never felt comfortable in our home.

CARLEY: You told me about your trials, so what's the victory now?

EDDIE: The victory, even as I am sitting here talking with you, is that everything I see here in my home now I truly love. And there's a reason for each item. There's nothing here that I pick up or touch that makes me question why it's here.

The Venetian glass plate you're eating from now is a good example. Not everything is precious, but it is *precious*. I bought these plates for five dollars at a thrift store, but if I bought those same plates in Bergdorf Goodman, they would have been fifteen hundred dollars for a set of eight.

"So working and being creative is where I found my safe place."

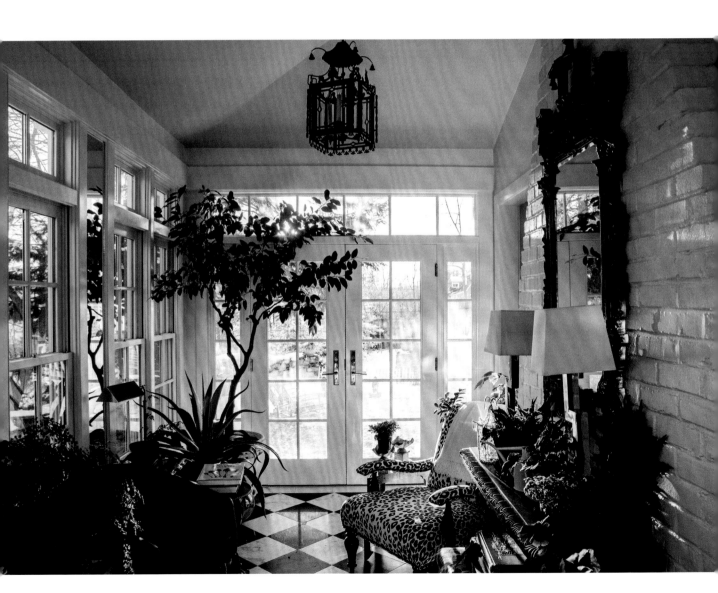

CARLEY: You said something earlier: "I look around my home and I love everything I see, and it all has a purpose." Do you feel the same way about yourself? Do you think about yourself in the same way? Do you love yourself?

EDDIE: It's getting better. I did struggle when I left my jobs because I always had a great title, so losing that was like losing a bit of my identity. Before Maximalist Studios started to gain recognition, it was depressing.

But I came to realize, I still had what mattered most: I still had Jaithan. I still had my little dogs and my parents. You know, it's all still great, but at the time, I couldn't help thinking, *Who am I now?*

My grandfather was a huge gardener. He worked on one estate his entire life. From the time he got out of the war, he worked up until the day he died. As kids, my brother Justin and I would go to work with him in the summer. Justin wanted to go outside and weed and do all those things, and I'd just sit in the greenhouse and plant and water things. That's what my

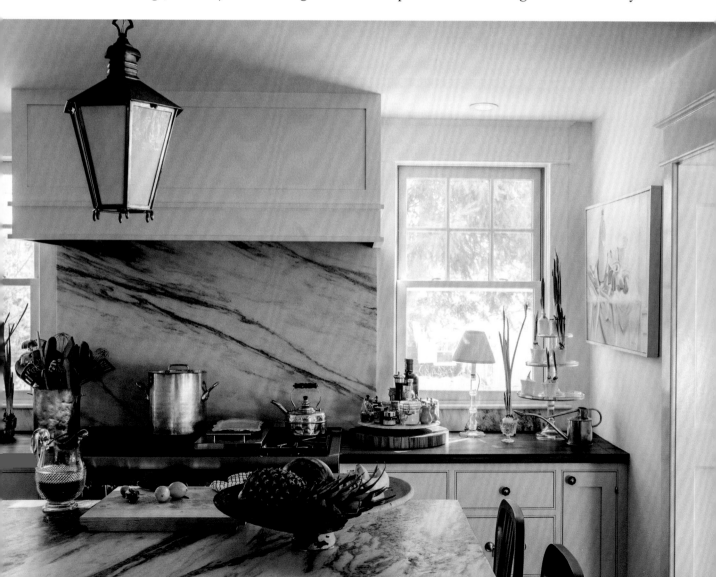

whole garden room was created from—that experience of being in that greenhouse in the summertime. This garden room is probably one of the most expensive rooms from our entire renovation, but we did it because I felt like I needed it—a place where I could plant and water and watch things grow and be surrounded by greenery year-round.

And some days when I pull in the driveway and open the door, I see our monogrammed door with the key cover and the Dutch door, and think, *I can't believe I live here. I can't believe this is ours.* Or I go into the garden room in the morning and pick off the dead leaves on the begonias and see the lemon tree blossom and look at new shoots on the banana trees and notice how the ferns are growing, all in January. And that feels like a huge victory. It's like a little victory garden, where I can finally feel the peace and quiet I wished for when I was growing up. Really, the whole house is a victory, because I truly feel myself here.

Martha Stewart said something once (and I believe it): We are only here on the earth renting and preserving. This house was built in 1923 as a center-hall colonial that was modified in the late thirties to a craftsman style. We saved this house from being knocked down, and we saved the integrity of it—from what a flipper would have done to it.

If someone were ever going to buy this house from us, I believe they would love it as much as we do. And I think that's such a victory, knowing we created something special here.

What does freedom *mean in the setting of your home?*

E D D I E : Freedom means being able to live on my own, and not having to rely on anyone else. I graduated from high school and went right into culinary school. I didn't need my parents' money or my parents' roof. Financial freedom offered me independence and the confidence I gained when I didn't need anyone's money. I was able to do it on my own.

Where is your sacred space in your home, the place you find the most peace?

E D D I E : In the kitchen, for sure. The kitchen and butler's pantry feel the most sacred because that's where all my favorite things are. I don't sit down a lot, but when I do, the formal living room is another favorite place of mine because a lot of my favorite books are in there. When I need inspiration for gardening, I'll sit in there and look through the books—that's my sacred space as well.

C A R L E Y : I agree. I love looking through my design books, too. There's something so restorative about that quiet act that it feels sacred.

What does your personal meditation or quiet time in your home look like?
How do you get away from the worries of the world?

EDDIE: Mine is organizing and decluttering—moving things around so my home doesn't get stale or stagnant. Clearing out visual chaos is very calming for me. I'm not OCD, but I do like things to have a proper place.

In the morning, I'll come downstairs, have coffee, and polish silver, which is something that's super relaxing for me. I love doing those mundane chores where I don't have to think about what I'm doing; I just do it. The end result is so satisfying—taking something that was tarnished and dirty and making it shiny and beautiful. It's the same thing as ironing napkins. If I could have a business of just ironing napkins, I would be so Zen, I'd be like the frigging Buddha [*laughing*].

Another Zen time is when Jaithan and I are together after a long day and we're too tired to make dinner, so we pick something up from one of our favorite restaurants. But I still like to take the food out of the containers and place it on nice plates.

If there is one part of your story that you think would set another free, what is it?

EDDIE: Don't listen to what people tell you. People told me I couldn't be an editor because I didn't know how to spell and write. I was always in the special classes in school. Kids would call me "Special Ed." They'd say, "Oh, here comes Special Ed." I was tortured by that. Do not listen to what other people say. Surround yourself with people who believe in you. I call it "social gardening." Weed out those people who are not good, especially now with Instagram and social media. And keep the friends who build you up.

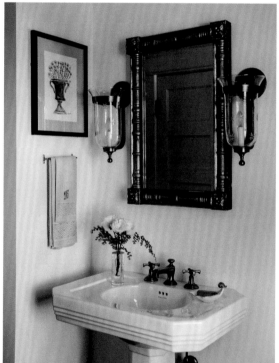

"The end result is so satisfying—taking something that was tarnished and dirty and making it shiny and beautiful."

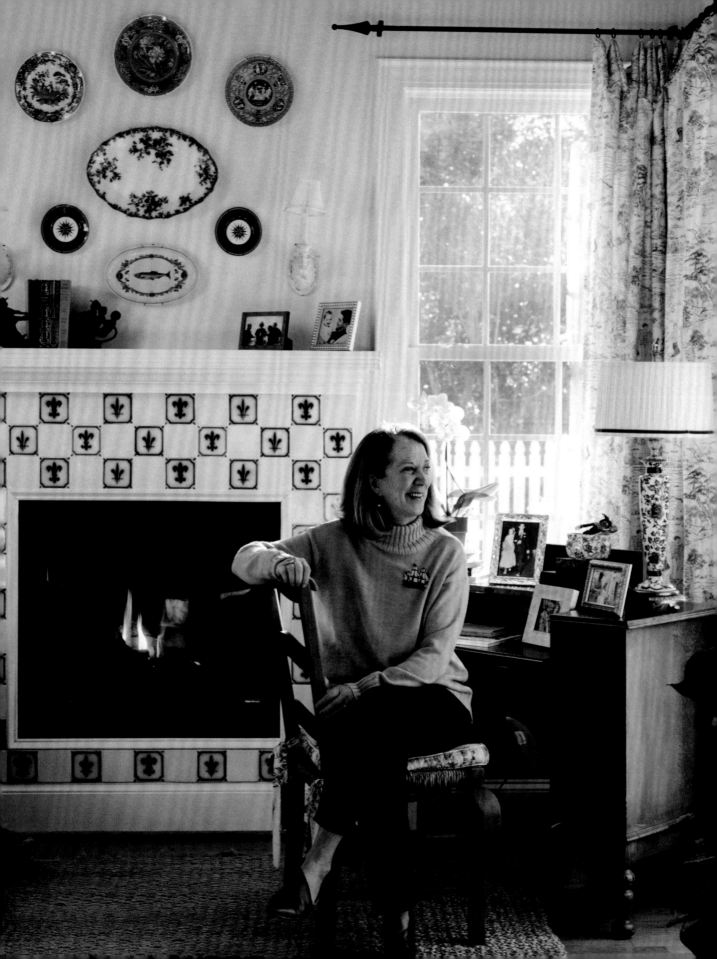

PAGE AMAN

GREENVILLE, NORTH CAROLINA

PAGE AMAN LIVES IN THE HEART OF GREENVILLE, NORTH CAROLINA, WITH HER husband, Mike, son, Michael, and their sweet collie, Anne Bonny. Page, who just so happens to be my mom, and my father, Mike, first met each other in college as cheerleaders for their alma mater, East Carolina University. In 1989, the year I was born, they purchased their fixer-upper, which was just steps from the Dowdy-Ficklen football stadium, where they once cheered on the field together. Since then, their home has transformed throughout the years, to finally emerge as a beautiful Southern-inspired, traditional home with European flair. Page studied education and started a school for learning-disabled children. Mike is a serial entrepreneur and business consultant, and an inspiration to me as a small business owner.

Page's home was the first to inspire me to be fully myself, and to see a living space as something that welcomes who we are while leaving room for us to grow into who we could become. Page is my idol, my best friend, and my mentor. The walls of her home have witnessed us in some very real moments of pain, but when I walk through her sacred space, I am greeted with an overwhelming sense of victory. While my mother and father fought bankruptcy, fought for my little brother with disabilities, and pushed my older sister to be all she could be, they also fought for my life for seven years, and prayed every day for me to have a life change. As I sit in their home today, healed and made new, I can say without a doubt that this home has been an anchor for me, and a fortress for my family when they needed it most. I am honored to share their sacred space with you now.

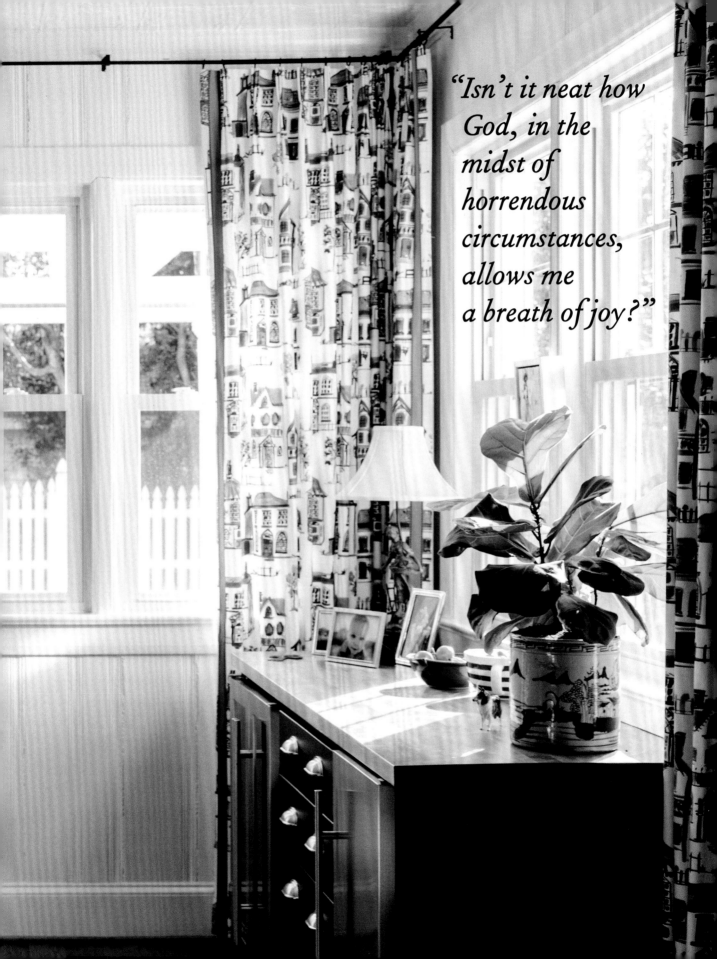

"Isn't it neat how God, in the midst of horrendous circumstances, allows me a breath of joy?"

Your story . . . Go!

PAGE: I was born in the furniture capital of the world, High Point, North Carolina, which made sense because my daddy was a furniture designer. My mom was a homemaker and stayed home with my siblings and me. I had an idyllic childhood because my daddy was an artist, creating magic and art for us in so many ways.

Daddy fostered real creativity in us. He wouldn't let us use coloring books; instead, he gave us crayons and a sketch pad to let our imaginations go free. Imagination was our foundation.

When I wasn't in school, I was always out in nature, riding bikes or our horses, and playing in the woods a lot, building forts of all kinds. I also played with Barbies a lot, but I never played with the dolls themselves; I just made their houses. [*laughing*] And I made fabulous

houses for those Barbies! I was obsessed with playing with dollhouses with my friends. I was a Girl Scout until I was in twelfth grade, and when everybody else would go hiking, I would stay back at my tent and lash tables together and dig up ferns and plant them around my tent. Houses were my comfort, my creativity, and I think I knew even then—they were my calling.

But then came the recession. My father lost his job as a designer, and we inevitably began to live in a lot of fear during this uncertainty. I wanted to be a designer when I grew up because I loved designing those houses. But he advised me not to become a designer because he was afraid I couldn't get work and that I would lose my job. So when college came around, I ended up majoring in child development. I love children. And when I thought about it, my dream growing up had always been about the whole picture of a family. I wanted three or four children, animals, and a beautiful home. So I majored in child development, was a cheerleader at ECU, got a job with the university, adored my job, and married my cheerleading partner, who was also my best friend.

We later opened a Dunkin' Donuts franchise when we were in our twenties. It was hard, hard work. As we began to have one child and then two, we realized our work wasn't the right fit for our family, so we sold the franchises, and, long story short, the people we sold them to declared bankruptcy. Because our name was still on the leases, your dad had to go back into the business and work, and it was far from easy. It was ugly, because he was working seven

days a week, probably fifteen to twenty hours a day sometimes, and I was alone at home with our kids.

CARLEY: I remember.

PAGE: Yeah, it was very hard. Finally, we sold those businesses, got out of there, and got into another food business, but we ended up selling that business, too. After that, your dad took a six-month sabbatical before getting into the communications business. Slowly, things started to change for us.

I always dreamt of decorating a home. I remember going to college and being more excited about designing my dorm room than almost anything else. But at that point, your father and I didn't have much. We didn't have the money to make the house beautiful, so instead I got creative. I mean, I had a tepee in the front yard. I would put y'all's artwork on the front door. And because you went to the elementary school right up the road, teachers would just laugh at the way our house looked, but it was a creative environment. Lots of Play-Doh, paint, crayons . . . plays that we wrote and put on together. Then once your dad got into the communications business and we started making good money, I began to really work on the house, and it began to transform into something glorious.

Your brother, Michael, was born in 1992, and we were thrilled because we already had two girls, and now we had a boy. It felt like the whole picture was coming together. It was hilarious 'cause you and Olivia would go into his room and put crowns on his head. But when he was two and a half, he began to have seizures, and it was a nightmare. Ultimately, the doctors told me . . . I don't even want to repeat what they told me about Michael, because I refused to believe what they told me. But he had some pretty severe disabilities. Right around the time that he got sick, your grandmother had a stroke, which was even more stressful because she was the caretaker for my dad, who had early-onset Alzheimer's.

So there we were, caring for a kid in the hospital with epilepsy, a grandmother three hours away who was in the hospital with a stroke that paralyzed her left side, and a grandfather with Alzheimer's that was getting worse and worse every day because his wife wasn't there to take care of him. We had grit and so we trudged through, but it wasn't easy.

I remember that during all of this, house painters Randy and Ray, who became two of our best friends while working on the exterior of our home, were painting the front of the house. While I was sitting out there watching them paint our ugly red brick house a creamy white, I thought, *Isn't it neat how God, in the midst of horrendous circumstances, allows me a breath of joy?* I was beaming, all because I was going to have a beautiful exterior.

I realized that Michael was going to need more help than what the public school could provide. So I, along with two other moms, started a school for learning-disabled children

in 1997. It was truly divine how it all came together. That school is really what saved Michael and taught him and brought him to his full potential. That school is why he is academically and intellectually the way he is today. He's a smart kid, as a writer, as an artist, as a person.

CARLEY: He became everything the doctors said he would never be.

PAGE: Correct. If I told those doctors today that he has had an art show at Pitt Community College, sold art at Emerge Gallery in downtown Greenville, has written a book, and is working on his second book, they wouldn't believe it, given the prognosis that they gave me when he was a little fella.

That school, our family, and the culture helped make him the great man he is today. And I think it was good for you and Olivia, because it gave you the perspective that people who have disabilities have great possibilities, and that with God, anything is possible.

Anyway, Dad's business and my business continued to flourish, and I could do more and more things in my home. I was so blessed. I mean, we would have children's Bible study, memorize scripture, have fun, and be goofy in the Bible study. You had been a kid who didn't cross the line, who didn't break the rules. I knew God had a very specific plan for you, a spiritual plan. I knew you were created to serve God. All my children were created to serve God.

But in about 2007, even before you graduated high school, you started making some bad decisions. In all fairness to you, you were an extremely creative child going to a public school that did not embrace unique children. You were also sandwiched between a sister who was top of her class. She was Clara in *The Nutcracker*. She was an excellent dancer, had lots of friends, and was very popular. And you had a little brother who needed an enormous amount of attention. And I was devoting my life to starting a school for your brother. You were kind of in the middle, and that probably had something to do with your struggles and the fact that girls at school didn't understand you.

It all became so much that sometimes I couldn't even leave the house. I would stay here and cry and pray, so it was important for my home to be beautiful. I needed to create a haven, even if that was just making sure there were freshly cut flowers in vases in the sunroom and kitchen and making up my bed every day.

But after we went through the hard time with you, and you went to Haiti and then to Palm Beach Atlantic University, God just began to pour out blessings. It's like God was saying, "You've been through it, girl, so I'm going to do some really sweet things for you right now." And that's kind of the season I'm in now. I'm very blessed.

If you had one pivotal point that changed the direction of your life, what would that be?

PAGE: There's not ever really one moment that changes us, but it's what we decide to do afterward. When I was in seventh grade, I tried out for cheerleading. I was so bad that the judges rolled back and laughed at me. It was mortifying. But what I learned from that was if

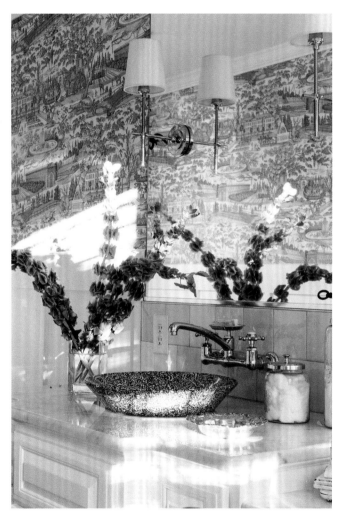 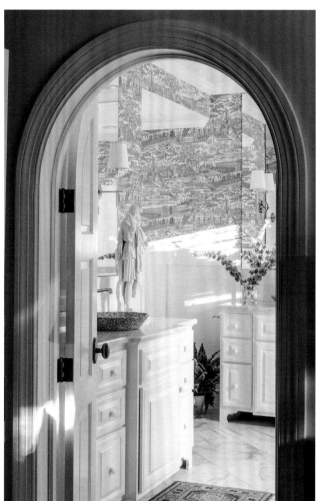

I worked really hard, I could achieve anything. I would practice in the yard every afternoon, with my father doing cartwheels alongside me. When I made the squad in ninth grade, I saw how vision and dedication could transform even what seems comically doomed. It's the same with a house. When we bought this house, it had been on the market for two years and it looked horrendous. It was a major fixer-upper (we bought it when buying a fixer-upper wasn't cool).

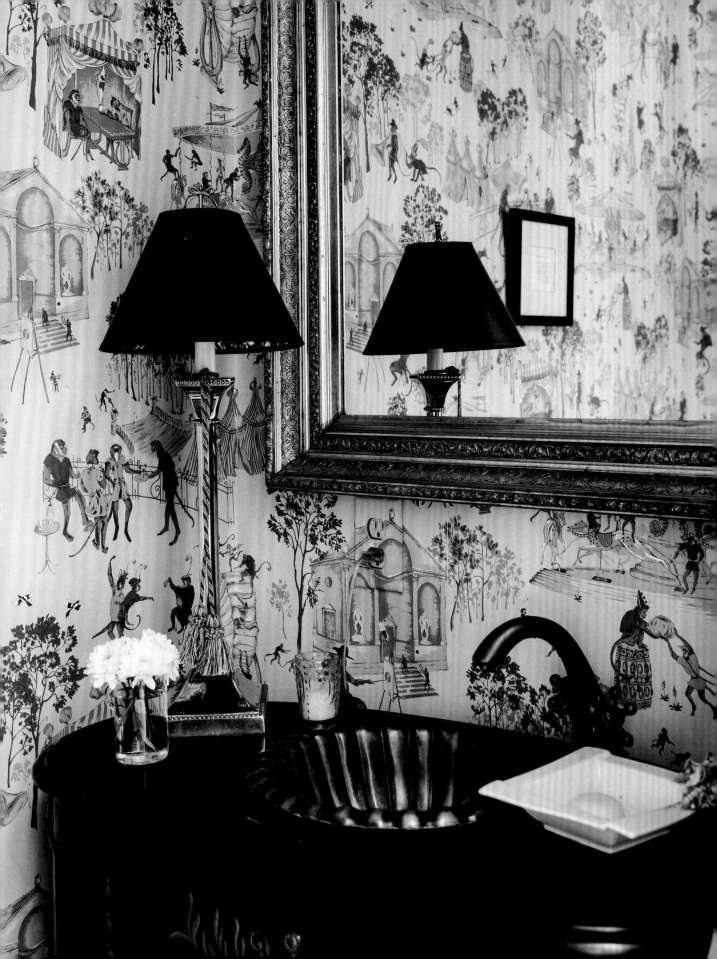

But we were still broke, and there was no HGTV show coming to save us. It took years to be able to afford to fix it up to the place we wanted it. But I had a vision for what it could be. Beneath that dusty old house was great character, good bones, and the potential for a home. I also learned that not only if I worked hard, but if I prayed about things, God would show up, because I would watch God work in my life, even when I wasn't totally walking with him. In college, your dad was my best friend. And then I started to fall in love with him. I would pray every night, "God, I want Mike for my boyfriend." When he became my boyfriend, I would pray every night, "God, I want Mike for my husband; I want to marry him."

When I continued to pray about something, and was diligent, and didn't give up, things had a way of working out. It was that way with my home, with you, and it was that way with Michael. It's been that way with everything, even with Olivia. Before she was born, I bought a picture of a little girl holding a nutcracker, and I said, "One day, my daughter's going to be Clara in *The Nutcracker*. And I hung that in her nursery. It's the power of prayer; it's the power of hard work, of having a vision for bones being brought to life.

CARLEY: The pivotal point for you was when you were laughed at in seventh grade, which led you to realize that if you put your mind to something, you could accomplish it. That changed the trajectory of your life?

PAGE: Yes, it did. I realized I can do what I set my mind to. And when I couple that with prayer and God's word, nothing is too hard. Nothing is too hard for the Lord.

How are your trials and victories represented in your home?

PAGE: Three of my happiest times [*starts crying*] were when you were married in the front yard, Livvy was married in the backyard, and Michael's graduation from high school was in the backyard. Prom pictures, cheerleading parties, birthday parties, children's Bible studies—they all took place here.

As for trials, I would lie on the floor right here in the sunroom and pray. I remember lying on the floor, praying for you, and praying for Michael. I remember when Livvy went to Florida State, and she was auditioning for their dance program. I was lying on this floor, praying all day that her dream would come true—that she would get into Florida State. One of my dearest friends called me that day and needed me to do something. I said, "I can't. I'm praying." She said, "I'm joining with you in prayer." It was Sue Aldridge.

This home held my grief even with our cat. I remember where your daddy sat holding Matey when the vet came over to put her to sleep. That cat was the love of my life.

Then I remember the victory of you falling to your knees in the kitchen the day you finally agreed to go to rehab. I can picture the exact spot where that happened.

And I can still see it now—your brother running around naked, getting potty trained, with me chasing him outside. Some of my friends would call and see him out there naked and say, "I'm going to report y'all to Social Services!" I can still feel how my stomach hurt from doubling over in laughter.

And I can even go back to the beginning, when my mom and dad walked up to this house when they were healthy and saw the outdated electricity and rickety old wood and telling me I had just bought a firetrap. But even then, I knew with a little love, I could build this place into a home.

What does freedom *mean in the setting of your home?*

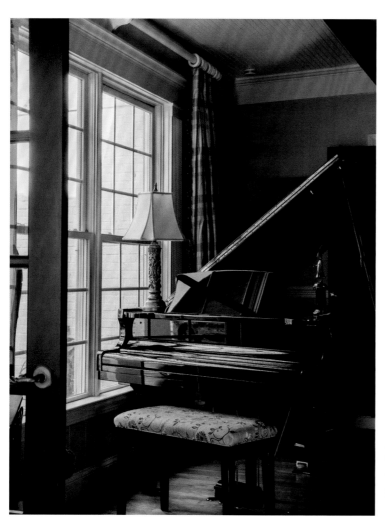

PAGE: When I go out in the world and I'm doing different things, especially when I was working in the school, I could come back home and have a respite. It could be the most grueling day, but when I stepped inside, I could sit in my blue chair with damask fabric, I could read my Bible, or I would read the *Mitford* [*Years*] series and just be calm. These simple rhythms became my serenity.

CARLEY: Do you remember when I got my first DUI and was arrested, and someone texted you? People started developing opinions about you and our family after that, but your home became a place where you could be free—free from opinions or outside influences.

PAGE: I think that's one reason I never left the house. I don't want to say I was embarrassed, but I was scared to go out in the world because I was afraid somebody would ask me about you. And when you didn't have a car and you were having to walk to work, I was afraid that I'd see you walking on the road, and it would be cold or it would be raining and it would have just crushed me.

I can remember sitting at the kitchen table telling some of my friends that you were going to rehab and how hard that was, or when you came home from falling three stories and you were still not in a good place and it was horrible, tragic, ugly. I had to get my housekeeper and her husband to help me lift you and move you around. Maria and I will still laugh about that and say, "Look where Carley has come from; look how good she's doing now."

CARLEY: And look at us now, sitting here in the same room that I used to sit in when I was in trouble. We have freedom here, and I think as hard as it was, I would come back to this room and confess.

PAGE: You would. It's almost like the Holy Spirit was in this room and you felt his presence and you felt safe enough here to tell him what was going on.

CARLEY: It was. There's a lot of freedom here. A lot of bondage was broken here.

PAGE: The Lord is in this place. I feel His presence here. When you were in high school and you were really struggling, I would go upstairs and anoint your doorframe with oil, I would anoint your bed frame with oil, and I would anoint your forehead with oil, and I would pray over you. And you were hilarious; you'd wake up the next morning and say, "Mama, did you anoint me with oil?!"

CARLEY: You wanted this place to be a place of freedom, and I will say, it was a place of freedom for us, especially in creativity. You didn't purposely raise me to be weird, but you really fostered freedom of creativity, and I think that's why I am the way I am today and able to have the life and career I have.

PAGE: Well, I think you, Olivia, and Michael are that way. That's how my parents raised me, so inevitably it trickled down. We were always having creative people come to the house—cooking, performing, playing, and creating with everyone we could. I thought it was just so important for y'all to be who you were, not to be phony. Olivia even tells me sometimes, "Mom, you didn't teach us to be cool, we didn't know how to be cool, and I'm so glad

you didn't teach us to be cool." All three of you are so creative and artistic, and art has become your professions. Art became the cornerstone of our home, and by God's grace I think that's how it's still standing.

Where is your sacred space in your home, the place where you find the most peace?

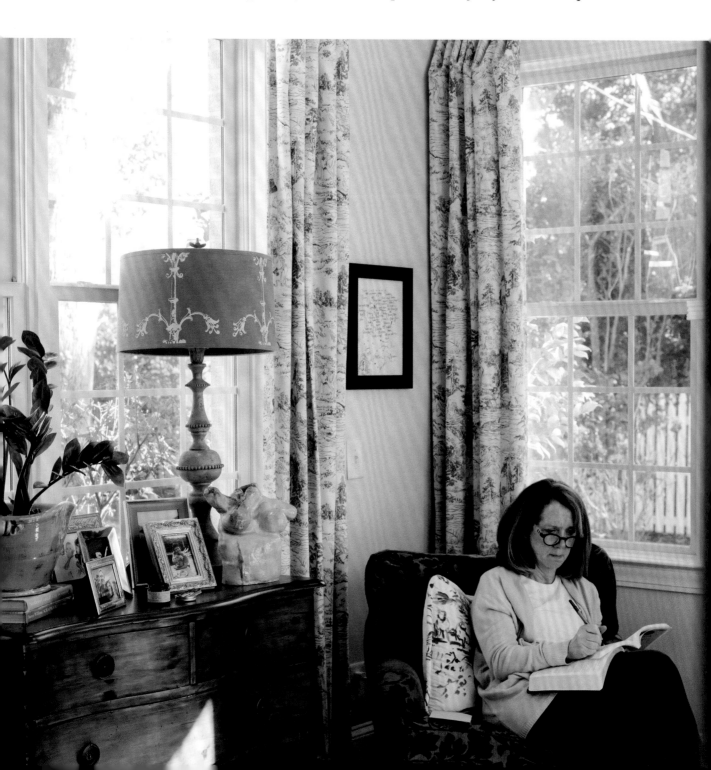

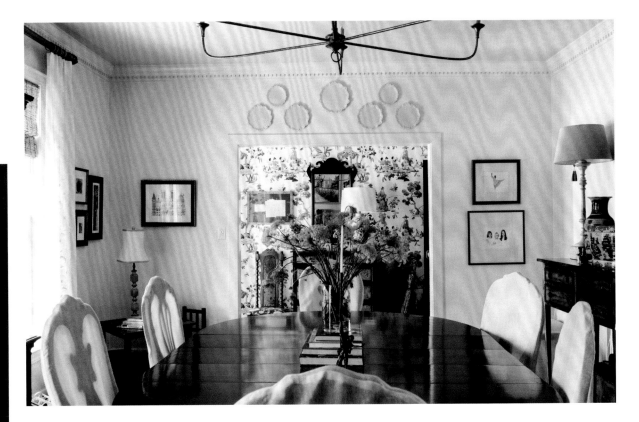

PAGE: Where the light touches everything—our sunroom. The chairs are comfortable, and if it's cold, I can turn the fire on. This is where my cat and dog love to come and sit with me. It's where I read my Bible. A close second is sitting at night in the dining room in the Stout chair that you and Daddy designed, with the fire on while talking to your daddy. I love that spot. But the sunroom is my sacred space, the place where I feel closest to God, where I'm able to be still and listen to the Holy Spirit and his direction in my life. We added this space when you all were teens, not knowing how special it would become. This space evolved into a place that I constantly gravitate toward because of the light, the toile curtain, and the pictures. Never in my wildest dreams did I ever think I would have a space like this of my own.

What does your personal meditation or quiet time in your home look like?
How do you get away from the worries of the world?

PAGE: I'm really not that structured. I come into the sunroom every day, usually in the morning. But sometimes if the morning is crazy, I do it in the afternoon. Sometimes I light a candle and make sure to have a vase of pretty flowers on the table. I sit down with coffee or a steaming cup of tea. Or I fill a pitcher of water and add in lemon, basil leaf, and berries just to make it pretty. Sometimes I'll read *Jesus Calling,* or sometimes I'll journal first—it depends on what I'm

teaching in Bible study. I'm teaching Jonah now, so I've been reading the book of Jonah a lot and studying that. Sometimes if I'm really stressed out, I just read excerpts from Jan Karon's *Bathed in Prayer*. It helps me a lot. It's got a lot of scripture in it, but it's full of sweet stories that warm my heart and help me to realize that the world really is a wonderful place.

If there is one part of your story that you think would set another free, what is it?

PAGE: Romans 8:28: "All things work together for good for those who love God and are called according to his purpose." God has a plan, and even when things are at their darkest, if you continue to pray, trust God, and work toward goodness, everything's going to work out; it's going to be just fine. God's got this.

CARLEY: How about an example?

PAGE: I was sitting at the kitchen counter when you were a teenager, and I had been praying and praying that you would change, that you would begin to make different decisions. And just the day before I had read the Bible story of the prodigal son. When it came up in my devotions, before I started reading it, I said, "God, I don't want to read about the prodigal son, because I've read the prodigal son enough times; I don't want to read it anymore."

But God spoke to my heart and said, *Read it.*

So I did. When I read it with the eyes of the Holy Spirit, I came to the part where the prodigal son was feeding the pigs and read, "And then he came to his senses." It didn't say that his father called him, and the son changed, or his father got a counselor in there to work with him or sent an intervention. No. It was when *the son* came to *his senses*. It was then I realized, *Carley has to make this decision. It's up to her to decide if she wants her life to be different.* Right then and there, I released you to God. I knew I could lose you, that you could die, but God had a plan, and I chose to trust Him. He brought you out of that dark night into the life you have today. I would tell anyone reading this that God can do the same for them.

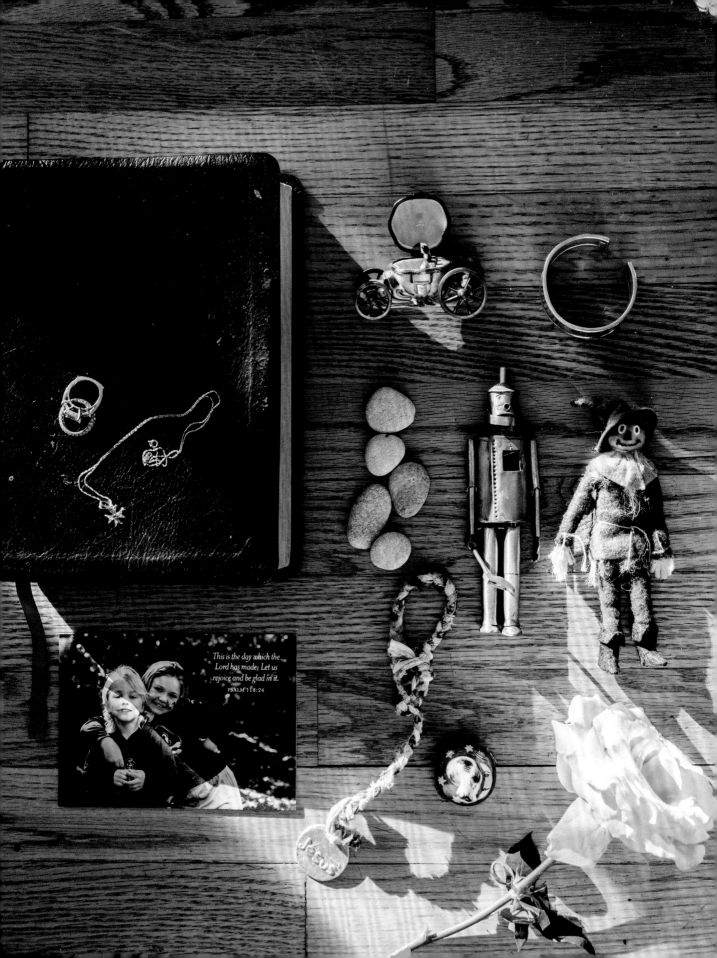

This is the day which the Lord has made; Let us rejoice and be glad in it.

PSALM 118:24

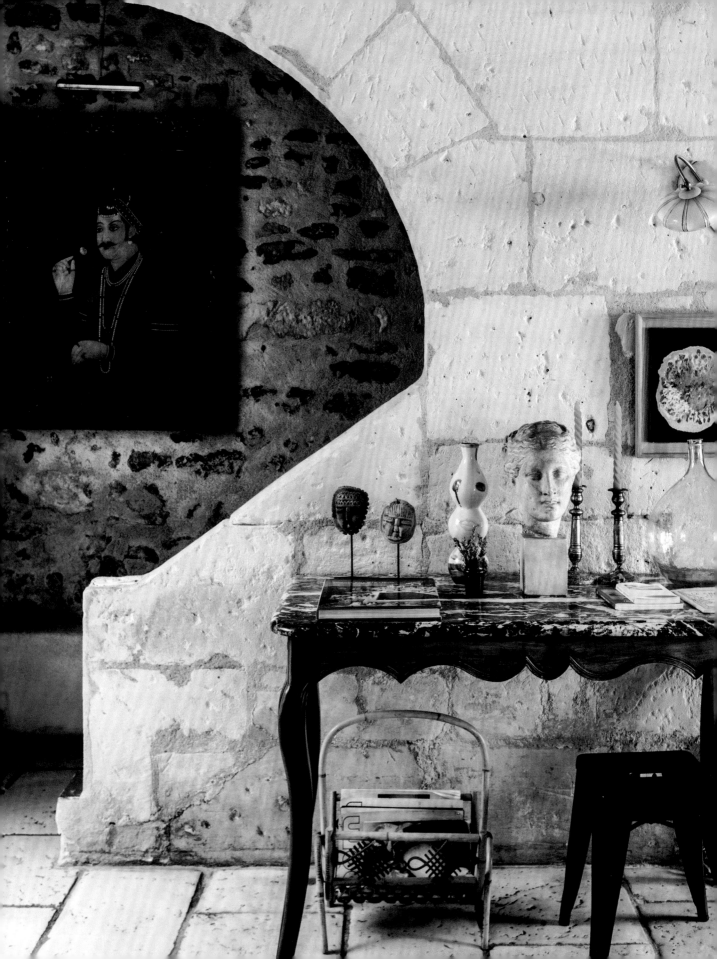

THE WANDERING HOME

STORIES FROM
CYRIELLE RIGŌT & JULIEN PHOMVEHA,
DAVID BRIDGWATER, AND MOLLY BERRY,
WHO WERE LOST IN LIFE, LOST IN TRAVELS,
BUT NEVER LOST IN THEIR HOMES.

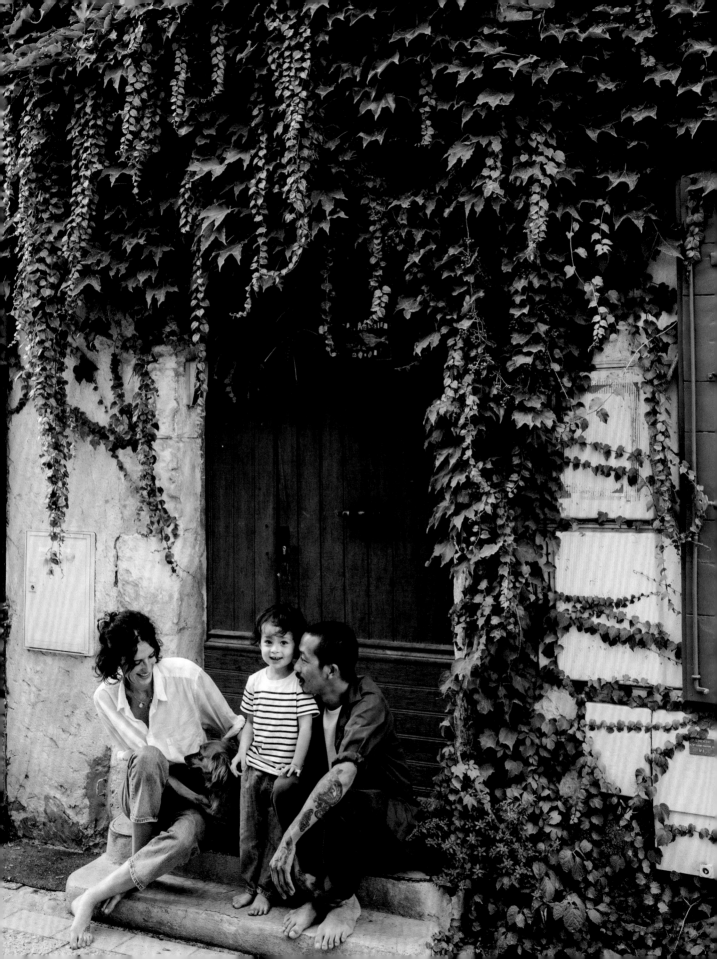

CYRIELLE RIGŌT & JULIEN PHOMVEHA

ARLES, FRANCE

CYRIELLE AND JULIEN HAVE BECOME MY LIFELONG FRIENDS. WE MET more than six years ago when I stayed at their *riad* in Marrakech, Morocco, which became my home away from home. We instantly bonded over our mutual love of photography and creativity. They are truly two of the most ambitious and talented people I know, running a successful and uniquely curated hotel in the heart of Marrakech, Riad Jardin Secret. In 2020, my husband, Jon, and I planned to visit and capture their farm home in Morocco, but due to world events, we were forced to cancel our trip. They moved back to their home country of France, where they found a special home in Arles, and created an oasis for themselves and their son, Nino, to escape the anxieties of the world. This home in the South of France is and was always a place of transition; however, they made sure it had a sustainable peace. They have skillfully decorated their home with memories of travels, and with their love for fashion.

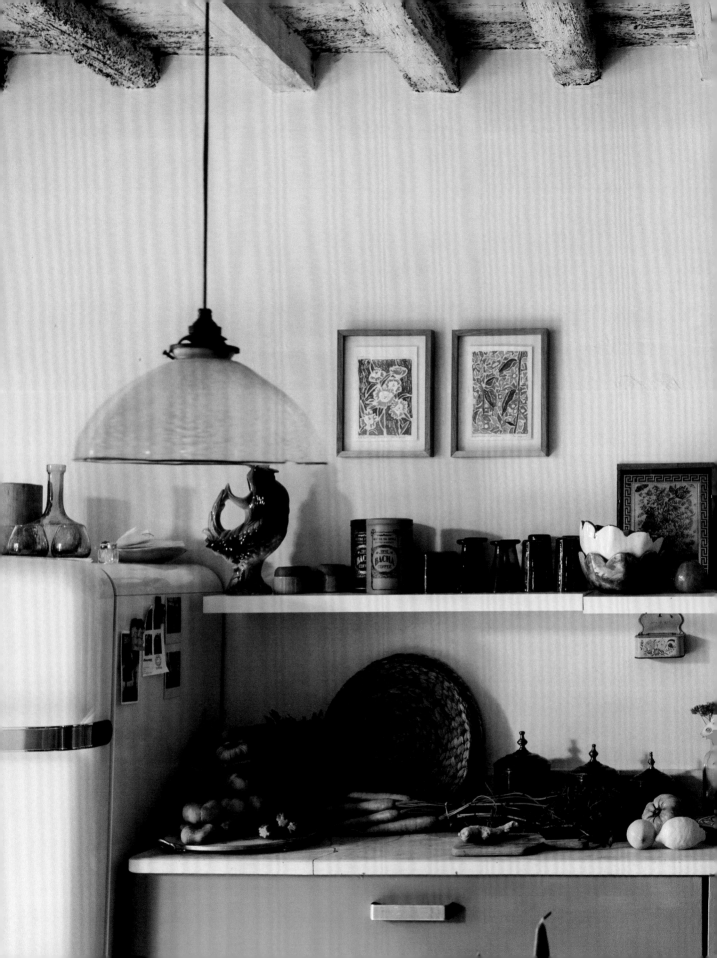

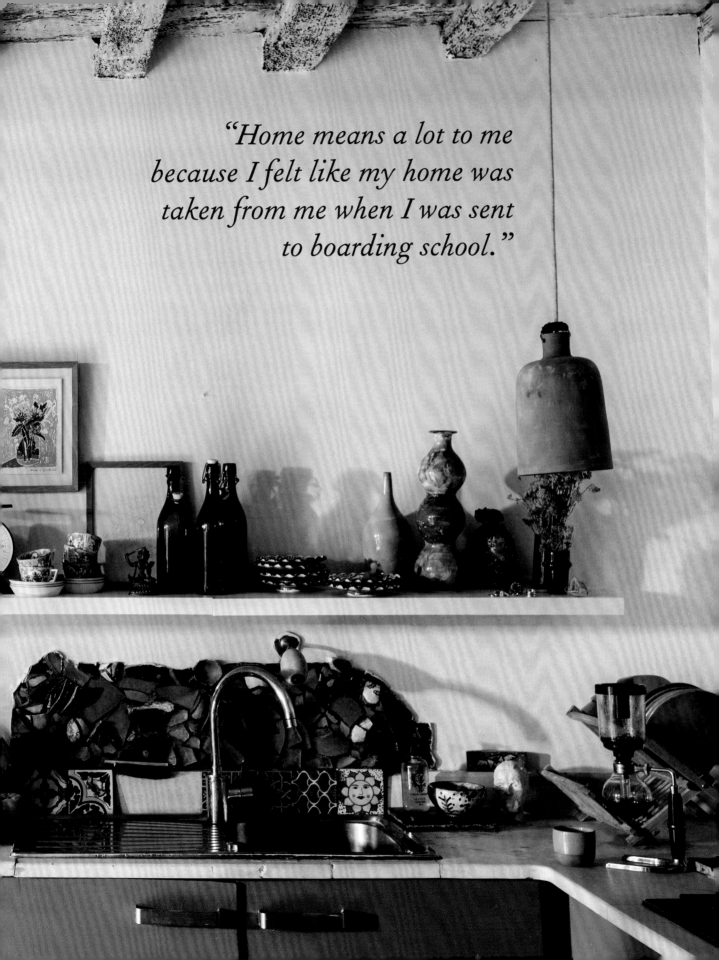

"Home means a lot to me because I felt like my home was taken from me when I was sent to boarding school."

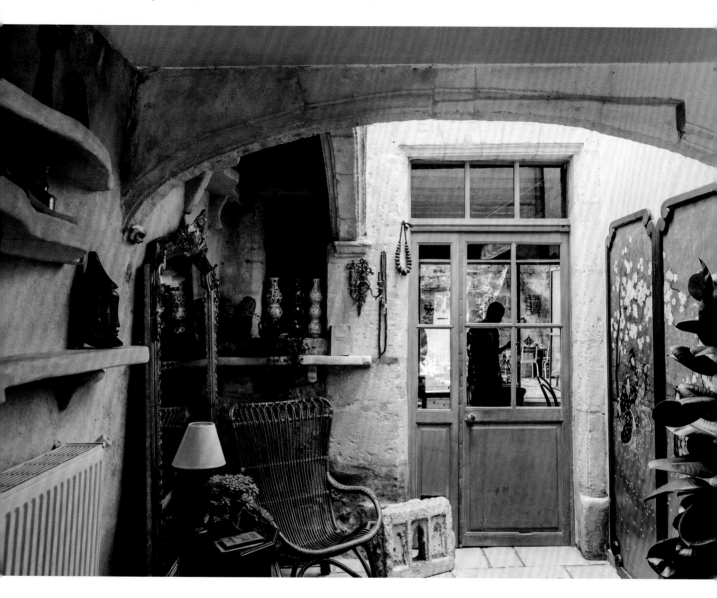

We laughed, we cried, we created; it was magical. I hope you all can see their passion and how they have truly created something that is one of a kind.

Your story . . . Go!

CYRIELLE: I grew up in a happy family in France until my parents got divorced. My mom met a very wealthy man, and at the beginning, it was nice for everybody, but once they got married, it changed. I have a sister seven years older than me, and the man my mom married has a daughter my age, so I was close to her. They put us in a boarding school when I was only seven and it broke my heart, even to this day.

CARLEY: You had to move away from home?

CYRIELLE: Yes. I used to have a magical home. I lived with my mom and my dad. We lived close to Paris. My mom worked in an antiques shop and my dad took over my grandfather's business and worked as a tailor. My grandfather was a Jew from Poland and had to move from Poland to France during the war. He had to hide from the Nazis, and escaped Poland. He became a tailor and became pretty good. He was not super famous, but he had good clients and started making a lot of money. He eventually opened his own store.

After my parents divorced, and my mom remarried, I was sent to boarding school. It was a very good school, but I didn't give a shit about that. I just wanted to stay with my mom. I was very close to my mom, so it was very sad for me. My dad was super sad, too, after the divorce and he couldn't really take care of us. It was my mom who was in charge of us at that time and took care of us.

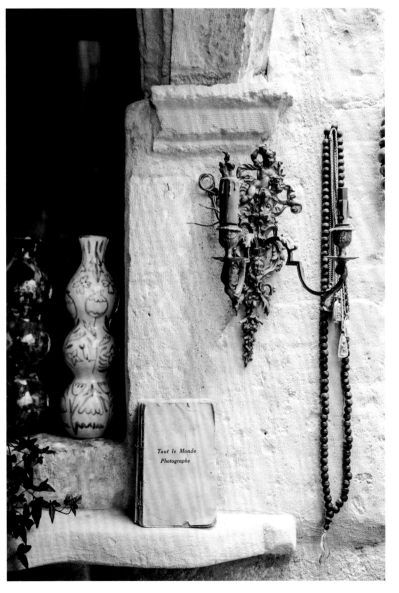

Home means a lot to me because I felt like my home was taken from me when I was sent to boarding school.

CARLEY: I think a lot of people could relate to your story. I can't imagine getting pulled from my magical home, the place where I felt safe, especially at age seven. It's almost like your childhood was taken from

you. It reminds me of earlier when we were planning this interview and Nino didn't want to leave the house, and you said, "Fine, you're staying."

CYRIELLE: Yes, because I don't want him to think that one day I will abandon him and make him feel what my mom made me feel. She did say she was sorry for what she did. She didn't do it on purpose; it was just her life then.

CARLEY: How did you end up moving to Morocco?

CYRIELLE: My parents used to go to Marrakech a lot and even the word *Marrakech* was always so magical to me, so I wanted to experience where they had been and see what they had seen. They used to travel in a Volkswagen van.

CARLEY: They sound like hippies.

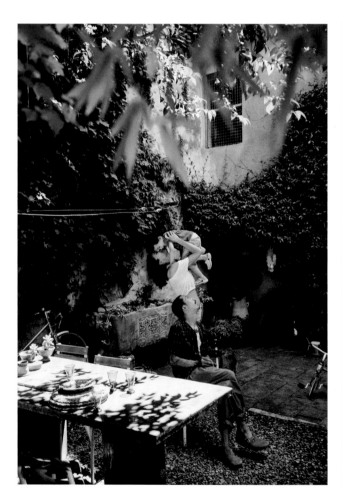
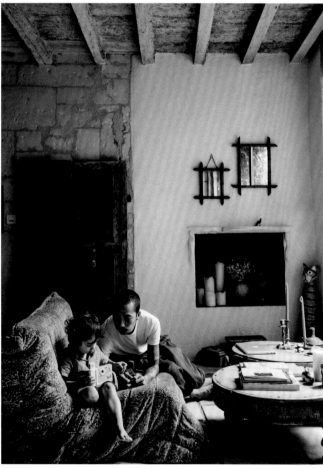

CYRIELLE: They were total hippies! Then I met Julien.

CARLEY: Was it love at first sight?

CYRIELLE: Not at all. He wasn't my type at first.

JULIEN: I had to work very hard for her. We met in Paris through a mutual friend and started traveling together, including to Marrakech.

CYRIELLE: We knew we wanted to leave Paris, and Morocco was always on my mind for many reasons, like the proximity to France, less than three hours by plane; it's so easy to get to, not expensive, and as soon as you arrive, you're in a completely different world. All of my problems faded away when I was there. When I was a model, I went there almost every month. Then one time when we were traveling home, we said, "Why are we going back to Paris? We don't want this anymore." So we decided to move to Morocco in less than three months.

JULIEN: We quit our respective jobs and started to pack. That was seven years ago.

CARLEY: Julien, what's your story?

JULIEN: My parents are from Laos, and they moved to France in 1977 after the [Laotian Civil] War because they had no other choice. They arrived in France with my older sister when she was two years old. I was born in the South of France, in Arles, and very quickly my parents became caterers. My mom never cooked professionally before, but always cooked at home. And I grew up in the shop, literally. I always saw my parents work a lot. I was there with them from seven in the morning until eight at night. Even when we had our house in the countryside, I was always in the city at the shop with them, waiting for them to go back home. Because of their example, work has always been very important to me. You know, with Asian people, it's like a cliché, but it's true. At the same time, my parents taught me the importance of family, though at that time, our house was never something super important for us because it was just a place to sleep.

When I was seventeen, I left for a bigger city. I kept up my studies, but realized it wasn't for me. I wanted to work for a guy who made T-shirts. I wanted to do something creative and work in art, but my dad always said, "No, art has no future."

I moved to Paris by myself and started a new job in fashion. I was surrounded by beautiful things. I moved on to another company, making motorcycle helmets and collaborating with designers. It was great, and I was able to ride motorbikes, which, at the time, was my

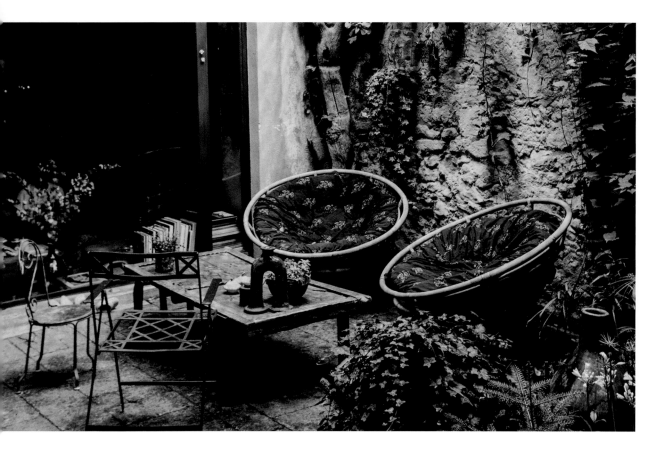

entire life. I was able to combine fashion with design, which was perfect. During that time, I met Cyrielle. I wanted to leave Paris and was thinking about moving to Los Angeles or Japan, because I've always been passionate about Japanese culture and the Californian culture, since I grew up skateboarding and lived with BMX riders and then got into the motorbike scene. Everything I did was driven by the West Coast way of life. When I met Cyrielle, we quickly started talking about moving from Paris.

CARLEY: Did you ever think having a child was part of your story?

JULIEN: No. For me, the good life was traveling and living a fast life. And when we met, we never talked about having a baby at the beginning, so we created the *riad* together; that was our baby.

CYRIELLE: When I was younger, I always said I didn't want a baby. But I always knew deep down that I wanted a big family.

JULIEN: When Cyrielle was ready, I said, "Okay, let's do it." Cyrielle has a lot of love to give and shows so much attention to our pets, I knew she would be an amazing mother. I knew she would give so much love to our kid. I just knew it was something we had to do.

CARLEY: I do see that with you and Nino.

If you had one pivotal point that changed the direction of your life, what would that be?

CYRIELLE: When I met Julien.

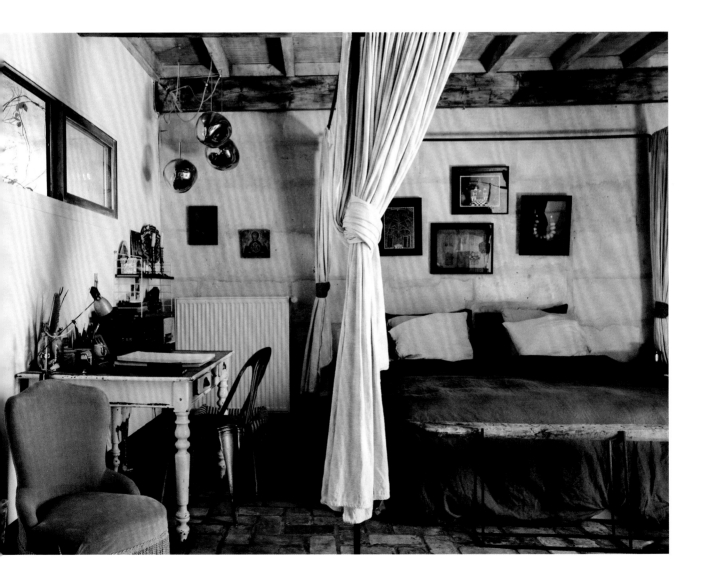

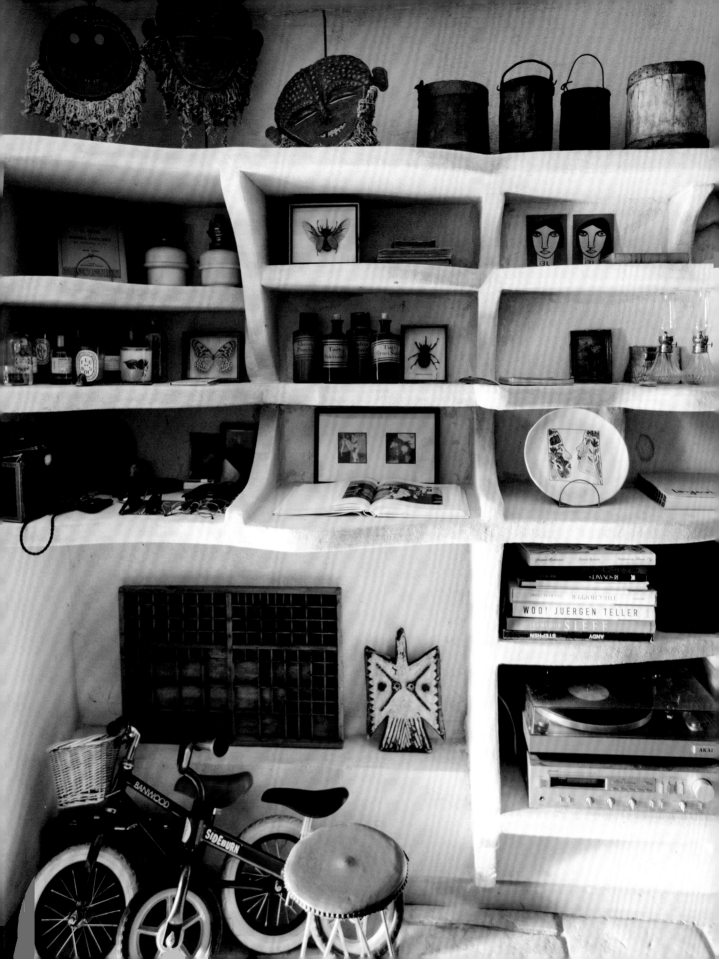

"I knew she would be an amazing mother. I knew she would give so much love to our kid. I just knew it was something we had to do."

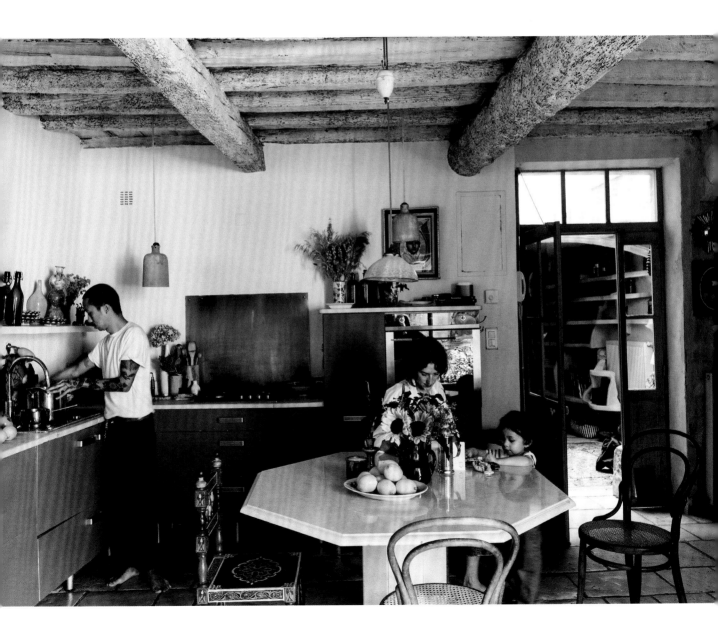

JULIEN: It's the same for me—the day we met and the day we decided to be together. It changed everything. Since that moment, we made a lot of big decisions—from moving to Morocco, to starting a business, and having a child together.

CARLEY: That's so romantic and sweet! What if you never met each other?

CYRIELLE: We'd be lost souls.

How are your trials and victories represented in your home?

CYRIELLE: I don't feel like my victory is necessarily represented in this home, because I felt like I left that back at our farm in Morocco.

CARLEY: But I think your victory has not been stolen from you. Just because the era of the farm is over, it doesn't mean you won't find victory here.

CYRIELLE: For the moment, even though I love this home, I know we'll be moving in the next few years.

JULIEN: It's difficult for us to answer this question because we know that this house is a transition for us. We fell in love with this home, but we are still looking for a different property. We didn't really start a new life here, even though our family is here. This transition has been very difficult for us.

CARLEY: You're in a trial right now.

JULIEN: Yes, we are.

CARLEY: And you're trying to find victory in this place.

JULIEN: Yes, totally.

CYRIELLE: I think a victory for this house is Nino's bedroom because of everything that it represents. No matter where we are, we are family, and we stick together.

JULIEN: If Nino feels good, we feel good. That's the victory and the most important thing for us right now. Our home is where our family is.

CARLEY: You've created something so that no matter where you are, your family is going to feel safe and have security.

CYRIELLE: Exactly. If we are in a hotel room, I know what Nino needs to feel at home.

What does freedom *mean in the setting of your home?*

CYRIELLE: My home is a place where I am free to be myself, to sing, and to express myself.

JULIEN: It started in Morocco. The only time we knew we would be truly free was in our own home, because we have to behave ourselves at work and in the streets. Our home is the only place where we can do whatever we want.

CARLEY: I love hearing you sing! I have an office, so when I leave the office, I try not to take work home with me. I'm blessed to have the freedom to own my own home.

JULIEN: For us, the *riad* in Morocco is an extension of our own home. It's where we host our friends.

CYRIELLE: People from all over the world wanted to stay at our *riad*, our home, and that meant a lot to us.

JULIEN: I feel free all the time. We took a job that allowed us to take time for our family whenever we needed—even if it was to escape to the desert to enjoy the sunset. That's why I don't consider what we do a job.

CARLEY: You seem very free in yourselves, and you know yourselves very well, which is represented here, and in the *riad*. Freedom in your own home is represented in everything that you do.

JULIEN & CYRIELLE: Yes, totally.

Where is your sacred space in your home, the place you find the most peace?

CYRIELLE: I don't have a specific place in mind, but wherever I place my eyes, there is something sacred in this home. The details are so important for us. I do love to sit here in the garden and in the entrance.

CARLEY: My entire home is a sacred space, too, but I have some spots where I can just sit and breathe. When I was in rehab, I asked a counselor what she does when she is working through issues and when she needs an answer from God. She said, "The best place is on your face." So I lay on the ground facedown, and doing that started to change my life. Now every rug in my house is a sacred place because it's the place where I'll get down on my knees when I struggle with anxiety, and hand it over to God. I incorporated this idea as well from my travels to Morocco, since a lot of people carry prayer rugs with them. You did mention that your sacred place has a lot to do with the light. I think that everyone wants to chase light, no matter what your background is. It gives you peace. Light is sacred and makes you come alive.

JULIEN: My sacred place can be anywhere in the house. I need to be surrounded by things I love. I like to sit in the entrance. One day, Nino forced me to open the door and we sat on the porch together and enjoyed watching people walk by.

CARLEY: Your entire house is your sacred place. I also think you are each other's sacred space.

CYRIELLE: Yes!

What does your personal meditation or quiet time in your home look like?
How do you get away from the worries of the world?

JULIEN: This is going to sound really cheesy, but I just look at Cyrielle.

CYRIELLE: It's the same for me.

JULIEN: When bad shit happens, we talk to each other, and we figure it out together.

CARLEY: Your ritual is with each other.

CYRIELLE & JULIEN: Yes!

If there is one part of your story that you think would set another free, what is it?

CYRIELLE: I would encourage people to trust themselves, be spontaneous, and take risks. No one wanted us to move to Morocco.

JULIEN: One of my friends made a bet on how long we would live in Morocco, because I was the typical Parisian guy who wanted to move there. Cyrielle and I always did things we wanted to do and never asked anyone before we made the decision.

CARLEY: It sounds like you both have the same answer: to believe in yourself and don't always take the opinion of others on a journey that you know you're supposed to go on, because no one can live your journey except for you.

JULIEN: Yes, and even if you think you can't do it, you should try it. There is nothing worse than to have regrets in life. It works for everything in life.

CYRIELLE: I think about how quickly we moved from Paris to Morocco. We had great jobs, had lots of friends, and lived close to family. Yet we were spontaneous. That's important. Don't think too deeply, because sometimes it takes you nowhere.

"No matter where we are, we are family, and we stick together."

ONVELLE

MARRAKECH

CHÊNE

GUY BOURDIN

67 POLAROIDS

✳ publishing

Mission
Chinese

VIETNA
NUI DA
65–66

Cazelle
Julien
OFFICINE UNIVERSELLE
BULY 1803

St JEAN
CAP FERR

minolta

XG 9

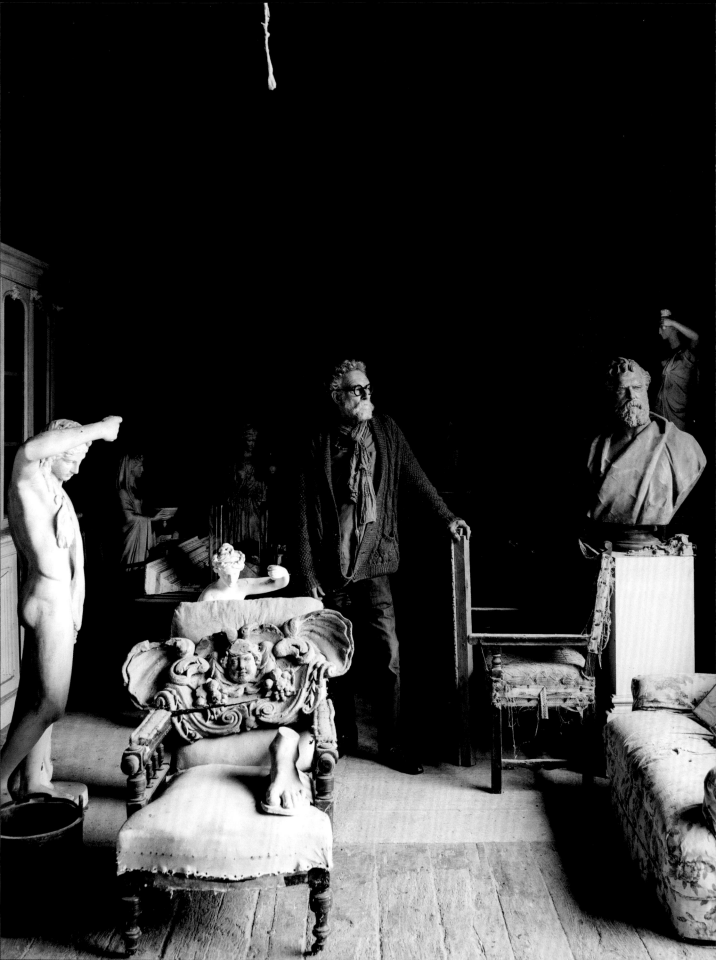

DAVID BRIDGWATER

WHEN DAVID AND I FIRST MET, WE WERE COMPLETE STRANGERS, BUT by the time I left his home outside of Bath, England, we were good friends. I found David on Instagram after his home caught my eye and my imagination. David is a talented craftsman and longtime antiques dealer, and we had lots to discuss during my visit. David is a unique person, and his home is no different. David is full of character, laughter, and history. His story is full of hardship, leaving his family at a young age, and creating a whole new life for himself. His love for his children and wife, Sarah, was evident as he spoke about them, and I could feel how important it was for him to create a family and a home of his own. His home is stunning, and I know his interiors and story will captivate you like they did me.

Your story . . . Go!

DAVID: I was born in Bridgwater, England, which is weird because Bridgwater is my surname, but it's just a coincidence. I always tell people that a distant relative gambled the town away, but you know, that's a complete lie. My father was working with my mother's sister's husband. He bought a farm. He was a solicitor, but he thought he'd be a gentleman farmer. Well, of course, gentlemen farmers down in Somerset don't last very long because the other farmers there are cunning, so of course he didn't last long. He had to go back to London to be

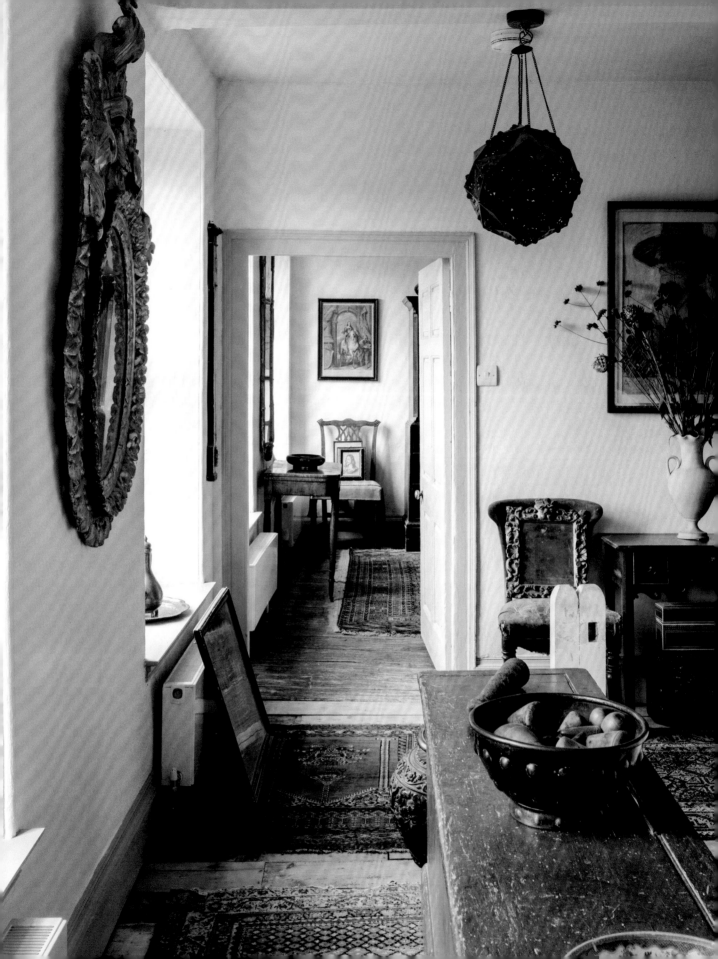

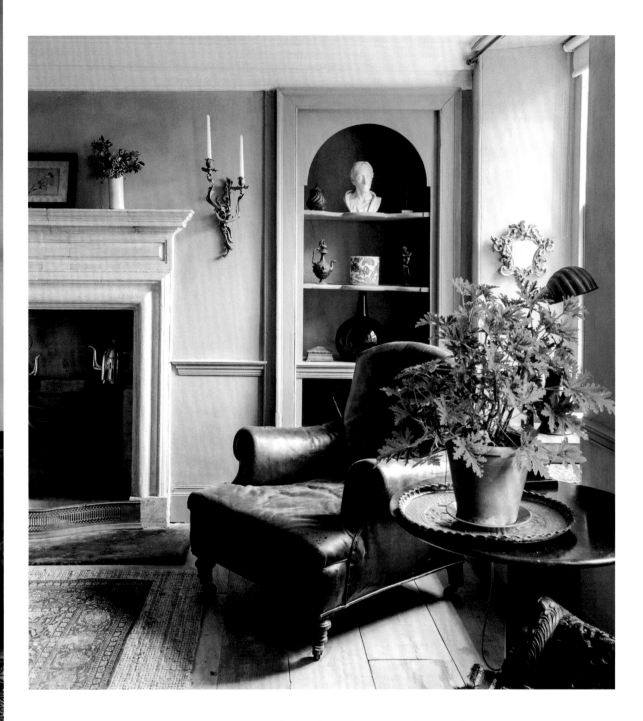

*"I think I'm quite clever—
although that's maybe me
thinking I'm quite clever."*

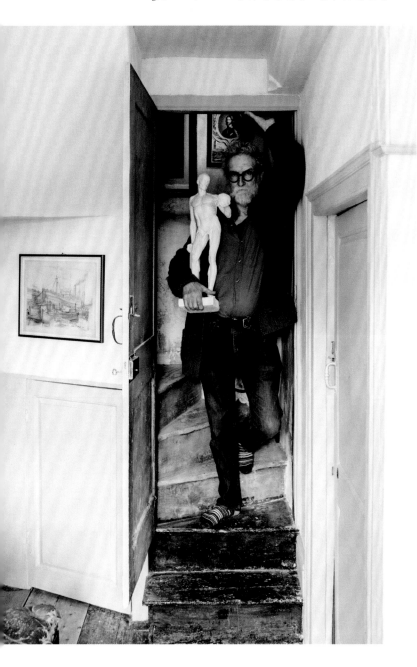

a solicitor, which I think he was probably quite good at. He was only twenty-eight when he died from a pulmonary embolism.

CARLEY: How old were you when your father died?

DAVID: I was only about two years old. I do have dim memories of my father, whether they're real or whether they're constructs from what I've been told, I don't know. A few years later, my mother married my stepfather, George. When I was five, we moved from Bridgwater up to Wellingborough, which is about sixty miles north of London. I spent my youth from the age of five to seventeen in Wellingborough. In those days, it was a tiny town. Anyway, I went to Wellingborough Technical Grammar [School], and they asked me what I wanted to do for work. I said I wanted to be an architect or an archaeologist. And then they gave me the chance to choose subjects. *Technical grammar* meant that the school had a technical department where you could do things like woodwork, metalwork, and technical drawing. I gave up doing woodwork and metalwork and just carried on doing technical drawing, but that's so typical of an English education. I gave up doing woodwork and metalwork, but what have I been doing all my life? Messing about with bits of wood and bits of metal. [*laughing*] They gave me the choice of doing history or geography—which one do you think I did? I'm an antiques dealer, so obviously I chose geography. [*laughing*] What have I done all my life? History.

Anyway, I've got a full sister and a half brother and sister who I see from time to time. I'm not very thick with them because I left home at a young age.

CARLEY: Tell me a little bit more about your stepfather. Was it a hard relationship? Is that one of the reasons you left at seventeen?

DAVID: My mother and stepfather wanted to get rid of me because they thought I was the problem with their relationship. To a degree, I'm sure I was because I'm stroppy; I know my own mind. I think I'm quite clever—although that's maybe me thinking I'm quite clever. But I could sometimes run rings around them with arguments. Sunday lunch always turned into a fight—certainly a verbal fight, but sometimes it could get physical. That's no environment for a kid to be brought up in. I was afraid of George because he would thump me. He used to do things like make me clean all the family shoes on a Sunday.

CARLEY: You mentioned earlier that you didn't feel secure in that environment.

DAVID: No, I didn't. I was never at home because it was uncomfortable. I was always out, not in pubs, but just out with my friends. And as soon as I was old enough, I'd go to pubs.

CARLEY: What happened when you were seventeen, after all the verbal abuse?

DAVID: It got to be too much. At one point, my parents tried to send me away to school, because my grandfather had left us a bit of money. They wanted to use that money to send me to boarding school because the money had been left in a trust. But the trustees of the will wouldn't let them have the money, so I didn't go to boarding school. I guess I would have been fourteen. I managed to weather homelife until I was seventeen.

I can't remember how it happened, but I went to various places in London to find a job. I

went to Sotheby's, and I had an interview with them. They offered me a job at seven pounds a week, but I couldn't live on it. I lived in a hostel for young working men when I first went to London and that alone cost seven pounds per week. I went to Harrods, and they offered me a job as a trainee buyer in the furniture department, extensively in their antiques department, and that was nine pounds a week, so I could just about live on that. That meant I had two pounds to live on after rent was paid. So I went to work for Harrods and it was great.

I dream about it sometimes, 'cause it's a vast department store and it was very old-fashioned in those days; it was a job for life. For a lot of people there, they started at seventeen and they would retire at sixty-five; they'd be there all their lives.

CARLEY: You mentioned you traveled a lot and you traveled in a van with friends. Tell me about that.

DAVID: I was at Harrods for eighteen months and then I decided it wasn't what I wanted to do. I wanted to work in antiques and interiors. It was a great introduction; it made me sort of a visual snob because Harrods sold the best of everything. You could buy a lion if you wanted to. They had an amazing pet shop with snakes and whatnot. And if dinosaurs were still living, they would have sold them, too. It was amazing.

I lived in London for about four and a half years until I got kicked out of the flat. They were redeveloping the common road

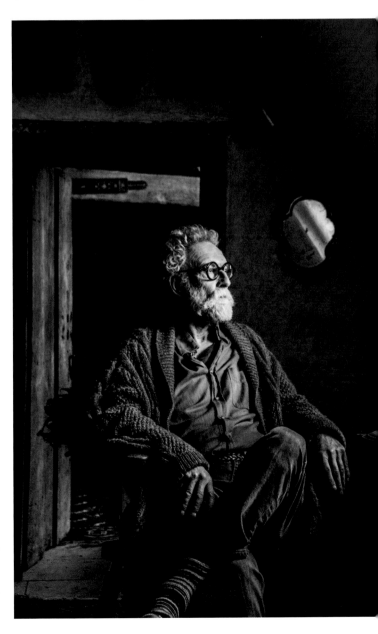

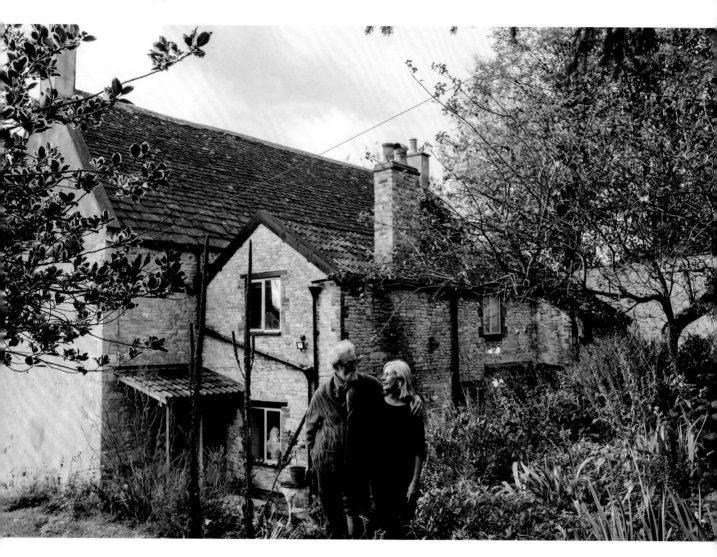

and the whole block, which was a block of about ten houses that were being converted into fancy, expensive, furnished apartments. So my friend Kiss and I got kicked out of the flat and I thought, *What on earth am I going to do?* I knew people in Bath, and it's a very beautiful place, so I thought, *Let's go to Bath.* So on January 20, 1972, my friend Kiss and I moved down to Bath.

CARLEY: Is that when you met a lovely woman serving at a pub?

DAVID: That was sometime later. I met Sarah in 1979, so there was plenty of life before her. Bath was a great place, and in those days, it was called "the alternative society." It was all longhairs, so I let my hair grow really long. There was lots of music and theater, and it was

relatively cheap to live there; it was like living on a film set. It's a very beautiful place. It was a bit like the San Francisco of England—lots of alternative stuff going on. It was a good place to be.

CARLEY: Do you think moving to Bath led you to live in this home, just outside of the city?

DAVID: Well, I bought my first house in 1975. I got a job very quickly working with a business that dealt in antique strip pine. That was a very good introduction to the antiques business, because it gave me the ability to see through things. I'd get an object covered in paint and it would be broken, and I'd strip off all the paint, fix it, polish it, and then sell it for a big fat profit, hopefully. I did that for a while.

CARLEY: You mentioned a little bit about your shyness as a child.

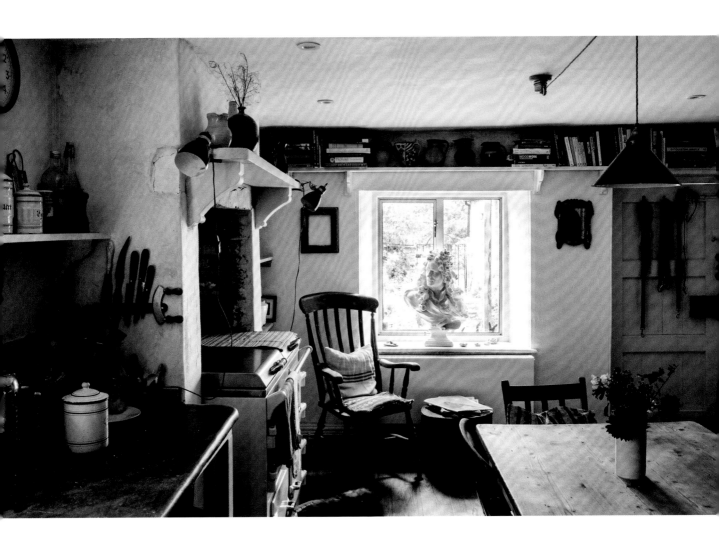

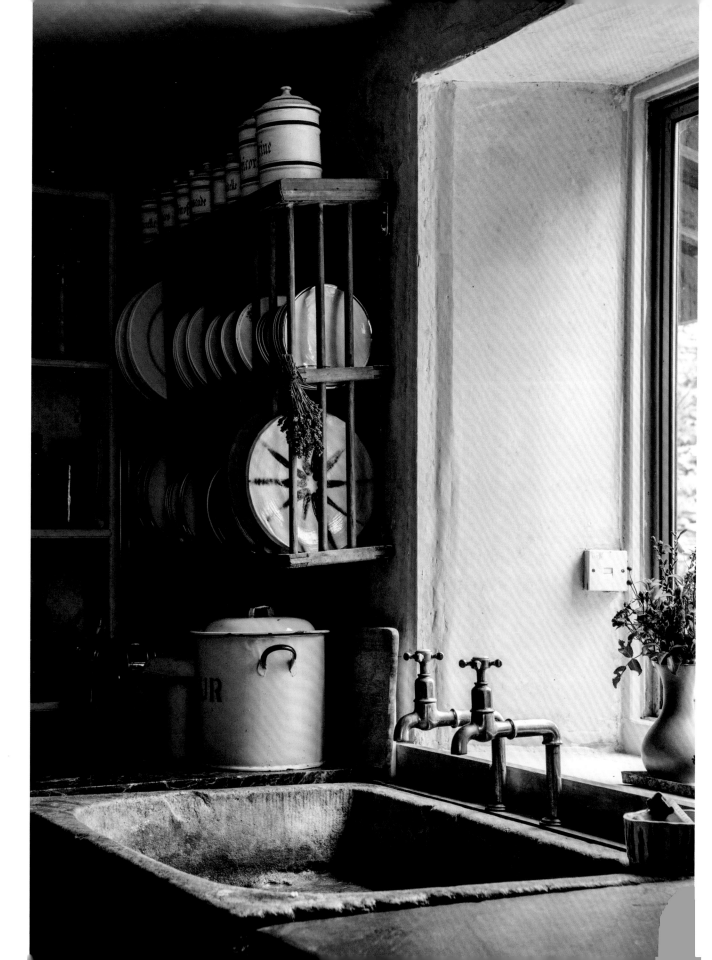

DAVID: Well, I was shy as a child. They used to make me do the Bible readings at school because I didn't have an accent. I hated it until I got up there and did it. But once I was doing it, I liked it. I must be a natural show-off or something. My friend and mentor Roy Martin said to me, "Why are you shy? What makes you think that you're any different from everybody else? Why should you be self-conscious? Everybody's like you, so stop being shy." Shyness isn't something that you can sort of click off. I took those words to heart, and I came out of my shell fairly quickly.

If you had one pivotal point that changed the direction of your life, what would that be?

DAVID: There's a series of them. I would say getting the job at Harrods. Going to college and doing interior design. Meeting Roy Martin; I wouldn't be the same person if I hadn't met Roy. Moving to Bath was another moment. One day, a friend said to me, "Do you want to buy my house?" And I said, "Yeah, sure! I'll buy it." We shook hands on it, and I walked out that evening owning a house, just like that. That was a pivotal moment in my life, because before then, I'd never had that security.

CARLEY: How did you meet your wife?

DAVID: At the top of the street in Bath was a pub called the Bell. There were about four great pubs in Bath, but the Bell was a jazz pub and they had live music. One day, I saw this beautiful face across a crowded room, and I thought she was really nice. It was probably a year or so before I went in again, and there was the same beautiful face working behind the bar. I asked her out several times, but she refused. In the end, I managed to grind her down, and she finally came out one night after work. We went to what they would call a "late-night drinker," a pub with a late-night license. There weren't very many of them, so our first date was at Roasters Pub. Within a month, she moved in with me.

CARLEY: How many years ago was that?

DAVID: Forty-two years ago, and we're still together.

CARLEY: Would you say your wife, Sarah, is a place of safety and security for you?

DAVID: Absolutely. I couldn't have done what I've done without her. She's been the yin to my yang, as it were. She's very sensible and levelheaded.

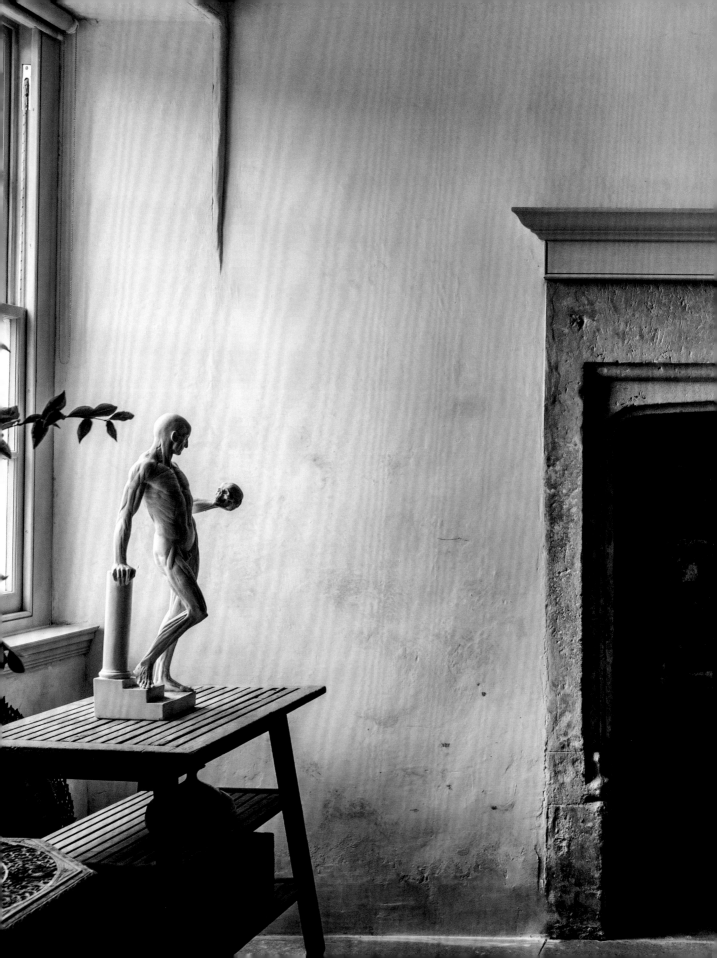

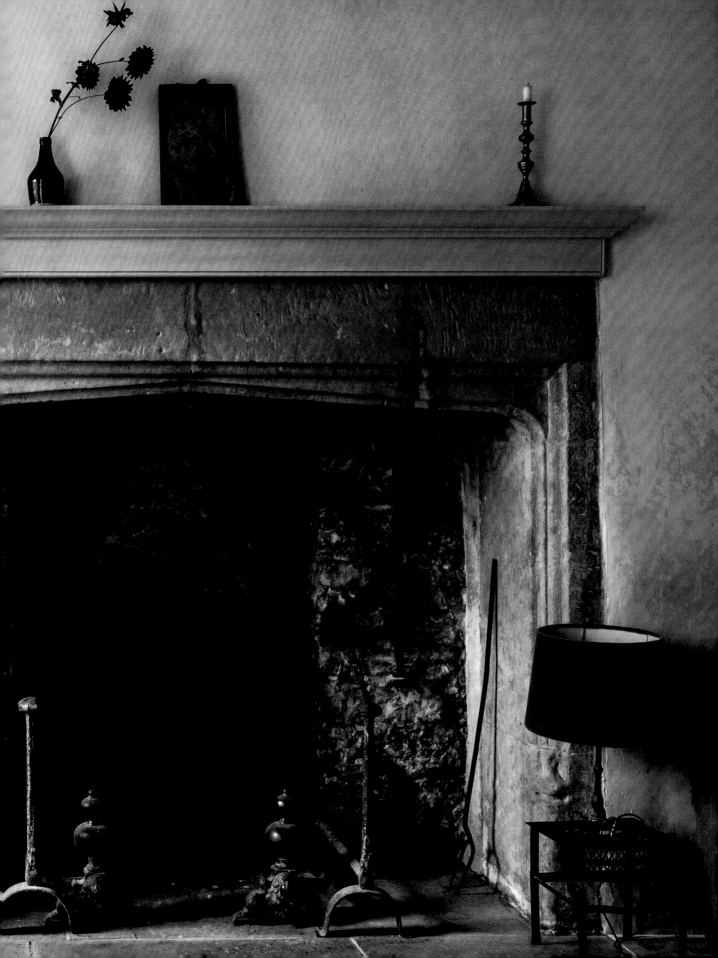

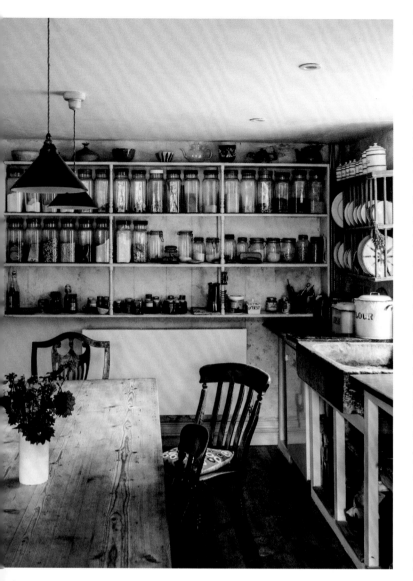

How are your trials and victories represented in your home?

DAVID: This is our sixth house, and we own this house outright. No mortgage, nothing. Each house has had its challenges. Each house has been a historic building in one way or another. I couldn't afford my lifestyle. It still amazes me when I look back and think how things worked out. When you're young, you don't see the negatives, you just do it. And one way or another, it gets done. I don't know how it's worked out, but it has. Now we live here. It's a beautiful place. Aren't we lucky? We've got ten acres of land. It still needs a bit of work here and there, but this is a ten-year project. By the end of ten years, I'll be eighty, so I've got another eight years to finish it.

CARLEY: You mentioned that, when you moved out at seventeen, you didn't have a sense of security in your home growing up. But now that you own this home outright with someone who loves you, someone who's not going to push you away, you must feel such a sense of security—and how that trial at the age of seventeen has turned into this victory represented within this house.

DAVID: Oh, absolutely. I had no idea where I would go when I was a teen, and I was penniless on several occasions. When I went to work in the theater with Roy, I was "boracic lint," as we say; it's a Cockney phrase for "skint." I had no money.

"*That was a pivotal moment in my life, because before then, I'd never had that security.*"

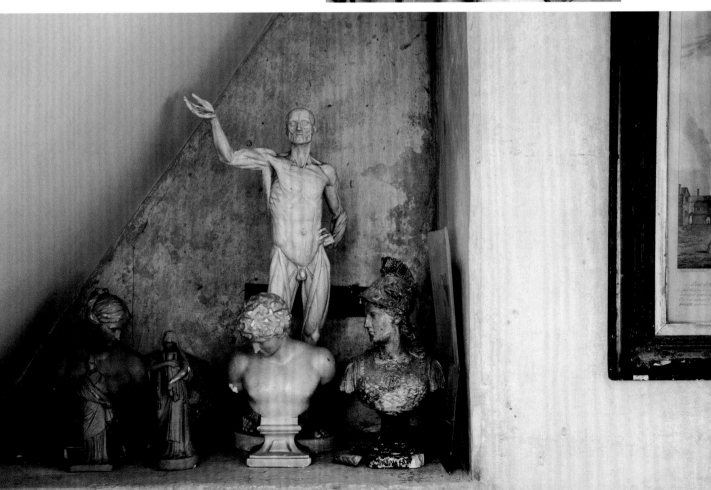

What does freedom *mean in the setting of your home?*

DAVID: The freedom to do what I like, the freedom to do what my wife likes. Freedom in my own home, wouldn't I be so lucky? [*chuckling*]

CARLEY: I think my husband can relate. [*laughing*]

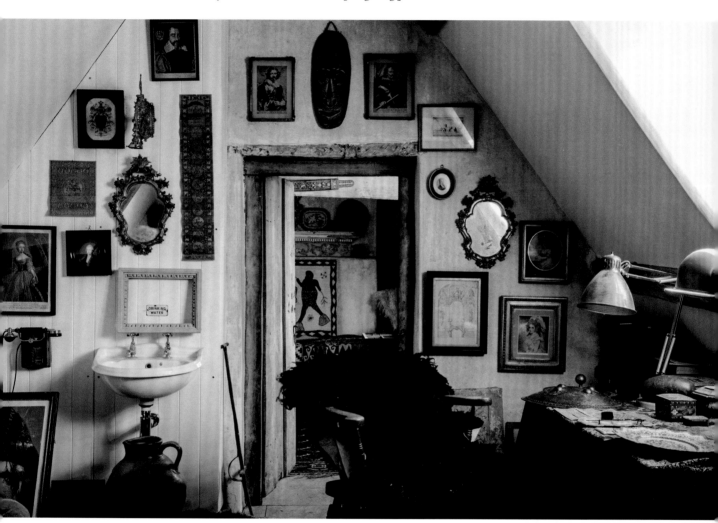

DAVID: You always have choices in life. You can do the right thing. Sometimes it's quite difficult because you don't want to do stuff like taking the dogs out for a walk. I'm really so lucky to live here, where we can take the dogs out for an hour-long walk on our own land. My wife wanted a house where she could walk out of the kitchen with a cup of coffee, into the garden, and sit in the sun in the summer. It's not just the house; it's the whole thing that sells itself to me. And I love the idea of being able to do up the barn. It will be like a modern space,

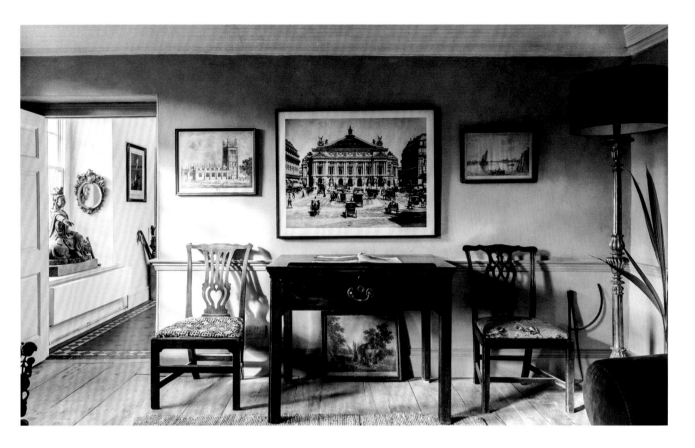

but within an eighteenth-century building—something really dramatic and dynamic, but simple and minimalistic.

Where is your sacred space in your home, the place you find the most peace?

DAVID: I think the kitchen is the heart of the house, so the first thing I did was get this kitchen working. It looked as though somebody came in here with a machine gun and shot it up. But as long as it's warm and everything works, and you've got a good bathroom so that you can keep yourself clean, the rest of it doesn't matter so much.

I like the attic, because that's where I work. That's where I do my intellectual work. And that's the area where I've got all my stuff. When everybody's gone to bed and it's quiet, I like to contemplate there with a glass of wine and think about what I've done. I can step back and think, *I did this and I'm so lucky.*

What does your personal meditation or quiet time in your home look like? How do you get away from the worries of the world?

DAVID: Gardening is a meditation for me, just like building stone walls. I love the research part of my job. It's such a good thing to be able to do, to dive into books or dive into the computer. As you know, the house is full of books. Knowledge is power.

If there is one part of your story that you think would set another free, what is it?

DAVID: I went to a wedding once and there was a boys' night the night before, so we all went to the pub, and there were a few young boys there. They asked me what my philosophy on life was and I said that my philosophy is "Go for it, but don't be an ass!" [*laughing*]

CARLEY: I think you lived out your philosophy by moving out of your home at age seventeen. You went for it!

DAVID: Yes, and I'm very glad I did. I deconstructed myself and then reconstructed myself. The only thing that you can really put your finger on is now. And with all the time you have, you get to make the decisions to do good things or bad, or just sit back and do nothing, which is almost worse, almost like doing bad things. There's no past, there's no future, there is only now.

"When you're young, you don't see the negatives, you just do it. And one way or another, it gets done. I don't know how it's worked out, but it has."

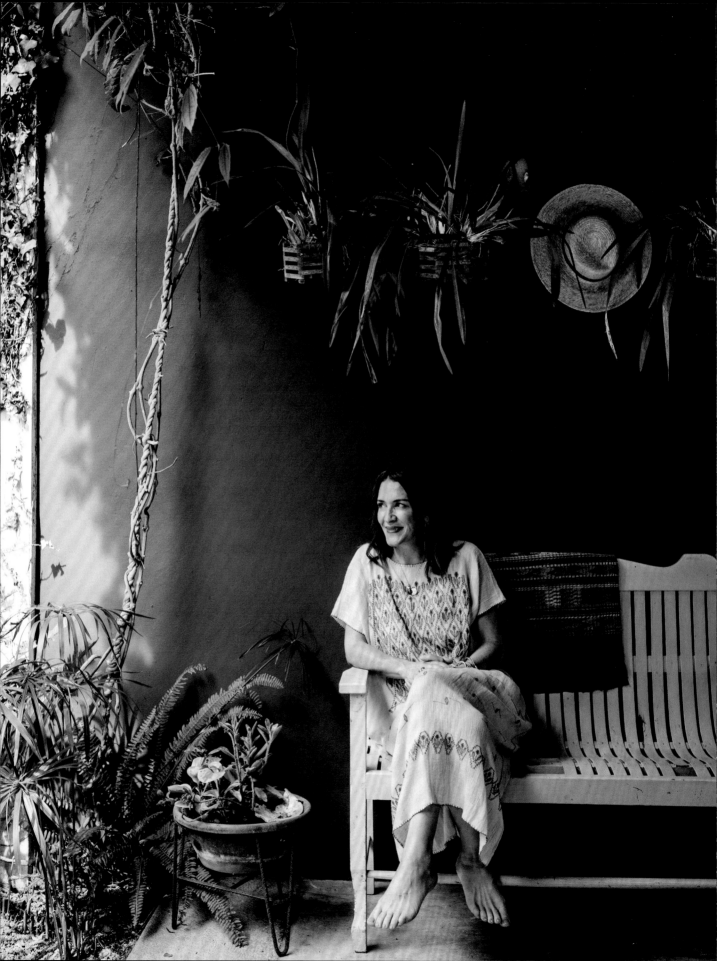

MOLLY BERRY

ANTIGUA, GUATEMALA

MOLLY BERRY LIVES IN ANTIGUA, GUATEMALA, WITH HER HUSBAND, Juan, and their two beautiful children, Joaquin and Hazel. Her home is a perfect balance of modern flair embedded in a historic-feeling hacienda that truly brings the outside in. Molly is the owner and founder of Luna Zorro, a textile company focusing on enriching and supporting the community around her by partnering with Mayan artisans who bring Molly's creations to life. Molly has a love for design, travel, architecture, and culture, all of which is impossible to miss while strolling through her light-drenched space. Originally from the San Francisco Bay Area, Molly struggled to find the perfect balance of career fulfillment and passion as she wandered through life, until eventually she found her calling, and is now thriving in her community. Molly and I have followed each other's journeys for some time, and when we finally connected two years ago on a FaceTime call, I think we both felt the same way about each other. I knew Molly's story went deeper than her colorful and joyful life might appear. There is so much heart and soul in the way she and her family live their life in Guatemala, and spending time with them and capturing their spirit was honestly contagious. Molly, Juan, and their children welcomed my husband, Jon, and me into their home and into their hearts, and I will forever be grateful for our time with them.

Your story . . . Go!

M O L L Y : I have always been a creative person. The youngest of four children, I grew up in a busy household full of activities. I learned to keep up, help out, observe, and adapt. I was born and raised in San Francisco, California, to parents who supported me and did their best to give me opportunities, parents who were always there to encourage me to follow my heart in all that I did.

Growing up, I was a pretty good student, but where I really excelled was in extracurricular activities like art, photography, theater, sports, and social activities. I was most in my element when I had the space to explore and create. I had a deep interest in the greater world around me, in culture

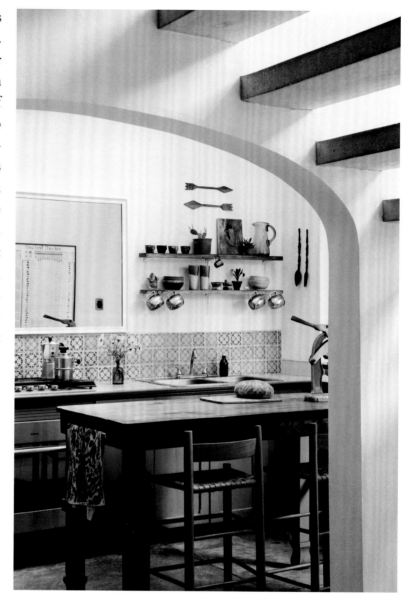

and society, but as a child my family didn't travel, mostly because my oldest sister is in a wheelchair and our family outings/trips were limited to car rides and road trips, which I always loved. Deep down, I always knew that when the time came for me to be more independent, I would see as much of the world as possible.

When I left for college, my father also chose to leave our family, unannounced to any of us, and he never came back. He started a new life with a new family. He moved on by proverbially "putting us in a drawer and closing it." It was a very hard, confusing time, but also one that ultimately shaped me. I went to UCLA and, two weeks into my freshman year, I was

suddenly faced with figuring out how I would pay to put myself through school. While it tested me in so many ways, with the support and encouragement of my family and my closest friends, I committed to working as hard as I could. I excelled in college, for one because I had to supplement my tuition with as many grants and scholarships as possible, but also because I loved what I was studying. I was a world arts and cultures major and was able to explore everything I was interested in—from anthropology to sociology, art history, design, and philosophy. Because I was funding my own education and studying while working, I was intentional and focused. Studying abroad in England my junior year was a major eye-opening, life-changing experience. I returned to UCLA ready to finish my last year, graduate with honors, and return to Europe as soon as possible. Around that time of my life, my mom, who is my rock and who at that time was facing many challenges of her own, continued to tell me: "Follow your bliss." This stuck with me, and while it wasn't always simple or easy, it was something I ingrained in my life choices.

The story of my life after graduating is a long and winding story of exploring who I was while staying committed to what it is that makes me feel most alive and inspired. I have always been entrepreneurial, and in the earlier years, that stubborn independence was paramount,

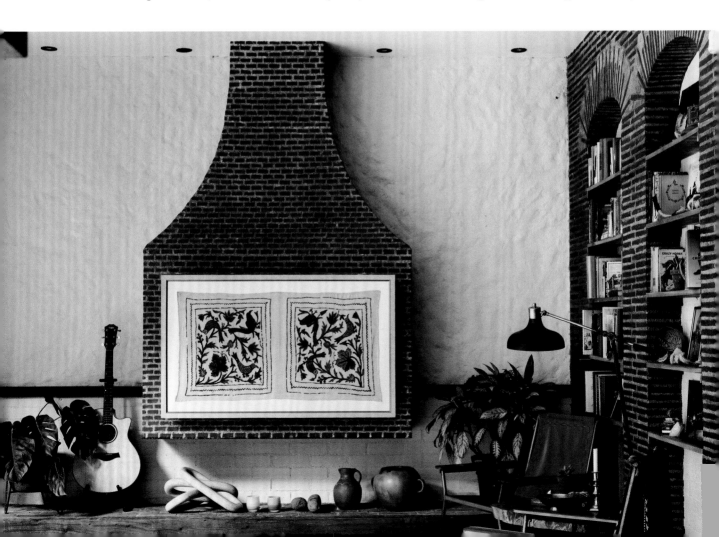

sometimes in spite of my financial situations. I wasn't afraid to work, but I was skeptical of working for someone else in a job I didn't feel inspired by. I chose an independent, less-structured career path and always preferred time and autonomy over money and a "guarantee."

After years of making ends meet creatively, learning a lot, and traveling whenever possible, I married my husband, who I've known since I was ten, when we met jumping on a trampoline. As soon as we were married, we moved abroad to Panama, where we basically started anew: new city, new country, new jobs, new opportunities. We were living on a shoestring but loving the newness and richness of our community. I learned Spanish, had my first child, our son, Joaquin Fox, and doubled down on my career path as a creative person. We moved to Guatemala, where my husband began building his agroforestry/regenerative farming business and where I launched my textile business, Luna Zorro. Our daughter, Hazel Moon, was born in Guatemala. We bought our house, and slowly but surely our businesses began to grow.

While it is all still such a process of learning, trying, failing, succeeding, and evolving, the life I have created for myself feels as authentic as I could imagine. My business has grown organically in a way I never could have planned on paper. It has grown from love, trial, error, hard work, luck, and commitment just like my sweet little family has grown. At times,

"While it is all still such a process of learning, trying, failing, succeeding, and evolving, the life I have created for myself feels as authentic as I could imagine."

raising a family and building a business simultaneously has tested every ounce of my being, and somehow, it has also given back in more beautiful ways than I could ever quantify.

Our home, our family, and our sacred space is something I cherish above all. It is the direct result of committing to a life path, a career path, and a story that I always felt in my core was possible. I am so grateful that I chose to "follow my bliss," even in the times when the going got rough. I am undoubtedly exactly where I am meant to be.

If you had one pivotal point that changed the direction of your life, what would that be?

MOLLY: While there were a few pivotal moments in my life, I would say the one that changed the course of my path the most is when my husband and I moved abroad to Panama. We were in a new country and city where we knew almost no one, we both started over in our careers, and from there a whole new world, literally and metaphorically, opened up to us in our early thirties. That has now been the last eleven years, which included everything

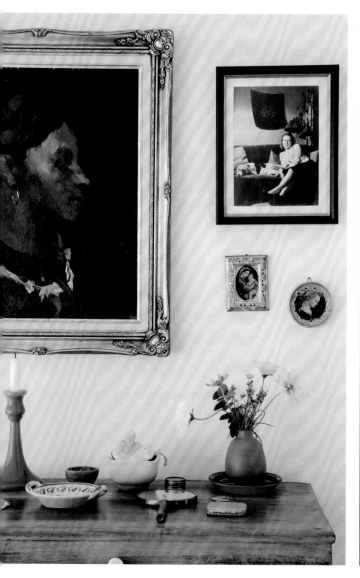

"I was most in my element when I had the space to explore and create."

from marriage to having children to buying a home to starting a new business. If my husband and I had moved to Guatemala first, I don't think it would've been the same. I think moving to Panama first built the foundation we needed to thrive in a foreign country.

How are your trials and victories represented in your home?

MOLLY: My trials and victories are reflected in every element of my home. Although it may not be completely obvious to everyone who visits, it is clear to me when I look around that the home I have created is a direct reflection of the experiences in my life. It is filled with love and family, my children, with art we have collected from around the world, furniture that we made with wood from our farm, textiles that I designed with the artisans I partner with, all enveloped in the lush, green natural environment of Guatemala. These are all things resulting in a long, beautiful, challenging, and inspiring path toward creating the life I had always envisioned for myself.

CARLEY: Do you think the heaviest trial hit when your dad left? As well as having a sister with disabilities?

MOLLY: Yes. And a big trial was the fear of lack, and not letting it impact the course and direction of my professional and creative life. I clearly haven't taken the most financially stable path, but I stayed true to what I really wanted, what I felt drawn toward, and that victory over my fear of lack led to the creation of this home. Here, we're sitting on textiles I make with women whom I am amazed by and whom I partner with, all in a studio I was able to build. All these successes or celebrations definitely came out of staying true to myself, in spite of the major fear of not having enough money. Having a sister with a disability and seeing my parents give much of their lives to care for her made me very aware of how much I have to be thankful for. I think that experience made up a huge part of who I am. When I wake up, my first thought is usually about how grateful I am for the sleep I got, or this beautiful room, and for Juan. I'm so thankful my children are healthy.

We live in a society that focuses so much on lack. A lot of our internal talk is about lack. I definitely do that, too, but then I try to turn it around and instead think, *But look at what we do have.* Then these things we do have become so much more valuable. My anxiety about money is the way I understand my relationship with my dad. My therapist said once, "What if tonight you could take a magical pill and you were to wake up tomorrow morning and you would never have to worry about money again—not because your financial situation changed, but instead that worry or that anxiety or that stress you have felt all these years about money were to just vanish? Would you take the pill?"

That question rocked my world. I don't even know why, because I knew I was supposed to say "yes" to that answer, but that anxiety is so much a part of me and how I operate that I almost don't even know who I would be without it. We talked about it more, and I realized in

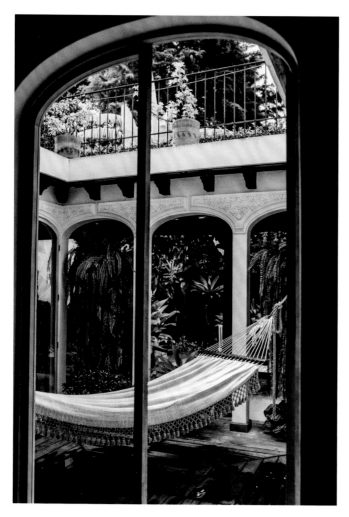

a way that anxiety about finances is my only connection to my dad—it's the only way to keep him in my life, in a weird way. After that day with the therapist, it's like my worry about money just went away. I mean, I still care about money, and I want to do things right, have a plan, and I want to learn how to invest my money more and be smart about it. But it's almost like the worry itself went away.

I feel very proud that my husband and I have stuck to committing to what we really care about. Even though we do compare our situation to our friends' or to what other people have, we haven't sold out or given up. I feel like this house represents our commitment to staying true to ourselves.

What does freedom *mean in the setting of your home?*

MOLLY: Freedom in the setting of my home means having a safe, nourishing environment for my family and me to rest, to be creative, cook, gather with friends, and, most of all, have a place to feel profoundly rooted in all that matters to us. My home is my happy place, my refuge, which for me is real freedom.

Honestly, our home is like a sanctuary, and I think living abroad is a very interesting existence in and of itself because you never feel like you're fully home. There's always still another home, which is just an interesting feeling. My children consider this their home. I consider this home. And every time I go to California, it feels like home, but then I come back here, and this is truly home because it offers a freedom from any other attachment I might have. It's a space that we have created together as a family unit. It's freedom from the connection to any other thing that identifies me.

"The space where you feel connected to nature has to be intentional."

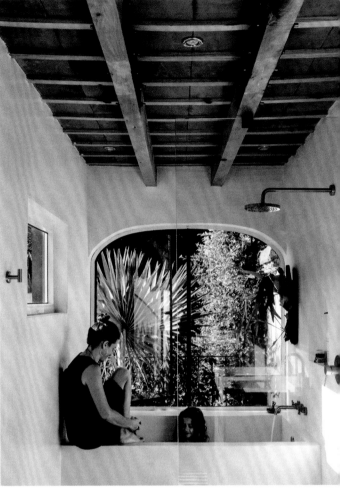

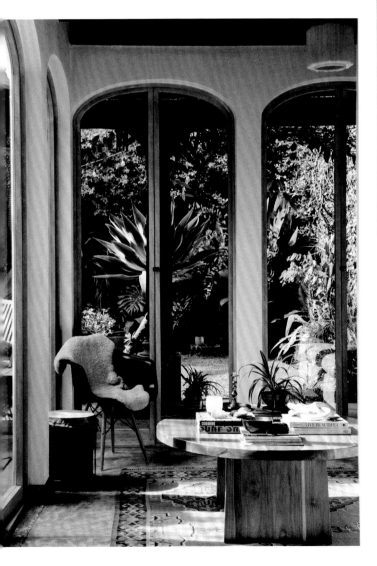

CARLEY: There's freedom here from all the different connections in your life, and you feel like you can connect here, and build here. When you're here in Guatemala and building your life, there's a freedom in that—untethered to all the responsibilities you used to have.

MOLLY: It's probably just a mental construct, but it really feels like that here. I have the freedom to do what I want here, to experiment, to make or not make. There is freedom in this house.

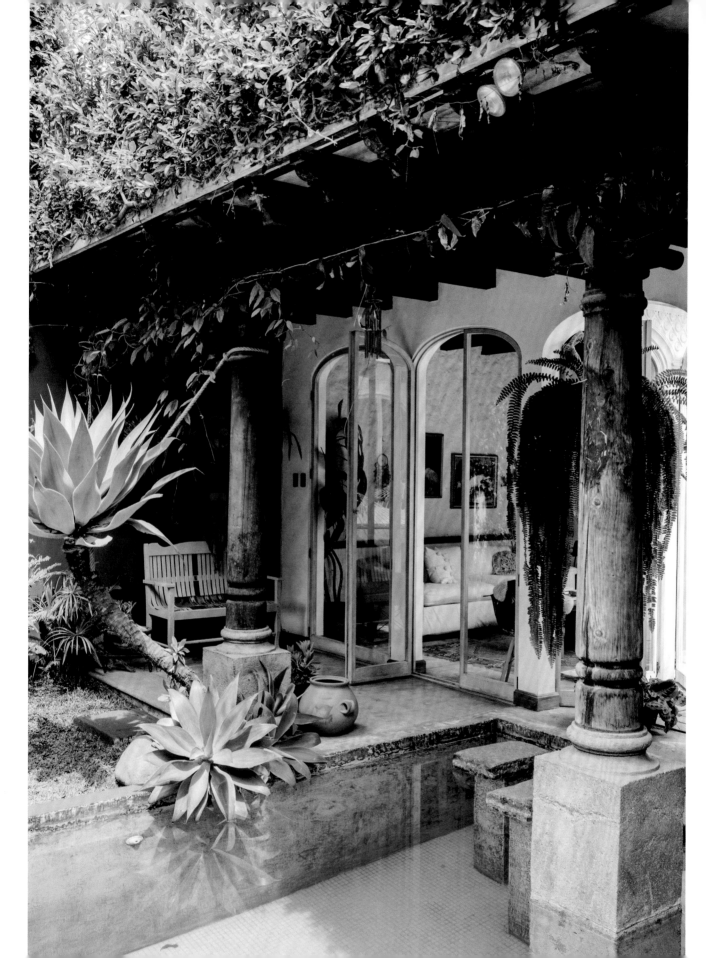

CARLEY: I feel it. I immediately felt disconnected from the outside world when I walked in here. It's a whole other world unto itself that I felt just by walking through your house and seeing the way you've created it. When I walked in, I felt a spirit of freedom here to disconnect from the world.

MOLLY: Yes, I feel at peace here.

Where is your sacred space in your home, the place you find the most peace?

MOLLY: What I love most about my house is the natural light and how, no matter which room I am in, I still feel warm and connected to the outdoors. But I would say that the area of my home that I find most peaceful is my living room sofa early in the morning, when I have my coffee and I am still the only person awake in the house. It's quiet, the light reflects just so, the garden is fresh and lush, and the comforting feeling of newness is fully present. I also love my garden, the kitchen, and now the new bathroom. The bathroom and bedroom have evolved a lot and both have become a sacred place for me.

CARLEY: Talk about that a little bit. You told me about the bathroom when you moved in. I saw the pictures of it before any renovations, and I'm not sure how you functioned in that for seven weeks. And then the way you and your husband saved up to create your dream bathroom is truly inspirational. I've taken pictures of you in your bathroom, and there is definitely something about it. I mean, your husband is in the tub, you're in the tub, everybody's in the tub. It has become a communal space.

MOLLY: Being able to creatively envision the space and build it is still a very new experience for me. And now, between the studio and the bathroom, I think, *I could be good at this.* I think, *I am good at this.* But I have that impostor syndrome, and then I think, *I don't really know what I'm doing.* I find myself saying that to people. But I do actually know what I'm doing, and I need these experiences to really drive that home.

We saved for a long time, but the main way that we paid for the remodel was by fixing up the old Range Rover, driving it across Mexico, and selling it. That trip became a life-changing, wonderful experience for our entire family that I will take with me to my last breath. And then we used the money we made to build this bathroom and closet.

We also used all the wood from a farm that we committed to almost eleven years ago. And so even the wood we used represents us: our adventure, endeavor, and commitment to each other—to not let the other one give up—and the love and growth of our life. And so, literally

and figuratively, the bathroom and bedroom represent a lot. I really do feel like every morning when I walk in there with the light shining through, I've entered a sacred space. It's amazing to experience.

What does your personal meditation or quiet time in your home look like? How do you get away from the worries of the world?

MOLLY: My personal meditation time and where I go to escape worries includes a few things: it's practicing yoga in a quiet room, it's meditating early in the morning in my garden, it's being present and intentional when cooking a meal for my family, and it's taking a warm bath with a candle and a good book.

Going into the pool in the early morning is something I always try to do before anyone else gets up, because if I can have ten minutes by myself in the morning, it sets the tone for my entire day. For sure, being in the garden in the freezing cold water jolts me back to life. I will be in the pool looking up at the trees, and thinking about how grateful I am—that this is where I get to be right now. And I think a lot about my family when I'm in the pool because I'm far away from them. Sometimes if the pool is freezing and I don't want to get in, I think, *[My sister] Melissa couldn't get in even if she wanted to.* That motivates me to live my life and not make excuses.

CARLEY: I'm the same way. My meditation is getting on my knees and praying, but sometimes I think, *I'm busy. I have to get started on work. I have to check my emails.* But meditation doesn't have to take long. Even just five minutes can seem like a tall order when life is crazy, but it's so important to do.

MOLLY: Yes, absolutely. I think connection to nature and fresh air really helps, even if you're just sitting by a window. The space where you feel connected to nature has to be intentional. Don't be near your phone. I know people say that all the time now, but for me it really is true. Picking herbs in the garden or cooking are both meditative acts for me because they get me away from my phone and from technology while also allowing me to create something with my hands.

If there is one part of your story that you think would set another free, what is it?

MOLLY: Don't be afraid to trust yourself, because nobody knows you like you know yourself. We go through so many obstacles and barriers that make it harder and harder to listen to

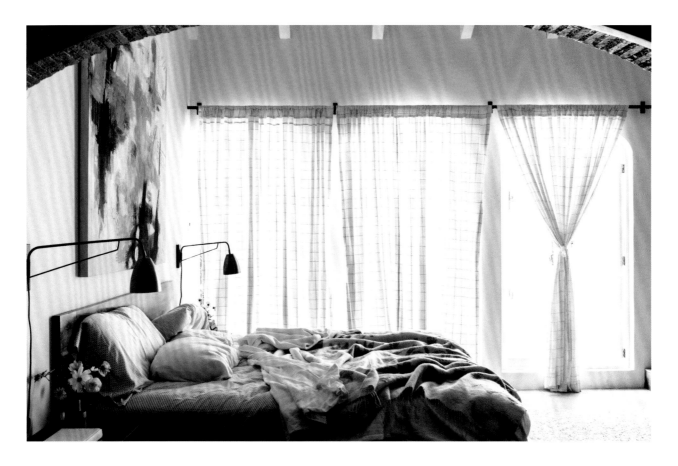

ourselves. We're bombarded with so much outside noise and unsolicited opinions, images, and comparisons. It's not anybody's fault. But I really believe you need to encourage yourself to look inward and hone that rather than looking for external answers. I think it's a hard thing to hear because it doesn't seem clear, but the more you practice it, the better you get at it.

CARLEY: What part of your story helped you learn that?

MOLLY: It's an accumulation of so many things, but building the studio was a big one because if anyone was going to think, *I don't know what I'm doing. I don't have enough money. This is probably not a financially sound decision,* it would be me. But I still decided to build that space. I knew it needed to exist. I could feel it. And now, every time I walk in there, now that there are employees and people, I think, *This is a real thing, because it started in my head.* Everything you can imagine can be real if you trust and listen to yourself. I had a lot of reasons not to do it, but I'm so glad I listened to the idea and paid attention. It's not like everything is suddenly perfect, because life is always an evolution and a journey.

Learning to listen to my instincts and prioritize my commitment to what makes me feel

the most alive, inspired, and healthy has made all the difference in who I am and where I am on my journey. When listening to our instincts becomes more than just a practice and, instead, a way of life, I truly believe this is when we can be the most available and impactful to the world around us. We are all surrounded by noise, comparison, temptation, and opportunity, which can take us off course unknowingly. But in my experience, all of the moments I felt the most lost or the most unsure, I ultimately found peace by going inward and connecting back with myself to make the choices I knew *inherently* were best for me.

"We live in a society that focuses so much on lack. A lot of our internal talk is about lack. I definitely do that, too, but then I try to turn it around and instead think, But look at what we *do* have."

PASSPORT

United States
of America

Canon G9X

LUNA ZORRO

LUNA ZORRO IS DEDICATED TO
MAKING A SUSTAINABLE
IMPACT ON THE COMMUNITIES
WE PARTNER WITH BY
CELEBRATING THEIR CRAFTS
AND TRADITIONS.

WWW.LUNAZORRO.COM

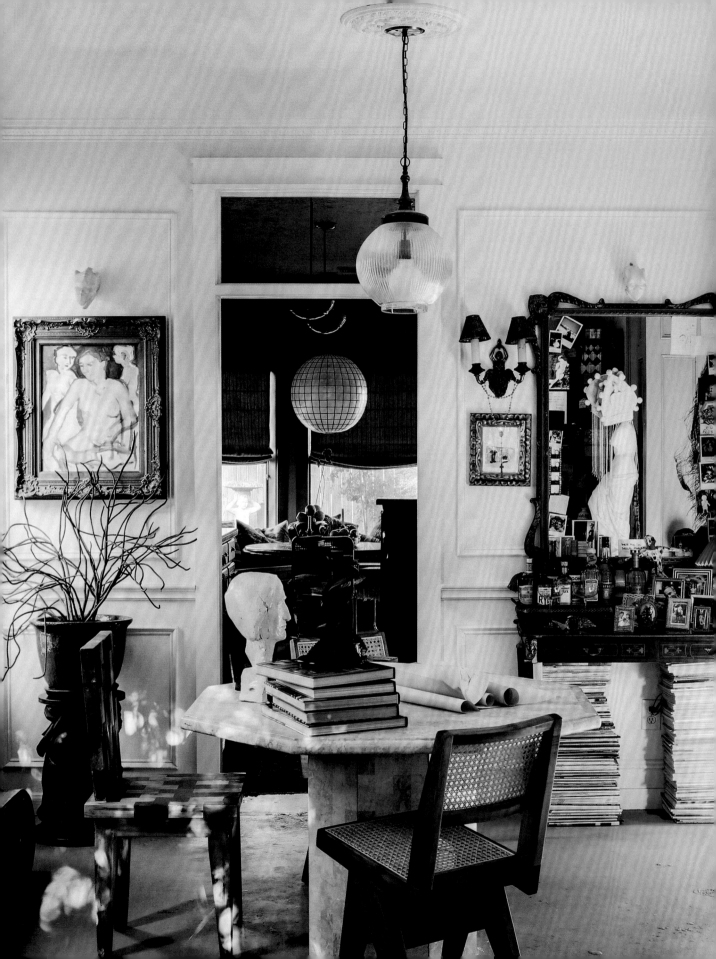

THE CATHARTIC HOME

STORIES FROM

COURTNEY MADDEN AND ELLE PATILLE, WHO REALIZED

THAT WHEN THEY COULD NOT CHANGE THE OUTSIDE WORLD,

THEY COULD CHANGE THE INSIDE OF THEIR HOMES

TO BRING COMFORT THROUGH

RENEWAL AND RESTORATION.

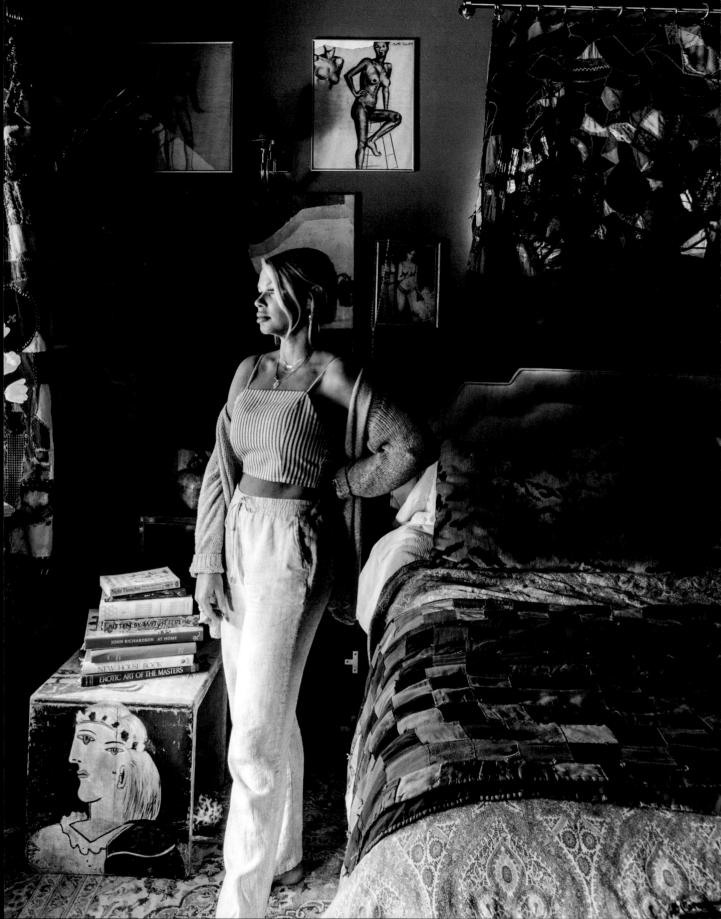

COURTNEY MADDEN

LEAGUE CITY, TEXAS

COURTNEY AND I FEEL LIKE LONG-LOST SISTERS. WE ARE WILD, FREE, and just fully "out there." When I first stumbled upon an image of Courtney's home, I knew there were so many layers to her that I wanted to understand. When I arrived in League City, Texas, we immediately started talking like we had known each other for years, and that didn't end during our entire time together. Some days, we would just chat about our trials and cry and hug each other. We have both been through difficult experiences, and I felt very seen and known by her and her home. Courtney is a true collector and maximalist, styling each nook and cranny of her house with books, sculptures, and little treasures. She is beautiful, raw, and like none other, and I can't wait for you all to see that shine through in her home.

Your story . . . Go!

CARLEY: I just prayed about it, and though I don't remember exactly what happened, I kept getting drawn back to your page. You're such an eccentric character on Instagram. I just thought, *I need to reach out to this woman.*

COURTNEY: Sometimes I wonder, *Why does anyone follow me?* [*laughing*] I think, *Where is the punchline?* And I'll ask myself, *Why do you still doubt yourself?* And then I'll think, *Well,*

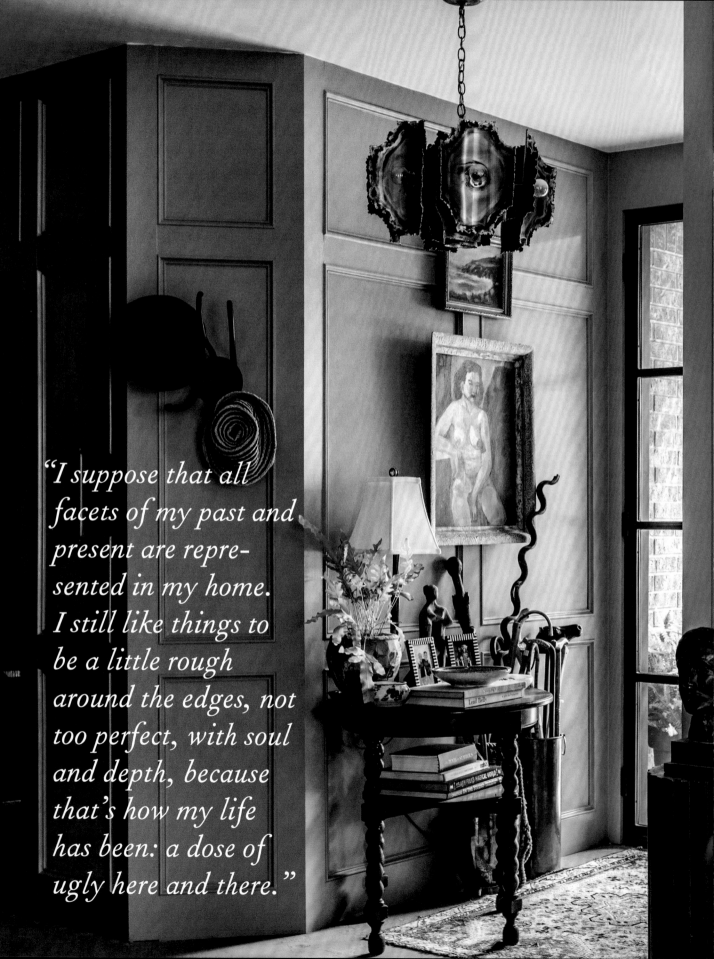

"I suppose that all facets of my past and present are represented in my home. I still like things to be a little rough around the edges, not too perfect, with soul and depth, because that's how my life has been: a dose of ugly here and there."

childhood trauma. I have been told terrible things my whole life. Sometimes I think, *You should stop sharing so much.*

I came from a chaotic and abusive home, which I thought was normal until I got away from it. I had just turned eighteen when I moved out with my husband. And when I saw him kiss his mom hello or goodbye, I thought it was strange, because physical love or affection from a mother felt so weird to me. I remember Child Protective Services being called to my house more times than being hugged or told "I love you." It was just a mess, and I didn't realize it until I got out of it.

If you had one pivotal point that changed the direction of your life, what would that be?

COURTNEY: When I got pregnant with my daughter, that was my turning point. The birth of my daughter, Faith, changed my life completely. When I got pregnant with her, all bets were off. Up to that time, I had only taken care of myself, and I didn't do the best job of it. I was using drugs up until a few months before I took the pregnancy test. I quit taking drugs immediately, and my husband got another job. I was nineteen when I found out I was pregnant and twenty when I had Faith. And suddenly I had to deal with going from being a child to having a child without ever being taught how to do that. But then God blessed me with the greatest gift I never deserved— a baby girl. I took it very seriously and still do. I got pregnant with my daughter, and thought, *That's it. This is what I am supposed to do. I'm supposed to be a mom.* Faith gave me a reason to live with meaning.

How does this relate to my home? Well, we lived in an apartment for a while, and I would spend my time decorating with things from the dollar store because that's all we could afford. I would go all the time and sell the things I'd find at Goodwill. I initially started with clothes, but during that entire time I always wanted to sell antiques. I was afraid to ship them because I didn't know what the hell I was doing. I would see cool things at the thrift store and I would think, *I just want to learn more about that*.

I started saving all the money I made and put the down payment on this house because I wanted a home. All my husband's money was going toward paying the bills, so we had to come up with the down payment from somewhere, and I had to figure that out. When we bought our first home, I started decorating. I was buying stuff from big-box stores because that's what friends did. But when I was done, I looked at the finished product and said, "I hate this," so I sold everything and started over.

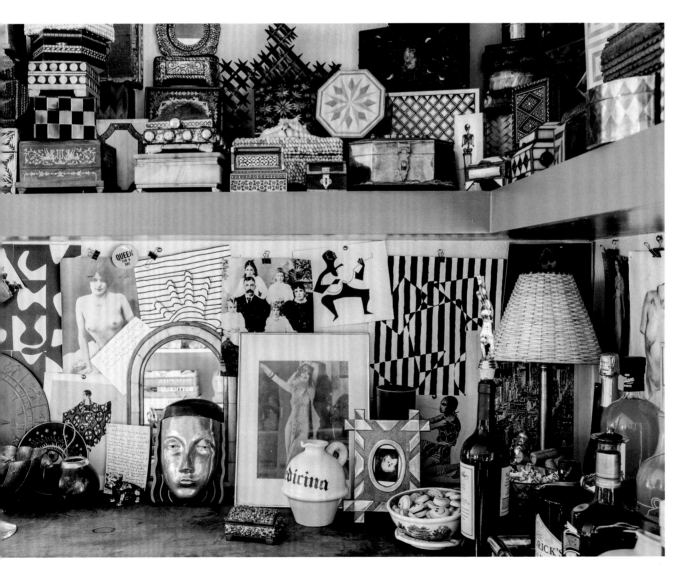

"*Every soul is on
their own earth
journey. Every
single soul is going
to make mistakes.
It's what you do
next that matters.*"

How are your trials and victories represented in your home?

COURTNEY: I suppose that all facets of my past and present are represented in my home. I still like things to be a little rough around the edges, not too perfect, with soul and depth, because that's how my life has been: a dose of ugly here and there. I have survived a lot of trials and tribulations to get to where I am today. Some things people would look down their noses at, and that's okay because every single moment has made me who I am today. And I love who I am. My mother is a survivor herself. She was abused and abandoned. She did the best she could with the tools she had. But there were scars left on us during her low points . . . things that took years of therapy to undo.

My kids walk all over me because I have no ability to discipline them, because of the way I was disciplined so ruthlessly for doing absolutely nothing. For the stuff my kids do, I would have been murdered, and they know it, so they walk all over me. But my husband disciplines them. I'm starting to learn and heal, and my husband is still on his own journey, and that's okay.

I've never been afraid to share the details of my life. I used to use drugs and be a dancer—it happened. I have never been ashamed of it. I was eighteen when my mom bought me a slip dress and six-inch stilettos and dropped me off at a club called Rick's Cabaret, and said, "The phone bill is due." I knew it was scandalous, but back then, I didn't care. I was a bat out of hell, a product of what I was going through. I didn't really have any guidance. The only "guidance" was from my mother, who was buying me that slip dress and dropping me off at Rick's Cabaret. My own mother did that. No one cared about me, so I didn't care about myself.

I didn't realize how crazy all those things were until I got away from it all. I guess I just never thought about it—how screwed up it really was—because it was my life. But then I look back and realize: I would never let my kids into that situation. I would chain them in their bedroom before I would ever let that happen. My whole life I've done what I had to do to get to where I am now, so I'm not ashamed of it. I am not embarrassed by my journey.

A victory for me would be my marriage. My husband said, "You'll never have to do any of this crazy shit ever again." And as much as he's had his own struggles, he's always taken care of me, and he has always taken care of the kids.

My sister and I were always pitted against each other. Only one kid was "good" at a time. My sister and I have matching tattoos that read, "Never tear us apart," but to this day, we can't get along. When my kids are mean to each other, I'll say, "No, we are not doing that in this house. You are siblings, you are going to be siblings for the rest of your life. We are a family." I don't expect my kids to be perfect, and I will give them every single tool they need and be there to help them.

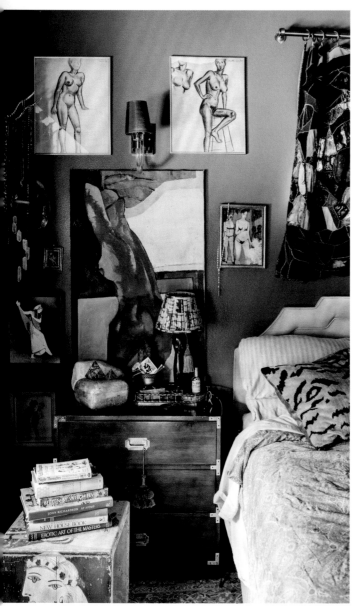

CARLEY: And that is the perfect realization of the trials becoming victories in your home. Was your mom the kind of person who had plastic on the furniture, so you couldn't mess anything up?

COURTNEY: [*scoffing/laughing*] No, but everything in the house matched. The room would have a theme and would be coordinated, so if geese was the theme, there would be geese all over the kitchen. She was actually very creative and tried to make our house a home. We had pink kitchen cabinets. Remember that commercial for Resolve, when the kids spill spaghetti [on the white carpet] and the mom says, "That's okay! We've got Resolve!" Yeah . . . it wasn't like that.

What does freedom *mean in the setting of your home?*

COURTNEY: To me, freedom at home is the absence of fear and the presence of acceptance: accepting myself for where I have been and who I have become. I can design a room and decide all of a sudden one day I don't like it, and I can change it. That's kind of how life is. You realize something about yourself that needs work and you have the freedom to do so until the day you die. You don't have to stay trapped in generational curses or trauma. You can do the work to heal and be better than the circumstance you were handed.

CARLEY: When you didn't find freedom in your old home, what does freedom feel like in your home now?

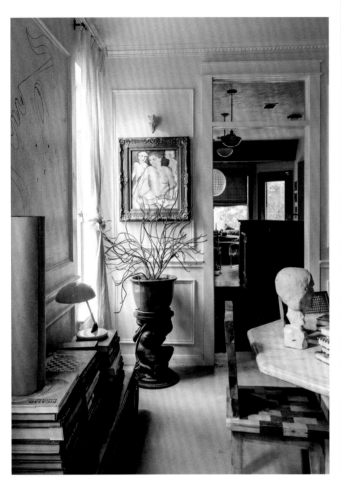

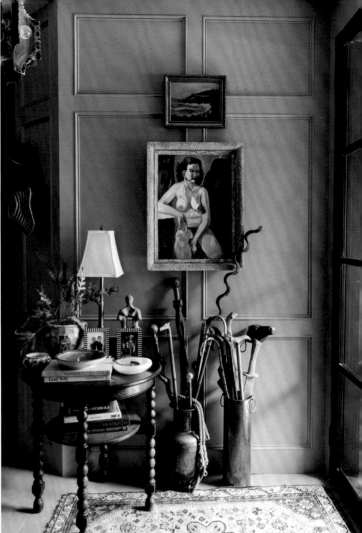

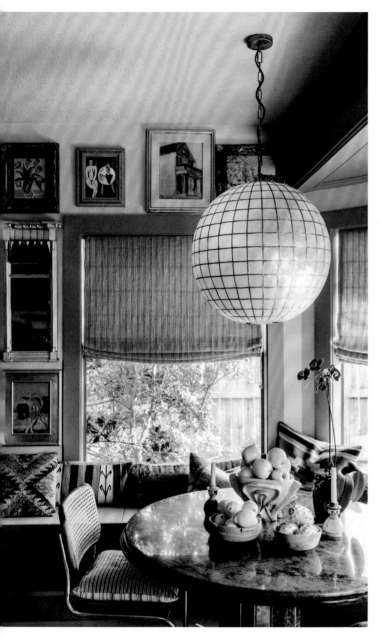

COURTNEY: Freedom feels like I can spill stuff, and it's not the end of the world. My kids can spill stuff and it's not the end of the world. There's not that tension of constant fear. I guess freedom is the lack of fear—we live here together.

Where is your sacred space in your home, the place you find the most peace?

COURTNEY: [*laughing*] This is going to sound weird, but my sacred space is my bathtub because it's one of the only places where I'm alone with myself. I love being able to take a bath and just check out or check in with myself. I love being away from it all and sitting to process everything. I am a big processor and I have to think about something every which way before I can let it settle.

What does your personal meditation or quiet time in your home look like? How do you get away from the worries of the world?

COURTNEY: I like to lie in my bed and listen to guided meditation, sometimes with crystals. I listen to guided meditation because I have a hard time verbalizing my thoughts and feelings, and it helps to listen to someone else. I feel twenty pounds lighter after taking a moment for myself, clearing my mind, and tuning in to who I am. There's something about taking care of myself and exercising that helps me keep my head on straight and helps me take care of others.

If there is one part of your story that you think would set another free, what is it?

COURTNEY: Every soul is on their own earth journey. Every single soul is going to make mistakes. It's what you do next that matters. Don't take hurt from others personally; you are sometimes just a part of their learning experiences. Also, I think the ability to accept things the way they are and say, "I can't change it, so I need to face it," is important. I think facing it is the only way through it. The only way out is through, and that's the truth.

Finally, I realized I had PTSD from all that happened to me. I lay right there on the floor and cried, like I was a little girl again. It was one of the most bizarre things, but that is what PTSD does. If you research why something like that would happen, you'll find that you

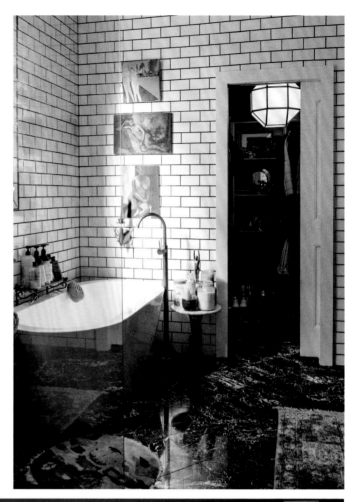

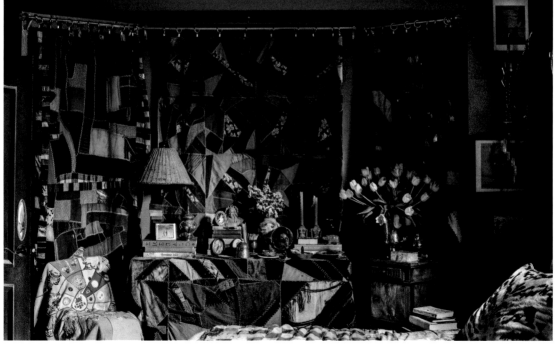

either never dealt with the trauma, or it comes out when you're finally in a place where you feel safe, which was here with my husband in my own home. Enough time had finally passed, I guess, that my brain said, "You're safe," and it all came out. I was literally crying in fear, like I was back to being seven, ten, fourteen years old. I felt such deep sadness that I had never felt in my entire life—and I've been through some shit. I'm okay now and I can finally deal with this the way I need to without using drugs or escapism. And I found a therapist who helped me. Part of me wanted to tell my husband, and the other part of my brain said, "No, you have

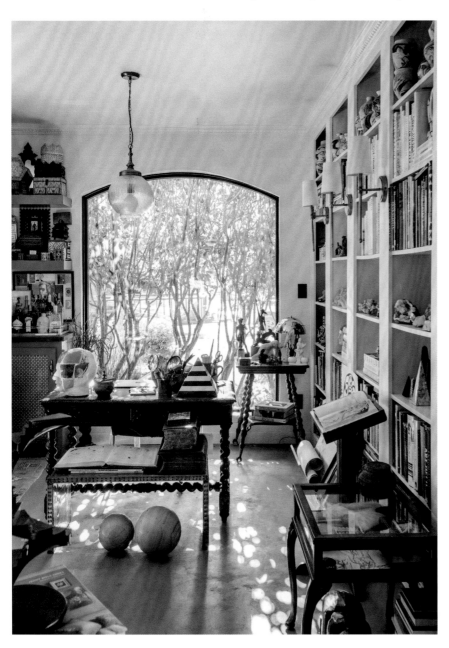

to do this by yourself; just let it out." So I apologized to my little girl–self and said, "I'm sorry that happened."

My therapist told me, "The reason why you survived all the things you went through is because control got you there. You learned how to control yourself and the people around you, and at times it worked. But now you're starting to drive the people around you mad by those old techniques, and you don't need that anymore." I had to start learning how to separate, because I was a really big control freak when I first got here. I had to learn to separate the past from the present. I don't have to be in this mind frame about that or this; I can let go of some of the control and I'll still be okay. I used to cry in my closet when I was little.

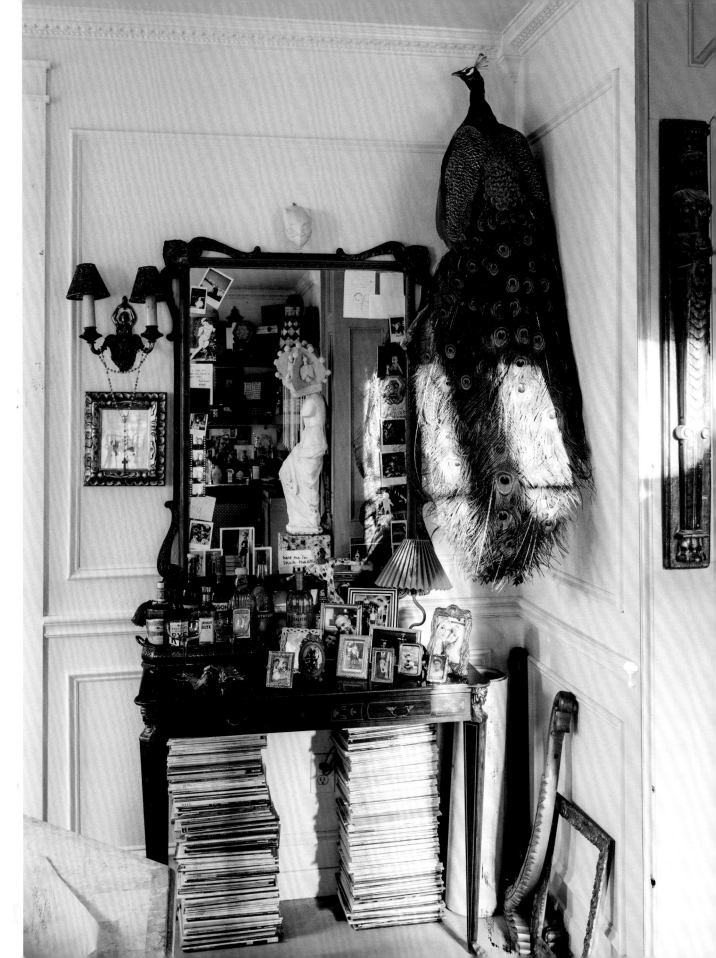

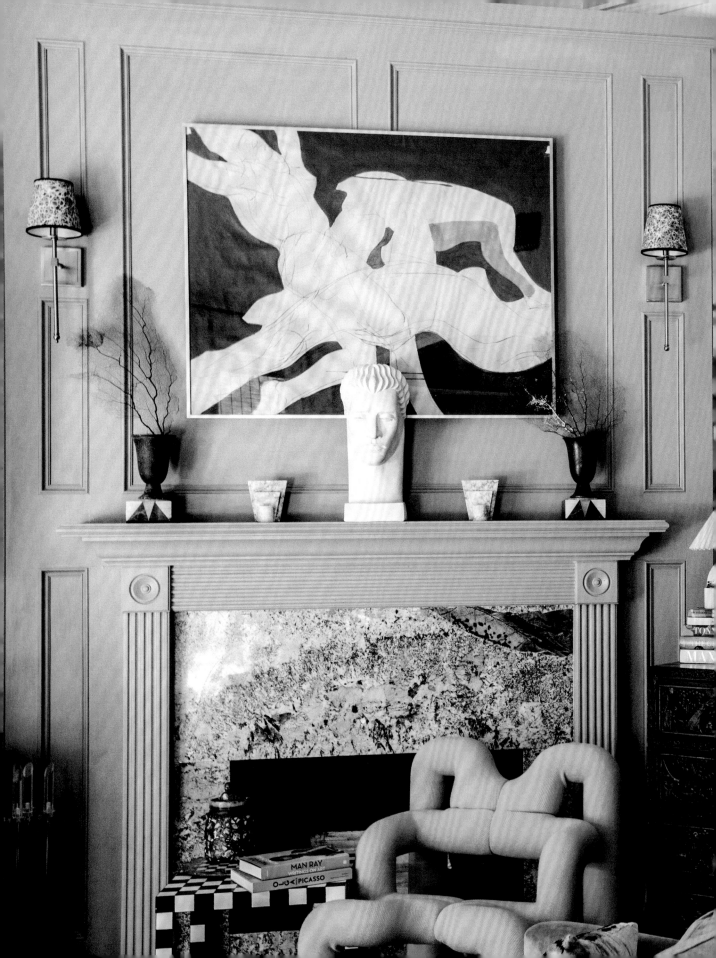

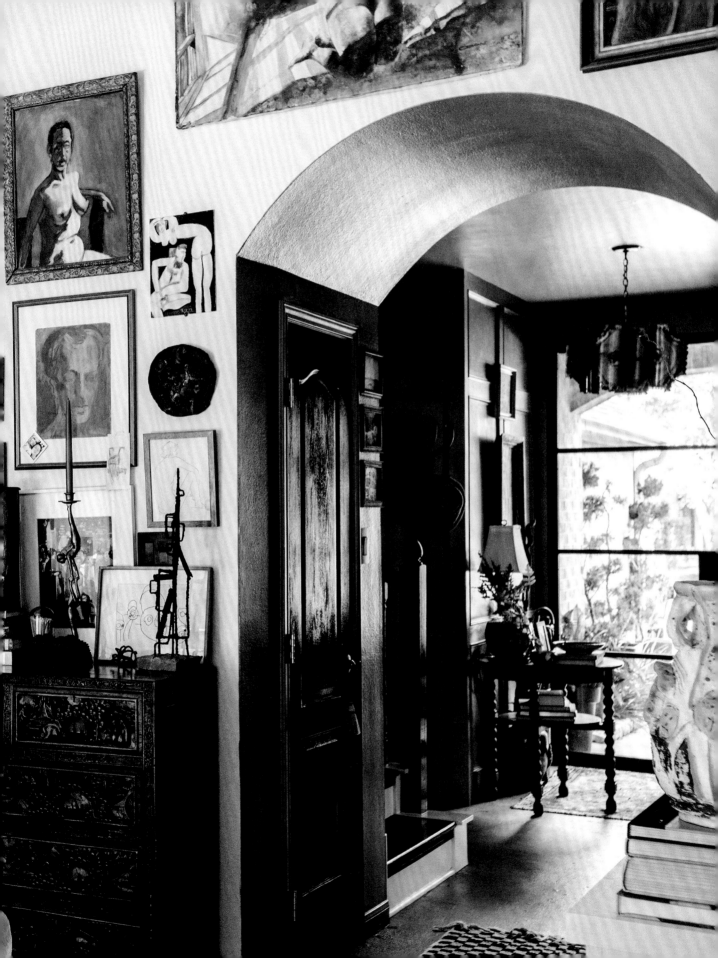

And still to this day, I will go and collapse on my closet floor. It's therapeutic and comforting for me.

CARLEY: That's the point of this book. I want people's chains to fall off when looking at spectacular homes created by everyday people who have gone through things you would never expect.

"We are a family. I don't expect my kids to be perfect, and I will give them every single tool they need and be there to help them."

ELLE PATILLE

ELLE PATILLE AND HER HOME ARE LIKE SOMETHING OUT OF A STORYBOOK. After finding her online, I knew I had to reach out. I saw something within her pictures that provoked a deep longing to know more about her. When I arrived at her doorstep in Toronto, Canada, we immediately hit it off. I believe people with similar scars can discern that in one another, allowing for instantaneous bonding. That happened with Elle and me. As she walked me through her journey in life and home, I just wept. Elle's story is truly a miracle, surviving the traumatic events that marked her journey, and where she is today is utterly amazing. Her home is full of whimsy, yet also dark and full of things that represent death, but also inspire life. Her home and story changed me, and I know it will do the same for you.

Your story . . . Go!

ELLE: Our home was the nicest, most well-thought-out designed house in our neighborhood. My father went to school for fine arts and later studied architecture, so it was no surprise. We had a handcrafted marble dining room table, with grays and warm pink veins throughout the marble. It was a breathtaking dining room table. Everything in our home was ahead of its time. It was filled with beautiful sculptures and furniture. It was spectacular. But we never got to use it, ever. I don't ever recall having dinner in that dining room. I maybe

recall one or two occasions of sitting on the sofa, but people rarely came over. We weren't allowed to sleep in our own beds while our father was out of town. Our toys were always stashed in our bedroom closets, and we weren't allowed to access them or our clothes.

I remember my godmother bought me the most beautiful navy-blue velvet dress with embroidery. As a little girl, I was drawn to the beauty of the textile, the pattern, the fabric. I don't think I ever wore it, with the exception of a school picture. It just hung in my closet along with everything else.

For our day-to-day clothes, our mother would buy our clothes from large bins, and the same four outfits were always on rotation. I definitely stood out at school, wearing the same outfits all the time. My mother's OCD prevented me from wearing any of the pretty things or playing with toys.

My mother grew up in a home that doubled as a rooming house for men, and I'm sure there was abuse in her household. She and her siblings had to make the beds for those men, and it was very militant. So I think it kind of trickled down. She made my brother and me ensure everything was perfectly done—no wrinkles. The sheets were always pressed. And in the morning, we had to make sure every single hair was taken off the sheets. We'd hold the sheets up and she would get tissue paper from the bathroom, and we would have to take each little hair or each little piece of lint and put it onto the sheets of toilet paper, just so it would safely make it into the trash and not on the floor. Everything had to be done perfectly.

CARLEY: Was your dad in the picture?

ELLE: He was always out of town on business, while my brother and I stayed in her care. When he wasn't there, we were limited to one bed, one bathroom, and a floor to sit on in one room. We weren't allowed to go into the other rooms. The living room and the dining room were never touched. The family room just kind of sat there. We weren't allowed to touch anything. And friends weren't allowed to come over.

CARLEY: I know you had mentioned that there was abuse in your home growing up.

ELLE: My parents' relationship was quite toxic, even before we were born. And I think my mom's insecurities with him spending so much time on the road added to her anxiety—not knowing what he was up to. And so it was taken out on us. If he wasn't around to see the abuse, it was as if it didn't exist or it wasn't so bad. She wasn't an easy person to live with, so I'm sure he wanted to avoid conflict upon his return. Unfortunately, it meant that my brother and I were left to deal with her.

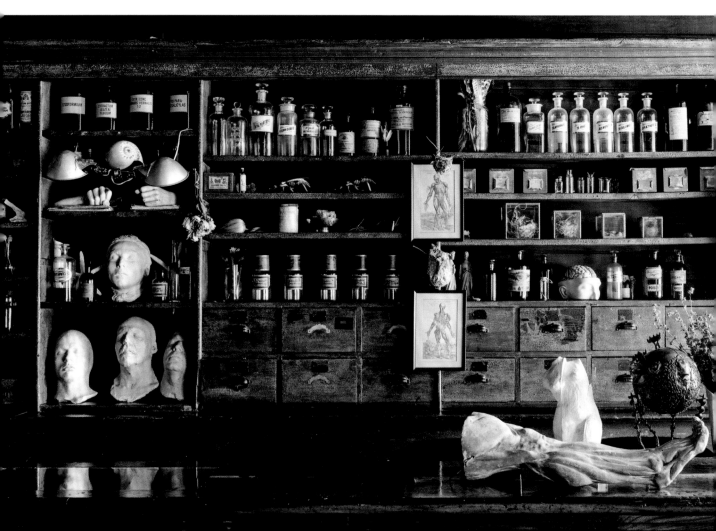

If somebody knocked on the door, we had a routine. My mother would shut off all the lights and my brother and I would lie on the floor so it would give the illusion that nobody was home and they would eventually just leave. She'd take the phone off the hook so nobody could reach us by phone. No one ever really knew what was going on in our home. I recall my brother wanting to expose what was happening behind closed doors. So once we took out one of our tiny recorders while our mother was in one of her moods. He said, "We're going to get all this on tape." He put the recorder in his pocket and pushed *record,* but all you could hear was chaos as he was pushed down the stairs.

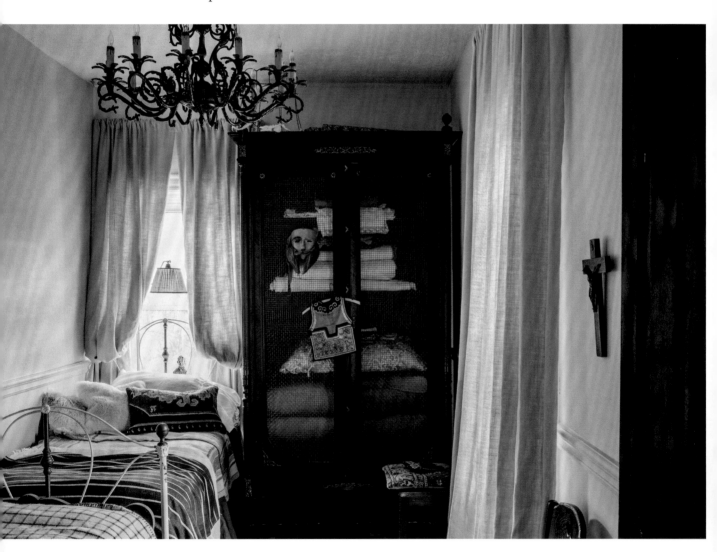

I was always looking for injured animals because I found comfort in animals, since they, too, were alone and injured. I knew that feeling all too well. I believed nothing ever deserved to feel that way, so they became my escape. We weren't allowed to have real pets, like dogs or

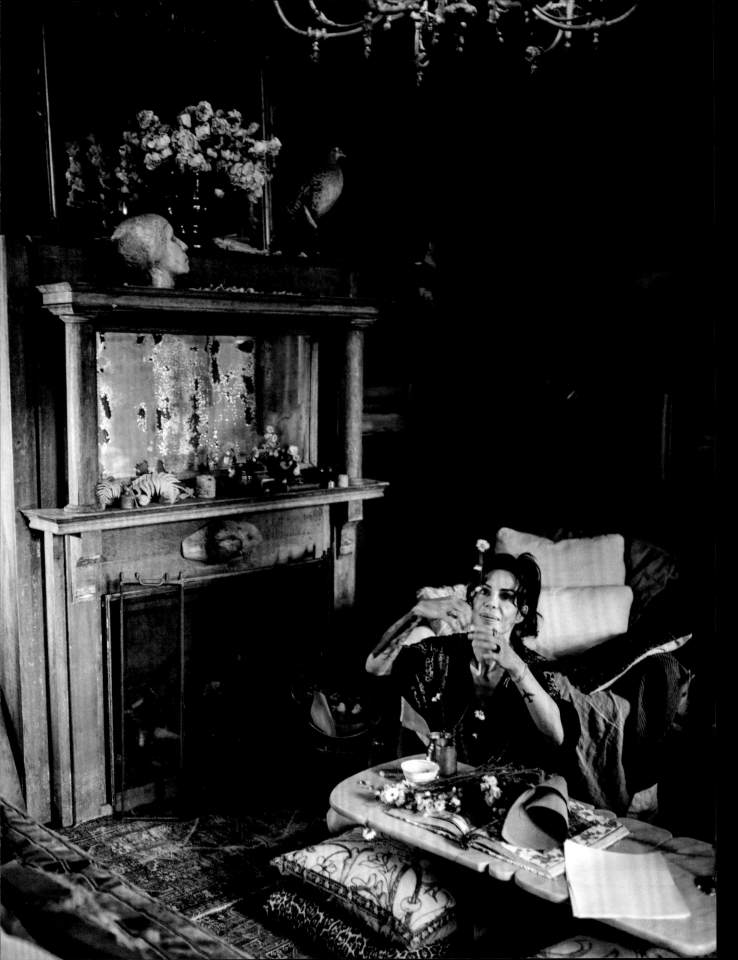

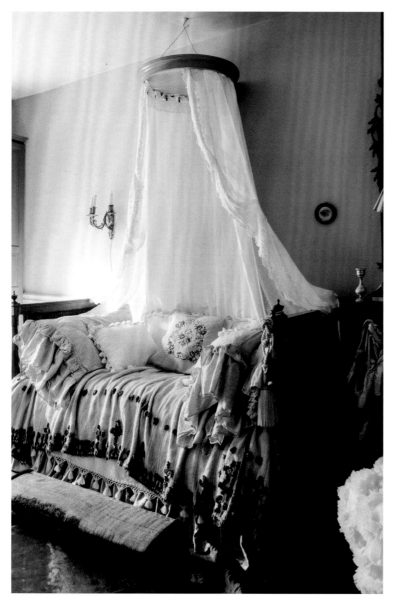

cats. We could have a hamster or fish, but that was the extent of it. I remember every spring I would spend time at my godmother's farm. I used to love going there because every year I would find barn kittens. I always felt I could give them a better life, so I'd always take one. Somehow, some way, I'd think, *This year will be different*, that finally I'd be allowed to keep one. But every time I went back home, I found myself walking to the variety store with this little kitten in hand, asking someone to give it a good home because, once again, I wasn't allowed to keep it for myself. That was every March break. It's one of the reasons why, as soon as I was able to have a home of my own, I filled it with animals.

CARLEY: And then, you went on to live with your grandmother after Child Protective Services came, right?

ELLE: Yes, the Children's Aid [Society] was eventually brought in. I don't recall a lot other than them checking in and having discussions with my parents. What I do remember is that, at a certain point, my father said, "We're going to your grandmother's." I was under the impression we were going to be living in her basement, so I started setting up the basement of my nonna's home. It wasn't fancy, but it was always cozy. We could sit on the sofas, and we could jump on the beds. There was nothing precious about it; it was just a well-loved home. And people were always there—it was like a revolving door. It was a real home, because my nonna loved to entertain.

I never once shed a tear that I was losing a mother, because I never felt like I had one. I was more excited about moving into Nonna's place. My grandmother was working full-time, and my grandfather was stricken with a rare debilitating disease, so a part of our responsibility was to care for him. Still, I was happier there than I could've ever been with my mother. I don't think I ever felt protected by her. I don't recall ever being held; perhaps those moments were reserved strictly for photographs or when she would hold my nose up in the evenings while she watched her shows, just so that I would have a cute little perky upright nose. How we looked was far more important to her than how we felt. Name calling wasn't uncommon in our home because she didn't think we were as beautiful as everybody else's children.

When I was in grade five, there was a field trip to my teacher's farm. He had approximately a hundred acres and I could barely contain my excitement. There were cows, pigs . . . you name it! I never really spoke at school, even when spoken to, but I was in my element now, surrounded by animals, so I started asking questions like "Can you

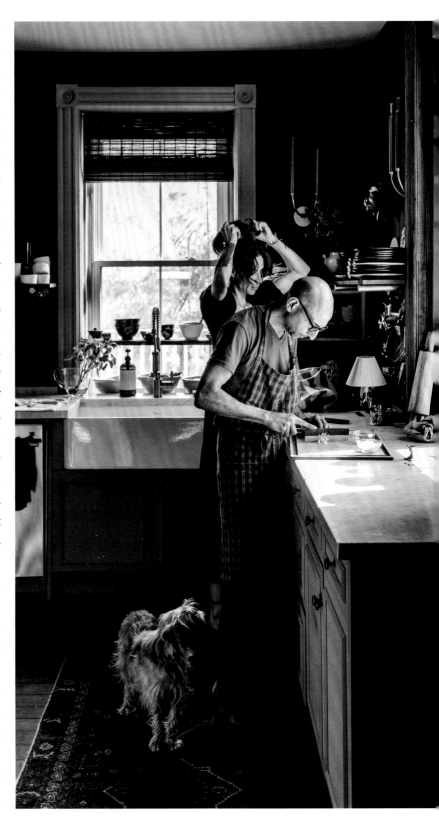

show me how to milk the cows?" So he did. I think that was the moment he realized he had kindled a spark in me, and he knew it was the animals. From that moment on, every time he found a dead animal on his property, he would place it in a plastic bread bag and put it in the fridge in the teacher's lunchroom. Then he would tell me, "I have another one for you." I was so interested in the biology and the study of animals, that I would draw well-done formal diagrams and label my findings. My curious mind was thirsty for all knowledge regarding animals.

The study of animals came easily, but the classroom environment was really difficult because I found it extremely slow moving and therefore boring. It was difficult to concentrate on subjects that were of no interest to me, and I was later diagnosed with ADHD.

CARLEY: What was the transition like into your next season of home in your grandmother's house? I know you said that you ran away.

ELLE: I was always on my best behavior until my teens because that's just how I was raised. I was so used to my mother raising her hand that I learned to be a "yes person" quickly. I was like that for a while, anyway, until I was about fourteen. My nonna was Italian. She and my father were both born in Italy. So it was a strict household: no boys, no makeup . . . which was tough as I entered adolescence. I started getting rebellious and angry, because I saw others dating and going to the movies. Both of my parents had gone off to live their lives. My nonna worked tirelessly for us and for her ill husband, but I wanted my freedom.

When I was fifteen, I was modeling, and I had the opportunity to go to Istanbul through my modeling agency. But my father said, "You're not going; you're too young." When I was sixteen, I was asked to go to Greece, and I said, "I'm packing my bags and I'm going. I want to have a life of my own." I thought I knew it all, so I just left. From there I went to Milan and worked. Moving from place to place from that point just became a part of my everyday life.

I finally came home a year later, when I was seventeen. There was a guy working on my street who was older than I was by about twelve years. He took a liking to me, so I ran off with him. I moved in with him and we eloped on my eighteenth birthday without anybody knowing.

CARLEY: Wow.

ELLE: Nobody came looking for me. It was like they didn't care. So I lived with him, and we opened a restaurant together. I was still trying to go to school, but that didn't work, so I kept dropping out. Obviously, I was too young at that point to be with him. I still had to figure out who I was, and I knew I had to move on, which I did. But I couldn't go back home. In-

stead, I started couch surfing with whoever would take me in, which meant I never really had a home. I just hopped around from place to place until something felt right or somewhere felt safe or somebody loved me. That was all I was looking for.

I ended up meeting another man, and I thought he really loved me. He asked me to marry him just a few weeks after we met, so I did, only to find out a year later that he was a drug addict. I didn't have the capacity mentally at that age to help him, but I thought I could because that was what I did: I took in the injured. I remember my girlfriend saying, "Addiction is a disease. If he had heart disease, would you leave him?" I said, "Well, no." She said, "Then you can't leave him." I stayed, thinking I could heal him, but I couldn't. Even his sponsors told me I couldn't heal him. But I said, "I can't have him going to an underground parking lot or to motels not knowing if he's okay while he's shooting up. I would feel better if he did it at home." His sponsors said, "No, you wouldn't." I said, "Yes, I would, because at least I would know he's safe."

After that, he started using at home. I don't think he ever wanted me to see it because he was embarrassed. He'd lock himself in our en suite, close the door, and put a towel underneath it. He would sometimes come out at night and other times he wouldn't.

When I would see him, I noticed that his legs were covered with burn marks because he would drop the hot spoon on his bare legs while he used. I knew he needed help. He suggested a trip and I obliged, even though what he really needed was to reenter rehab. He refused, saying, "No, I just need to go on a trip."

I said, "Okay, where do you want to go?"

"Just book a trip to Mexico," he said. So I booked the trip.

Finally, the day came that we had to leave. I had packed his bags for him because he was in no shape to do so, nor was he coming out of the bathroom. He used right up until the car came. Shortly after getting on the plane, he started having withdrawal, because it was a last-minute flight. We had aisle seats across from each other and I could see the sweat beading on his skin and the withdrawal shakes starting. With the flight attendants staring at him, I just kept asking for blankets and I wrapped him in them.

We arrived in Mexico, and it wasn't long before he started using. I knew then I couldn't help him.

When we got back home, I knew I had to say goodbye to another relationship, another home, and start again. It ended horribly. When I was trying to leave, he got violent. He said that I was either leaving in an ambulance or a body bag. He had me pinned at the top of the stairs. Thankfully, his friend was there and came to my aid. The police were called, and he was taken away. I felt horrible that it had come to this, yet at the same time I was so scared of that man, a man I obviously didn't even know. I later found out that he was living a completely different life with another woman in Italy. I no longer had a husband, a home, or a car to escape

in. So I borrowed a car because I was legally advised to just grab whatever I could and get the hell out before he got out of jail. I packed whatever I could and left in that borrowed car.

Up to this point, I don't think I ever really felt like I had a home. Every place I stayed was always temporary.

CARLEY: Until now?

ELLE: Until now. Now I have a home, a place in which I feel safe. I can have company over, I can entertain, and I can have all my animals running around and jumping on the furniture—finally, I have a home full of life and love.

Growing up, I had a girlfriend who lived across the way from my first childhood home. She had two orange cats, and I would be over-the-moon excited to be able to visit her and her cats. Her grandmother was always in the kitchen making batches of molasses cookies that

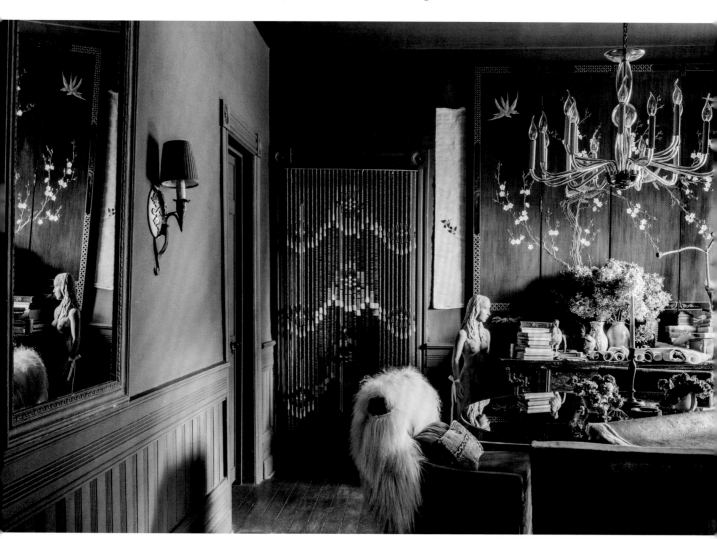

were so chewy and delicious. We'd grab a plateful, and everybody would get onto the sofa to eat them while watching movies. There were crumbs and cat fur, signs of life. Going over to that house was such a treat for me. I didn't get to go often, but when I did, I loved it. I think that household always stuck with me and represented the kind of home I longed for.

CARLEY: It's amazing you have that now.

ELLE: I do. I have everything I ever wanted.

If you had one pivotal point that changed the direction of your life, what would that be?

ELLE: Meeting my husband Mo. Before him, I always saw myself as damaged goods. I got married on my eighteenth birthday, but that failed. I got married again a couple of years later, and that failed. I was like a gypsy, floating around the planet, just doing whatever felt right. So now here I was at thirty-four, engaged five times and divorced twice, when I met Mo. And I thought, *Here's this man who is so well put together.* But I felt like a mess.

I remember we went bowling on one of our first dates, and I spilled the beans about ev-

erything. I thought, *If I'm going to scare this man off, it's going to be now, and this should do it.* So in one shot, I told him everything, thinking this man was just going to run off. He didn't even flinch.

CARLEY: I have chills.

ELLE: I knew then he wasn't going anywhere. I could tell him my deepest, darkest secrets, even the fact that I tried to take my own life, that I had problems and anxiety, that I was de-

pressed and I didn't think I had any self-worth. And still his response was "It's okay. It's all right."

I told him, "Okay, but you're going to get tired of me."

But no. He's still here.

CARLEY: Ten years later. He adores you.

ELLE: My husband was the first person who told me that he loved me enough, that nothing would ever scare him off. His love is truly unconditional.

CARLEY: He took you—all of you. I can relate.

ELLE: Even though I had this incredible man in my life who was willing to accept me and all of my flaws and all of my anxiety and everything else, I still wasn't happy. There was something missing. I would break down. I was emotional. I was still hanging on to the pain of why my life had

"*I need all my senses to be working at once in order for me to actually feel whole. It's the freedom of finally being able to be me without being judged.*"

been the way it was and why I wasn't loved by my parents and wondering how could they turn their backs on me, their own daughter.

I don't think my parents know half the shit I've been through.

I remember after I tried to take my own life, I was in the hospital, and my father came once to visit me with his girlfriend. He didn't have to say anything, as his look of disappointment said it all. Even the first responder gave me tips on how to do it properly the second time around. When people are speaking to you in that manner, it's virtually impossible to ever have confidence.

CARLEY: They weren't giving you any hope.

ELLE: My fortieth birthday was fast approaching, and I knew I had to change something. I was talking to a dear girlfriend of mine when she mentioned plant-based therapy that had done wonders for people she knew who'd had traumatic events in their lives.

After she and I had that conversation, I brought it up to Mo and said, "Hey, what do you think? I'm going to be forty. I'm almost at the halfway point. If I can find a happier me, now is the time."

He said, "Well, if we're going to do it, we're going to do it right." He did all the legwork. He dug into the Shipibo people of the Amazon in Peru, and he found a place where we could go on a healing journey with plant medicine. It was the most incredible experience of my life.

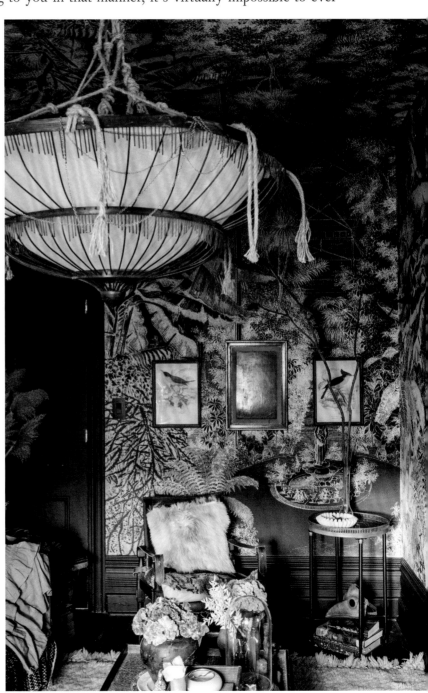

As hard as that trip was, everything changed in the ten days we were there. It [the Shipibo people and the medicine] knew exactly what I needed. I met with five shamans. They took me through my life, replaying every phase of it, the way it should have been, not the way it actually was. I finally got to relive a beautiful childhood, I got to relive a beautiful adolescence, everything was beautiful. And I came out of that experience confident. I'm so grateful for the shamans and the strength they have to help pull people out of dark places, because I truly believe they changed me. Even though I have such an incredibly supportive husband, I needed that experience.

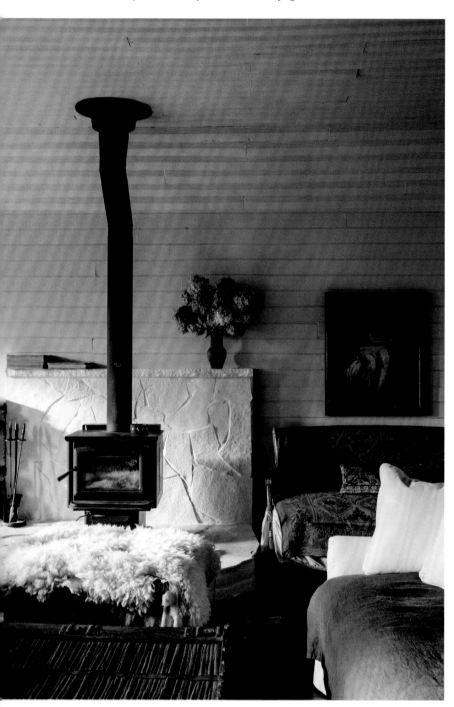

CARLEY: You needed internal healing.

ELLE: It had to come from within me. It couldn't have come from Mo, as much as he wanted it to. I think it was hard for him to fully understand my story. I don't think he had the capacity to deal with my story and my struggles because no one can, especially if they haven't gone through it themselves. That visit to Peru was the beginning of my new life.

How are your trials and victories represented in your home?

ELLE: I think it's the whole package. It's my animals, my supportive partner, being surrounded by nature and everything that's imperfect.

CARLEY: The victory of having imperfect things in your safe and perfect home.

ELLE: I'm surrounded by everything that brings me such joy. Everything is old; everything holds an energy. It's a home for all things lost and forgotten, especially the vintage taxidermy. I feel like nature has always been my protector. I cared for injured wildlife and in return they gave me unconditional love. I don't look at them as trophies. I don't look at them as victories. I look at them as a part of the family.

CARLEY: Those were things you weren't allowed to have growing up. You weren't allowed to have animals in the house. You weren't allowed to sit on the sofa.

ELLE: We're surrounded by taxidermy right now, but you'll notice that I don't display them as trophies. Some are asleep on the sofa or found perched as they would be in nature. Their lives are not forgotten here and they're no different than the Victorian death masks or mourning jewelry I collect. Everything is precious, both past and present. It's a home of all things imperfect.

CARLEY: It's something you lacked in your former home, growing up.

ELLE: That house had no energy: everything was new, nothing was touched, nothing was ever moved.

CARLEY: Here, you're moving stuff all the time, creating all the time.

ELLE: Everything was stagnant in my childhood house. I don't think our mother ever moved or changed. It was just her law: "This goes here, and it stays here for as long as I'm going to live here." She sold that home a few years ago, and it still looked identical to what it was when we lived there—not a single thing had changed, not a single thing was ever used.

CARLEY: Wow, it's the complete opposite here.

ELLE: I know. I can't stop moving things.

What does freedom *mean in the setting of your home?*

E L L E : I think the freedom to create, to self-express, to dance around, and to feel safe. I fill my house with music, because I think that's a part of what I need. I need all my senses to be working at once in order for me to actually feel whole. It's the freedom of finally being able to be me without being judged. I was so tired of being judged and being told that I couldn't do something. I was always told, "You can't travel. You can't do this. You can't do that." And so this house is my space to do all of that, and to say, "I can do it, and I have done it."

Where is your sacred space in your home, the place you find the most peace?

E L L E : This question is tough because every room in the house represents different parts of me. I think we all have different sides, and I have a lot of different things that I love. It's really hard to say there's one specific room. But we do have a little room off the kitchen that has become the one room where I feel the safest. Perhaps it's the size, the calming energy, or maybe it's the color palette. I can't quite put my finger on it, but I feel it.

C A R L E Y : You know, I think after being around you a bit, I do find you gravitating to this space.

E L L E : I do. I do love this room.

C A R L E Y : When we were sitting here having a conversation the other day, we were both crying. And then I started to photograph you. There was such a sense of peace that was over your body as I photographed you. Even in your face, there was a certain relaxation. I do think there's something really special about this space.

E L L E : Maybe it's just the energy of this space. Maybe it's the energy of all the old books in here. There are days I come in here and I will pull out the books and read the dedications to the people they were written to. And I think of how beautiful that is. And sometimes I'll look up the names of those people and see if they're still around. For me, that's a beautiful day.

We leave so much of ourselves throughout our lives, and then once it's gone, it's gone, and we don't get it back. I think it's so important for us to keep all of that alive and to remember where we came from, where we're at, and where we're going. I think each space should be able to take care of all of those sides of how you're feeling psychologically and physically.

What does your personal meditation or quiet time in your home look like?
How do you get away from the worries of the world?

ELLE: My devotion time is very different; it's not a step-by-step process, and it's not something I do to escape or get away from everything. My devotion time is for nourishing my body in the best possible way. It's probably the most sacred thing I do throughout the day. My meals are sacred. It's when my husband and I sit down at the end of the day and share that time together. I taught myself to nourish my body properly and to take that time for myself; that is my devotional time.

If there is one part of your story that you think would set another free,
what is it?

ELLE: Don't seek the approval of others. If you haven't gotten their approval as of yet, no matter who they are, don't romanticize it, because you'll never get it. You'll end up looking back and regretting all those years wasted. I think freedom is the ability to realize who is healthy for you and who's not, whether that's a husband, a friend, a family member. No matter who they are, it's okay to let go. Don't seek approval if it's not there, because you'll never freaking get it. Just let it go. Forgive completely and let it go.

CARLEY: I got chills. You've been through a lot in your life. I hope that you see, and I hope that you feel, that you are redeemed and restored, and everything that was taken, everything that was broken, is restored. If you could look at your younger self and see where you're at now, what type of hope would you share about yourself and your story to that young girl?

ELLE: I would tell her that she's stronger than she thinks.

CARLEY: You have been through so much and I want people to see the hope and the victory through your story. What hope would you share with someone maybe going through the same thing?

ELLE: Be kind to yourself. It's not you. No matter what, it's not you. Just be kind to yourself. You can make all the excuses you want for people's behavior. You can make excuses for them, but in the end, that's their behavior, and it has nothing to do with you and who you are, and you don't deserve any of it.

CARLEY: Do you feel like you've healed from your past? Or do you think it's still a journey for you?

ELLE: Life is a journey, but I feel free and I feel happy. I heal a little more every time I share my story. Memories always come back, as you know, and emotions will always be there. But I no longer wonder why. I no longer ask, "Why me?" Because I know it wasn't about me. Our mother didn't know how to fix herself, and I'm not a part of that life anymore, nor do I need to be. Whether she's in my life or not, my life doesn't change. I don't feel like a victim anymore. I think that's the most important thing: that I don't feel like a victim anymore.

CARLEY: I'm so glad you are where you are now.

ELLE: Me, too. I'm glad I have forgiven. Forgive completely and let it go. It will set you free.

"Now I have a home, a place in which I feel safe. I can have company over, I can entertain, and I can have all my animals running around and jumping on the furniture—finally, I have a home full of life and love."

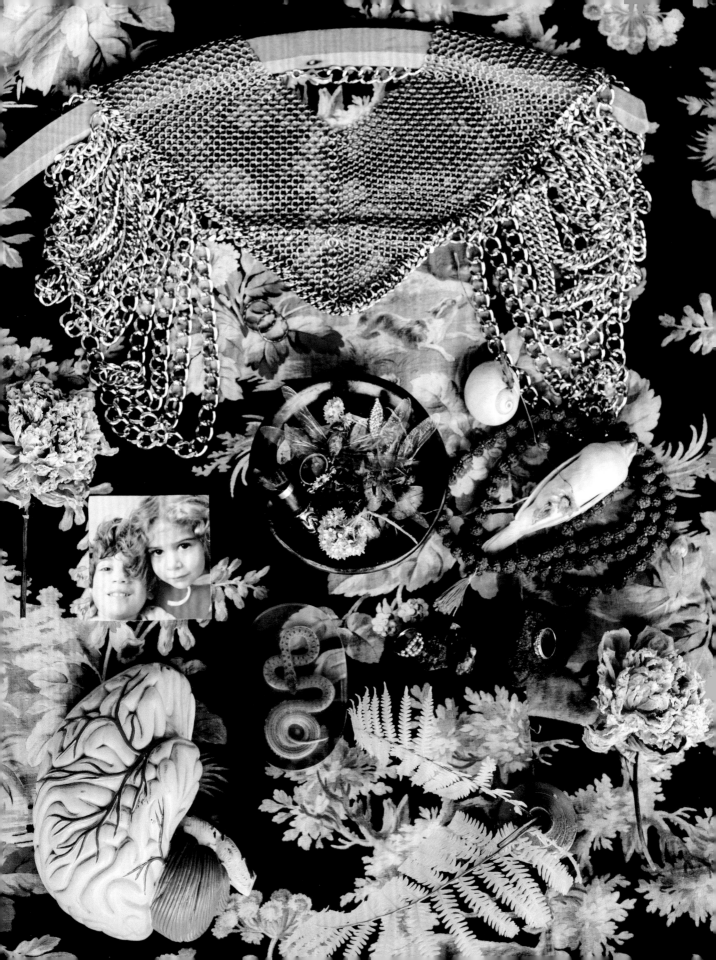

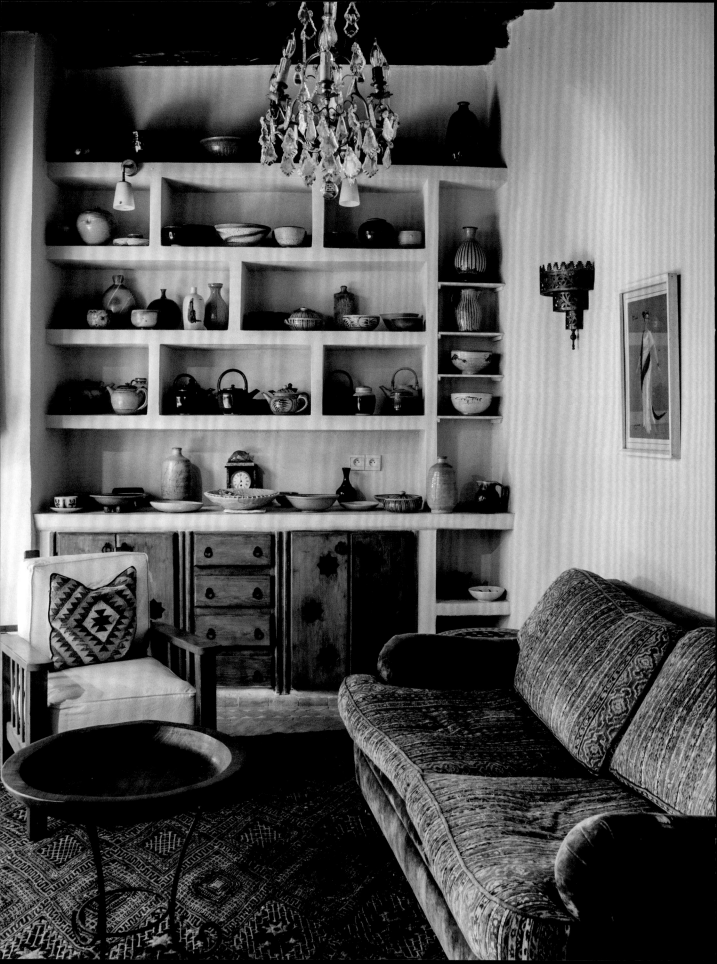

THE MELDED HOME

STORIES FROM

USHA BORA & CLAUDIO CAMBON AND MARK BROKENSHIRE,
WHO HAVE MADE A HOME DESPITE DRASTIC RELIGIOUS,
ETHNIC, AND CULTURAL DIFFERENCES,
SUCCESSFULLY BLENDING THEIR STORIES
WITHIN THEIR HOME.

USHA BORA
& CLAUDIO
CAMBON

USHA AND CLAUDIO'S COUNTRY HOME IS TUCKED AWAY AMONG THE VAST fields of Normandy, France. When you first enter the gates of their fairy-tale-like garden, the sense of joy is immediate and foreshadows a time you'll never forget. I first met Usha on a trip to Paris at her store, Jamini, where she sells textiles and home-decor goods sourced from her native country of India. When we met, I knew we were kindred spirits. She invited my husband, Jon, and me to her home in Normandy, where we met Usha's partner, Claudio, and where we shared a delicious local meal and a lot of laughter. I always knew I wanted Usha and Claudio to be a part of this book, and I'm so glad it worked out. When Claudio isn't farming in his vegetable fields or cooking, he's snapping photos or working as a translator. Usha and Claudio have gracefully blended their families together after they both experienced divorce. They often escape the business of Paris to their tranquil Normandy abode. When we arrived the second time at their perfect oasis, it felt like home. The environment, the food, and the life inside made me feel rooted in something truly special. They have both walked through many seasons, and their home represents that so well. You will see something so charming and peaceful when you flip through images of their sacred space.

Your story . . . Go!

"Our home now is not just about Claudio and me, but it's about everyone who comes in here. I really want to make that feeling of home for my kids, their friends, their boyfriends, their cousins. Everyone who enters here should feel that our home is a safe space."

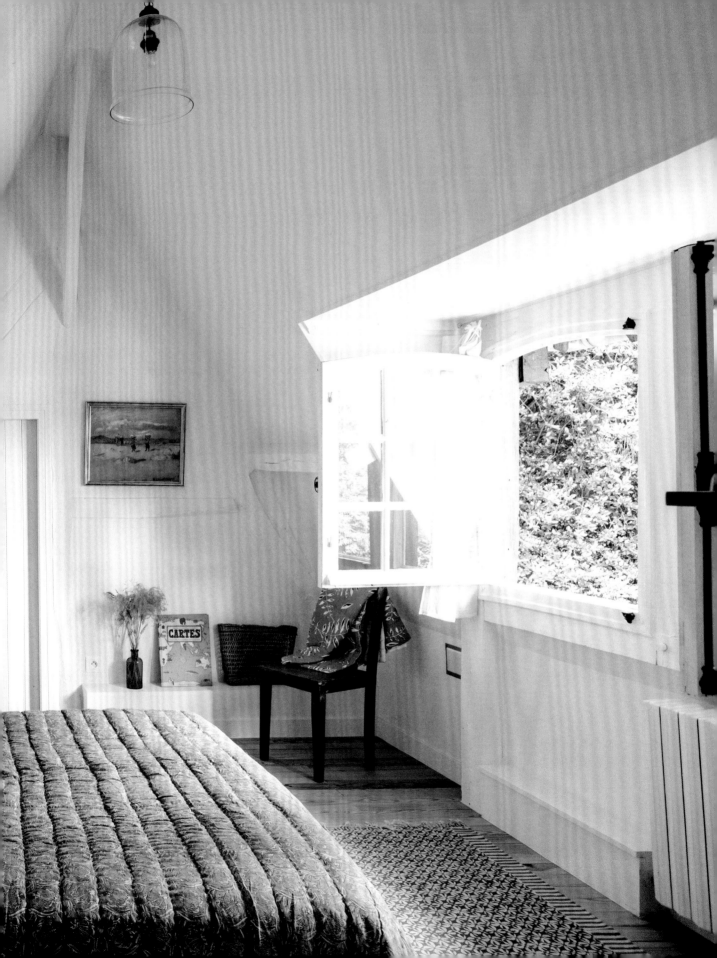

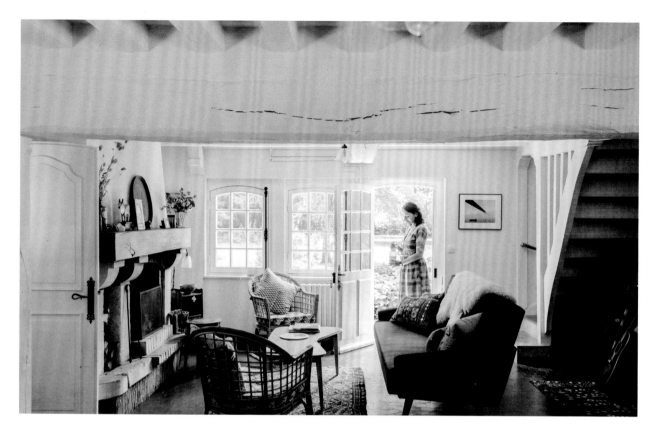

USHA: I never really had a happy family chapter. We never went on vacations, we never traveled, nothing. Instead, what I was taught from a very young age was to study. Now, this might be a stupid thing to say, but it gave me the drive: I wanted to go out and conquer the world. That's something I had from a very, very young age. I don't know what it is. I mean, some people have it and some don't. I had it. I just knew I wanted to be better than anyone else. I wanted to do better in school. I wanted to be independent. I wanted to be strong. I wanted to be the best at whatever I did. I don't know where it comes from; maybe it's nature, maybe it's nurture, maybe a little bit of both. That's what drives me today. That's what I tell my kids: if you have a gift, you have to use it. Prove something to yourself, give something to someone. That's something that has really shaped me.

I was also very close to my grandfather, my mom's dad. I was the first grandchild, and my mom was a university professor, and always very high strung because we lived very, very far from the town where she worked, so she had to travel four hours from our home in Tipong to Dibrugarh to deliver her history lectures. The distance and terrible road conditions made this a long and arduous trip, four hours there and four hours back. She was always tired, angry, crabby, and screaming. Those are the biggest memories of my childhood. Now, as an adult, I've come to realize that she was extremely angry and depressed.

I think because I saw my mom like that, I wanted to get out of it. Maybe that was what drove me. I can't put my finger on it. But it was my grandfather who gave me love when I was growing up. He was the director of the whole forest area in Northeast India, which was the biggest tropical forest in India. Every time my mom couldn't handle me because she was teaching, she would just dump me with my grandparents, and my grandfather would take me everywhere. We would chase elephants, tigers, and rhinos. I spent my life in the forest, with my granddad. I was coming from a home where everybody said, "Study, study, work, work, work," and then I'd go to the forest where there was beauty everywhere. It was magical. So that gave me the balance I needed.

Other than what I got from my grandparents, there was no love in our family. There were no signs of affection. It was just, "Do this, do this, do this." There was no hugging, no kissing, no "Good job." Nothing. It was just all work, work, work. I think our whole family relationship was a bit nonexistent. We were all taken care of, but my mom always said, "No, just study." For example, when I wanted to read a book, she would say, "No, we don't have money; just do your work." When I wanted to drive, she said, "No, you'll bang the car." Everything was "No."

The only positive, lovely things in my life were my granddad and my friends. I had loads of friends, but I don't know how, because my parents never let me invite my friends over. They never once said to me, "Call your friend for a sleepover." I had to fight for it. I had to get great marks in school to be allowed to say, "I'm the first in my class, so please can I have my friends come over?" I had to prove that I was so good that even if they were really angry or upset or busy, they would have to say yes. It's that same thing as having to fight for what you want.

CARLEY: Now it's the complete opposite with your children.

USHA: Yes. My children are very smart. I teach them that when you have a gift, you have to use the intelligence you have. You can decide later whether you want to give it for free, whether you want to earn lots of money, or whether you want to work for humanity. But no matter what, cultivate that gift. It doesn't really matter what you do, but strive to perfect it. When you have something, you can't waste it.

CARLEY: It's part of the deepness of who you are.

USHA: When you have something, there's a reason you have it. It's not to throw away. That's the thing that shaped my personality, I think. I had lots of friends and I think that was because I enjoyed being out of the house because home was not fun.

CARLEY: What a difference now!

USHA: Yeah, what a difference. We did always live in beautiful homes, like colonial British bungalows, because my dad worked in a company that had a colonial history.

CARLEY: But you said there wasn't much love there.

USHA: No.

CARLEY: Beauty alone didn't make it a home, right? Because you can have the most beautiful home in the world, but if it's not filled with love, what is there?

USHA: Yes, and that is where my whole interest in design comes from. I would decorate to make things beautiful to replace the lack of affection.

I do appreciate two things my parents taught me. One was hard work. At times, I hated them for it, but I think it was something that really put me in a place where I like being. I don't regret having worked so hard. I really don't. The other thing they taught me was to play music. My mom forced me to learn music, and I hated her for it. I mean, she really forced me to practice music every day and take lessons. I'd cry and tell her I didn't want to do it, but she'd hit me. But now I think it's the best thing she did for me.

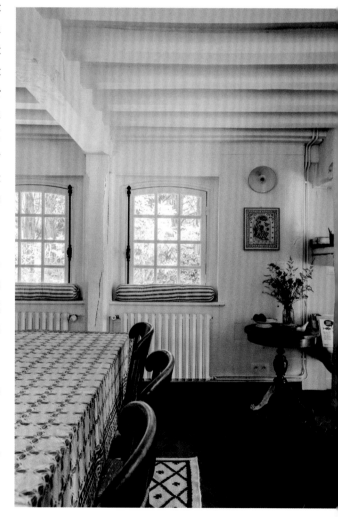

CARLEY: Something that sticks out in my memory when I first spent time with you years ago was when you played guitar and sang. It's interesting that something you dreaded is now something you love.

USHA: It's not the music I dreaded; it was the discipline. It was really hard.

CARLEY: And you, Claudio? What's your story?

CLAUDIO: I grew up with about two-thirds of my childhood in America and about one-third in Europe because my parents were professors, and they were in a bit of a unique situation that a lot of immigrants who come to the United States find themselves in. They came with the attitude "We're American now. Forget where we came from." This attitude was especially true of immigrants who came to America with the added burden of poverty. My parents went to the United States of their own volition to be professors, so their connections to their home countries of Italy and Germany were more equitable in a way. They struck the

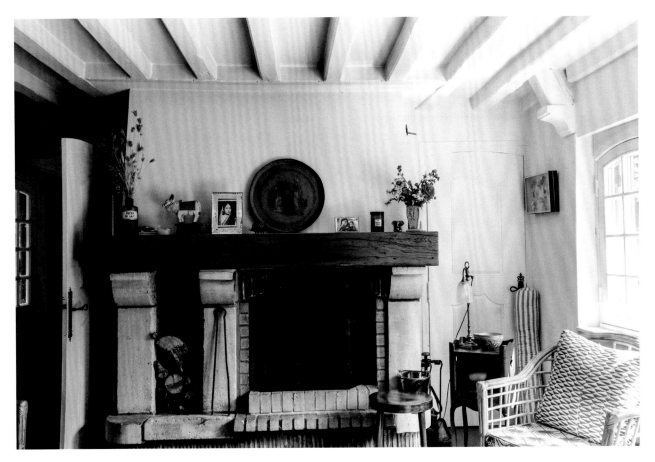

right balance between loving the things that let them have a good life in America, which was different from their life in Europe, while at the same time still being fiercely connected to their roots in Europe, both personally and professionally. This meant I was raised in an environment that was all about building bridges between these worlds. It was very, very important to my family. And that set the stage very early on in my life to want to go everywhere and travel.

CARLEY: How did you become an artist and photographer?

CLAUDIO: My dad's parents were both painters. In fact, a lot of paintings in our house are theirs. The painting in the room you're staying in, on the bathroom wall, is one of my grandmother's paintings.

CARLEY: Tell me about your first wife.

CLAUDIO: We were together for about twelve years. I met her in Los Angeles. She's Mexican American and comes from a huge family. She has about one hundred fifty first cousins. At one point, I had a funny conversation with one of her cousins, who is one of ten kids. I asked, "Are your parents really Catholic?" He said, "No, they just didn't have a TV." My ex was a community organizer, before Barack Obama made that profession famous. My divorce was certainly not something I had planned. I felt like a failure, and as with many of these situations, it felt like a mark on me that would tinge any future actions. And so I had to figure out how to get out from underneath that—not letting that shadow hang over me and not living in the wake of "Oh, I really messed up that situation, didn't I?" Which then led to "I don't deserve good situations."

If you had one pivotal point that changed the direction of your life, what would that be?

CLAUDIO: My dad's death when I was twenty. It was just simply time to grow up. It made me realize I had to be responsible for myself. I had to do certain things and I had to work very hard. It's that simple. And I was able to understand him a little better. He was a very joyful and generous person, but not necessarily very communicative on an emotional level. He was very shy that way. He had an obvious personality that people saw, but as a person—as a whole—he wasn't immediately obvious, and understanding who he was and why he was that way took some time. It meant taking what I had learned from him, and my mom of course, too, and putting that into practice. That accelerated the trajectory of my life. It was a moment of clarity.

USHA: The pivotal moment for me was when I went to business school. I came from a small town, and I was a good student, but I never thought that I was a great student. I went to a reasonably good school, a very good university, but I was always in the middle of the class; I was never at the bottom and never at the top. I was studying economics and I was playing a lot of music on the side. I was singing with a band. I loved my life. But I didn't know what to do after I finished college. Everybody said, "You're so smart. Apply to get into a business school." So I applied to lots of the top business schools in India, but I didn't get into a single

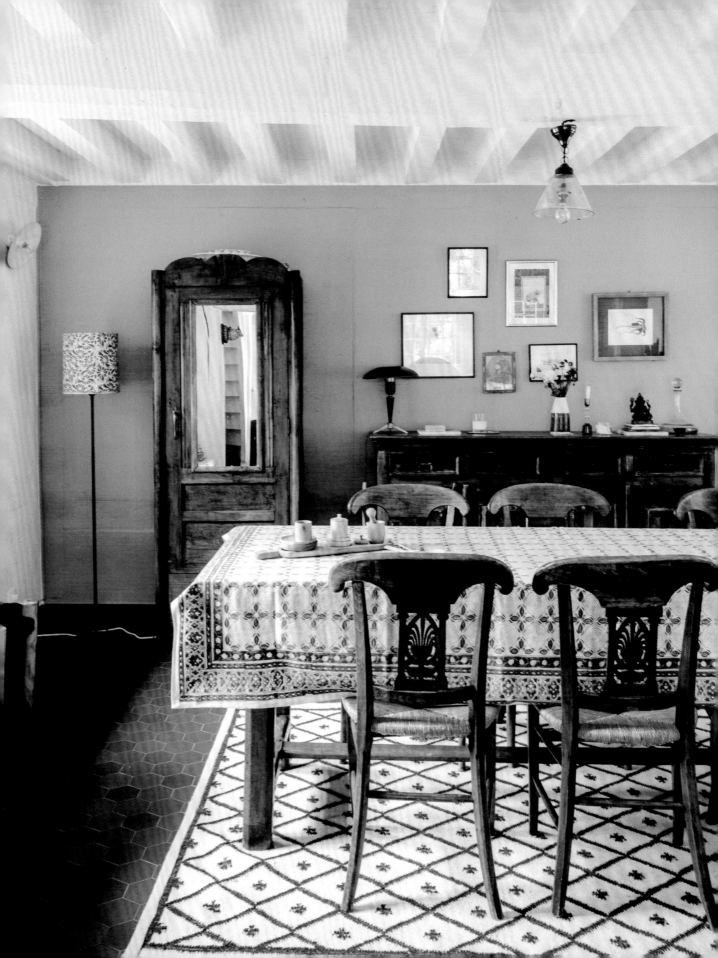

one. I failed miserably. Instead, I started working for a very small consulting company and was dating a guy I worked with. It was really exciting, and I was very happy. The guy I was going out with said to me one day, "You should apply again to business school."

I said, "Of course not. I'm never going to make it!"

He said, "No, just apply again, and this time, you'll know what the exam is going to be about, so you'll be better prepared."

At that time, I didn't want to work for other people, and I was already beginning to feel it, even though I enjoyed my job. So I thought, *Okay, just for the heck of it, I'll apply again and maybe this time I'll make it.* This time, I had the drive. I was still working, but I would wake up at four A.M. and study before going into work. I lived with my grandmother, who was very

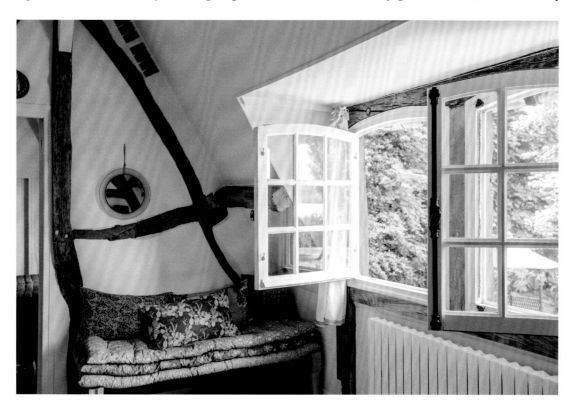

ill at the time, and she was nasty. She was depressed as well, just like my mom. I think living with my unhappy grandmother drove me to get out and seek a better life. I started applying to universities, and I started to get rejection letters. I got a no from everybody. And then the top school, the best one, sent me a letter at the very end. I thought, *Okay, I'm not going to make it; it's going to be a no just like all the other schools; I'll go back to my job.* But the school said yes! I couldn't believe it because that university took only one hundred and ten students out of twenty-six thousand. That was a pivotal moment in my life. It helped me gain faith in myself and made me realize I wasn't so bad.

Now when my children say to me, "It's not possible," I tell them that I don't believe that sentence exists. Everything is possible. If it's not exactly how you want it to be, you figure it out, you change, you adapt. Getting into that business school changed my life completely.

C A R L E Y : That confidence is with you still today.

U S H A : Just be who you are, but be driven, focused, and don't waver.

How are your trials and victories represented in your home?

C L A U D I O : It has taken me a long time to feel like I'm a fully functional, integrated member of society. I'm sort of floating in space somewhere in the Atlantic, somewhere between Europe and America. And when we started looking for a home to buy in Normandy, I thought, *How can I even qualify?* I had the shadow of a past foreclosure weighing on me. The idea of looking at a place was great, but I wouldn't have tried if Usha hadn't pushed us. And it worked. We became homeowners. For the first three years, I was thirty feet ahead of the expenses, working all the time. We barely made it, but I'm very, very, very grateful that we did. It's not something that I would've thought was possible, but Usha pushed us to say that it was possible.

C A R L E Y : That's beautiful.

U S H A : My trial is the fact that I didn't have a home in France after I got divorced. I was so used to a country home and having family and friends around, but after the divorce I didn't have that. It was a huge loss and I missed it. I loved having my family and friends together, making meals. You really can't do that in an apartment in Paris. I never had a warm home within my immediate family. But I was very close to my aunt and uncle, and we would have big family gatherings, with everyone together. They're not the most exciting or interesting people, but they're very generous. They live in London, and ever since I moved to Europe about twenty-five years ago, they would feed me and take me out. I remember when I got divorced, the first thing I did was call them and say, "Please, can my girls and I come stay with you?" I was missing my family and I just wanted to be in somebody's home. Which is why it's very important to me to build that for my family and for the people we love. I think my trial was not having that home and that comfort and that feeling of being looked after. This is why I feel that our home now is not just about Claudio and me, but it's about everyone who comes in here. I really want to make that feeling of home for my kids, their friends, their boyfriends, their cousins. Everyone who enters here should feel that our home is a safe space.

"When you have something, there's a reason you have it. It's not to throw away. That's the thing that shaped my personality."

CARLEY: Yeah. That's the victory.

USHA: I think people feel that. They tell us when they come here, "It's so nice. Thank you for making us feel so welcome."

CARLEY: Isn't it interesting that so many people in the world experience all these trials, but sometimes never realize how important it is to recognize that at the end of a trial, there's always some sort of victory?

USHA: Absolutely. And I think there is always a victory, though a lot of people don't recognize it. I mean, that's the problem, right, because there's always a victory, but they're focused on the trial.

CARLEY: Exactly, and the victory may look different for every trial. It's so interesting, and that's why I think I've been led to certain people specifically. I was led to this table where we're eating now, having met you on a whim that was divine; it wasn't coincidental, which makes me tear up. And the fact that in my spirit I knew somehow that you would be able to correlate your home and the trials that you've walked through in life to the victory you've created with your sacred space here is simply amazing.

USHA: I never had this from my family, but I saw it in my ex-husband's family. A home is really about passing on something safe and wonderful to others. We built it and put money into it, so it's also about trust for me. It's even about trusting my kids to handle our hard-earned money.

CARLEY: It's a legacy.

What does freedom *mean in the setting of your home?*

USHA: We trust our kids enough to use the space. That's not easy. In fact, a lot of parents say, "This is mine. I'm not going to give it to my kids." Or "My kids don't know how to deal with it." My mom never trusted me to do this or that because "it will break." She never trusted me to drive the car. But I saw the trust my in-laws had for their kids. I wanted that, too. "Use it, break it. It's just a glass, it doesn't matter." You know, it's a level of letting go. I think that's very important for me. A dish is not important. If my kids break a chair, it's not important. What *is* important is the trust that I'm giving to them and to say, "Okay, we trust you enough to know that you don't want to break it, but if it does, it's fine." It's about letting

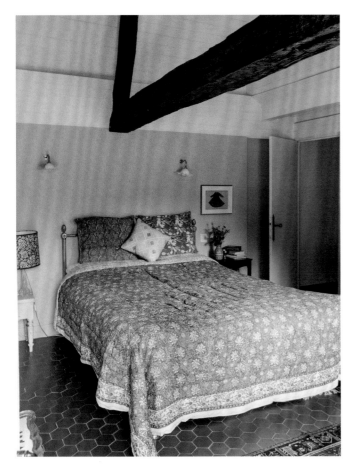

go. My parents never had that perspective. They never let me do what I wanted. Instead, it was always "Don't do that! Be careful!" I just wanted them to trust me, and to realize that I could handle it. I really want to break that cycle and not pass on to my kids the mentality that my parents had with me.

CARLEY: There's freedom here.

USHA: Yeah!

CLAUDIO: Freedom is very much in concrete terms here in this space, in this town, which is very different from Paris. Paris is about density and density of in-

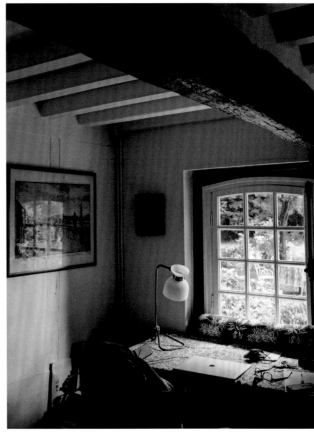

teractions, which is what makes the city great, but that can also make it trying.

There is also freedom of time here. Sometimes we come to Normandy from Paris just for twenty-four hours. And, though it's not laborious, we have to open and close all of the shutters, making sure we're closing up the house securely. And yet I've never come up here once and then gone through that whole ritual—opening up the house and then closing it down twenty-four hours later—and thought, *That's too much work for twenty-four hours.*

USHA: Freedom here is acceptance. This is Normandy, and there are red-blooded, hard-core

right-wing people in this part of the country. When I go running, I see people watch me because I look different. My mindset is: be who you are; everybody accepts you. Even here in the middle of Normandy, I think that's a big deal.

CARLEY: Yeah. I think it's a big deal, especially now.

USHA: Yes, especially now, absolutely. For me, this house really allows me the freedom to be who I am, who I want to be, and who I am in the world.

Where is your sacred space in your home, the place you find the most peace?

CLAUDIO: I think the two sacred spaces for me would be our bed, because of the way that room is built; it's such an interesting space. The other is the fireplace. I'm no fan of the winter because of how dark it gets. Maybe that's why the last thing I do in the winter each time before leaving the house is to clean up the fireplace and set it

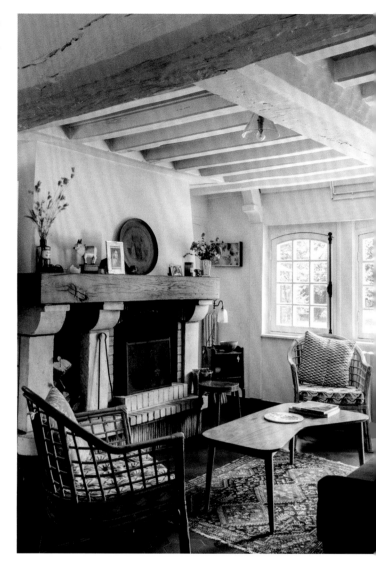

up for the next time, with everything from the paper to the cardboard to the kindling to the firewood, so that when we come back, we can come in, plunk down, and light it. And it starts up like a jet engine. We sit there, close to the fire when it's getting dark out. It can be windy or cold, but there's just something about the fireplace, about being there, that's so peaceful. That's probably the one place in the house where I actually pause and let myself rest.

USHA: My sacred space is the living room, for a couple of reasons. First, the sun comes in there in the morning, so I'll sit in there, in the quiet, and drink my morning coffee. That's my little "me time," my space. Second, it's a place that holds a lot of influences: Indian furniture, French furniture, my kids' photographs, Claudio's pictures, and even a friend's octopus draw-

ing. There are always cut flowers in a vase on the table, and it smells so good. It's whole, filled with everything that matters: friends, family, beautiful textiles—everything is in there. I can look at a different corner of the room and I'm instantly transported to a different part of the world.

CARLEY: I feel that.

USHA: I remember when we bought that lamp in Belgium, and it's sitting right there. There are just a lot of different memories, feelings, experiences in this space.

CLAUDIO: Funny story about that lamp. We bought it in Brussels in January, and we had left the GPS in the car and parked it in a garage. When we got back to the car, we noticed a bunch of broken glass on the ground, and quickly realized the driver's window was broken because someone had stolen the freaking GPS. We had to drive back from Brussels to Paris, four hours at night in the middle of January with cold wind and a broken window. We even stopped at a gas station and bought some extra gloves and hats. Every time I look at that little lamp, I think of that story.

What does your personal meditation or quiet time in your home look like? How do you get away from the worries of the world?

USHA: I have three things that I do. One is my meditation time when I'm drinking coffee alone early in the morning. That's really my time when I think about different things that need to be done or different issues that I'm facing, and I calm myself down without having interference from calls or human beings talking or traffic. The second thing I do is run by myself. It's really the time when I'm most creative. It's the time when I challenge myself. My running time is my thinking time. It's more than meditation; it's active thinking. The third thing I do is play music, which is when I'm really in touch with myself. It's a moment when I'm the happiest.

CLAUDIO: Running and walking is what I do. Sometimes I might go for a run in the morning and in the afternoon, especially in the rich afternoon light. Or I'll go for a walk down the road. It's just simply about appreciating the sky. And maybe I'll slip in a phone call to someone I haven't talked to in a while. There's something about the general process of connecting to the earth, of stepping off the sidewalks and the concrete, and being on actual earth. Making a big meal for friends is also a very important thing for me. In a way it's sort of like the fireplace. Learning to be on time as a chef, getting everything ready, and making everybody

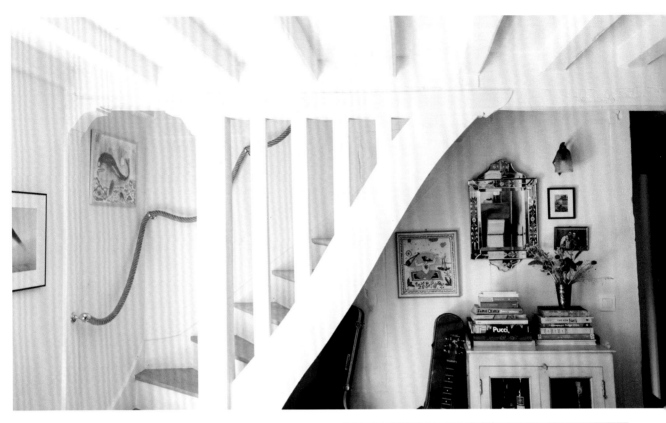

happy and sharing time with people is something wonderful for me.

CARLEY: So sweet. You mentioned the way you prepare the fire, there's a step-by-step process that feels almost ritualistic.

CLAUDIO: Yeah, it's very ritualized. Nothing beats the sensation of that jet engine sound when the fire really goes off.

CARLEY: You perform a ritual so that you can sit and enjoy it. Like your morning coffee, Usha.

USHA: Yeah, sometimes even if I have to push myself to do it, I pour myself coffee. Even if I don't finish it, I still sit there. I still go through the

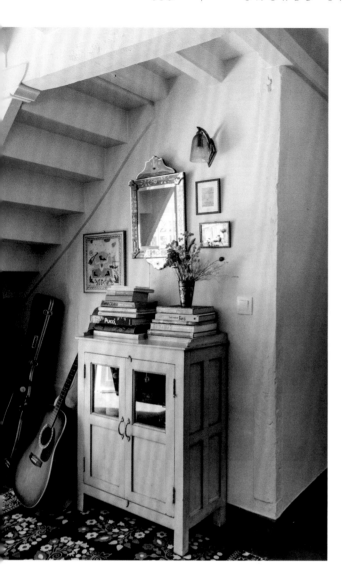

"There are always cut flowers in a vase on the table, and it smells so good. It's whole, filled with everything that matters: friends, family, beautiful textiles— everything is in there."

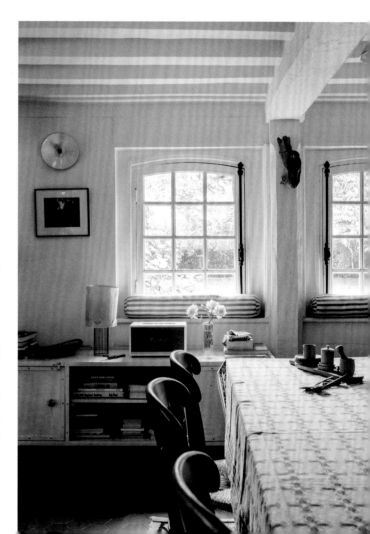

steps of taking the time. Sometimes it's three hours or three minutes.

CLAUDIO: There's a whole ritual to coming up here that matters. The first step is opening the garage and pulling the car out. And then there are all these markers on the journey, escaping the traffic points of Paris, the different roads, getting off the main road

onto the country roads, past the last traffic light. And then coming here and then opening up all the shutters.

CARLEY: I love that ritual of opening the shutters. You've mentioned that a few times.

CLAUDIO: Yeah, it opens up the house. And before we leave, I set the fireplace. I make sure the dishwasher is empty and all the dishes are put away, so that when we walk in, the house is ready and open for a new time.

If there is one part of your story that you think would set another free, what is it?

USHA: I learned to not be afraid—to take risks and have faith in myself. That's what I tell everyone. I tell my family all the time, "You want something? Then ask for it." In French, there's a phrase I heard at my office that really shocked me. When my coworker couldn't get an answer through email, I said, "Pick up the phone and call them." In response, she said, "*Je n'ose pas,*" which means "I don't dare." It was the first time I'd heard the phrase and it really freaked me out because I couldn't grasp the concept. The French use this phrase all the time because they're so concerned about the right moment, about not wanting to offend. It's a concept of being afraid that doesn't exist to me. I'm not scared because I feel that if it's not meant to be, it's not meant to be, and that's it, so move on. This is something I've gone through in my life. So now the girls in my office will call one out of two times if they don't get an answer through email. They're learning this same lesson, too.

CARLEY: Yeah, I'm a caller. I want to make it happen. But you know what? Because you had that type of reaction, you also helped those people learn not to be afraid. It's a chain reaction.

USHA: If it's not meant to happen, it won't happen, but don't let that stop you from living life the way you want to live. And of course, maybe seventy-five percent of things are not meant to happen, but so what? Does that mean that for the rest of your life, you're going to live inside a tunnel and be afraid?

CARLEY: That rings true for me, and especially with this book, because I'm not a writer. I was diagnosed with severe learning disabilities at a young age—with hearing comprehension, reading comprehension, and writing comprehension. I was the kid who was almost taken out of the class for special education because I struggled so much in school. If I could go back

now and tell my teachers that I'm writing a book, they would fall out of their chairs. I took a chance with the fear of rejection. But if I hadn't believed in myself and taken the risk, then it wouldn't have been possible. I really relate to what you're saying: it's worth striving for.

CLAUDIO: The things I'm the proudest of are the things I've dared myself to do and dreamt of doing. After college I worked on a cattle ranch in Colorado for a year and a half. I was a full-on cowboy. At the second place I worked, we had to hand-feed the animals with pitchforks. There was not much automation. That was the real deal. No one made me do it. I dared myself to do it; I figured out a way to do it. The more often one can do that for oneself, the happier one is, which I think is important. I wouldn't necessarily want to use my example, but it's the encouragement I would want to give people: things are worth trying for.

It's also one of the ideas that's very important for us to transmit to the kids: things that are worth having require some degree of striving, and that striving is difficult, wonderful, necessary, and important to do.

CARLEY: You had a failed relationship, yet you weren't afraid. I'm sure in the moment you were thinking, *This is a huge risk to go after another person,* but you didn't allow your circumstances to dictate your future or allow yourselves to think, *I'm not going to go after something just because of my past failures.* Instead, you thought, *I'm going to go after something I want. I'm not going to be afraid.* And because of that, look at what you've created together.

CLAUDIO: The thing about striving is that you have to dream for what is not necessarily there yet. Appreciate what you have, but also be hungry for that thing that isn't there yet and make it happen.

Emmanuel Carrère

D'autres vies
que la mienne

P.O.L

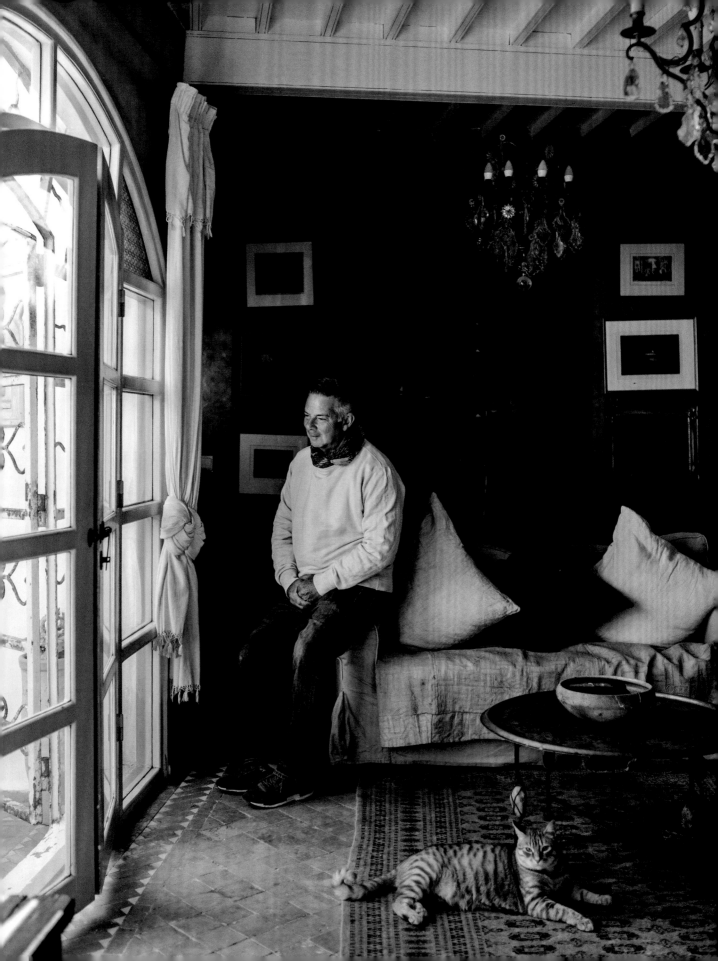

MARK BROKENSHIRE

OUR TIME WITH MARK BROKENSHIRE WAS NOTHING SHORT OF A MIRAcle. Mark's home is situated in the eighteenth-century medina of Essaouira, a sleepy and windy seaside town in Morocco. The foundation of Mark's traditional four-story Moroccan *riad* is as old as the town and is meticulously maintained, in keeping with the building's historic roots. We first met Mark in 2018 on a trip to Arles, France, and from the moment I saw his home and got to know him, I knew there was something so deeply special about him. Mark is originally from northern England, and he studied to become a monk early in his life. Even though he left the monastery, Mark's Catholic faith is still very present, not only in his home, which is tastefully designed with crucifixes, but also in his heart. Mark is a true historian and retired teacher. Shortly after moving to Morocco, Mark opened his home to guests on Airbnb and finds joy in sharing his magical space with others. After many canceled flights due to the pandemic, it seemed we would never reach Mark's steps, but we knew that leaving his story and home out of this book wasn't an option. When we finally arrived at his doorstep a few years later, a sense of relief came over me, knowing that fighting to share his home and story was worth all the effort. Mark's seaside home is peaceful, enchanting, and has almost a holy feeling about it. Mark is humble, creative, and truly one of the most amazing people I have ever met. As he shared his life with my husband and me, tears streamed down my face. His story is full of trials and pain, but in the end, it's also full of

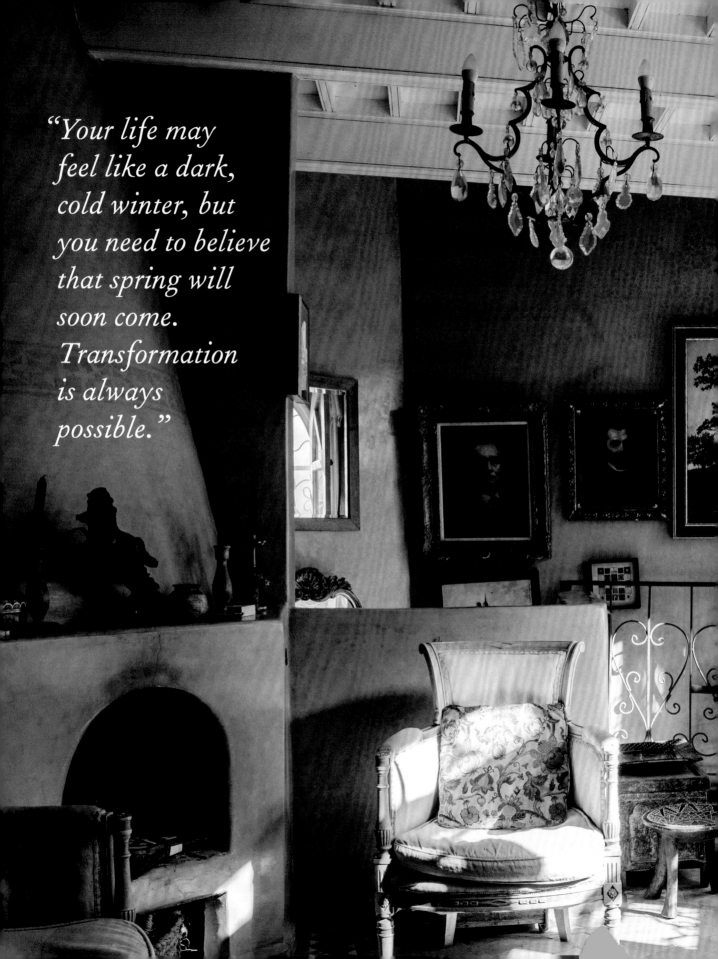

"Your life may feel like a dark, cold winter, but you need to believe that spring will soon come. Transformation is always possible."

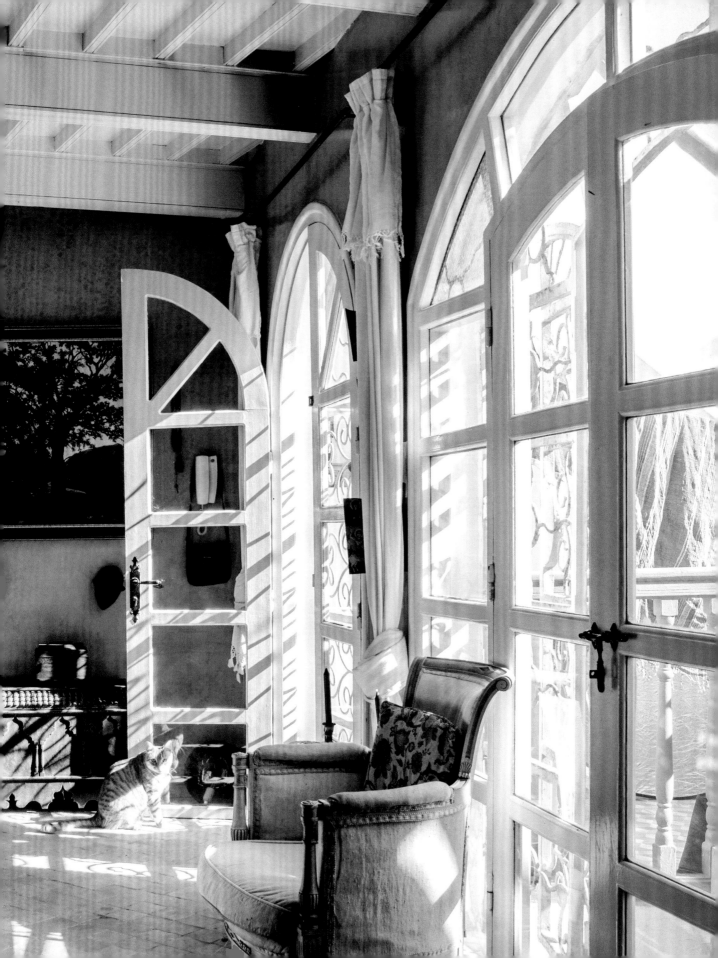

redemption. I hope his words and home bring something special to your eyes and heart. For me, it was a sacred time I will never forget.

Your story . . . Go!

MARK: The name Brokenshire originated in Cornwall. My father's great-grandparents lived in a small town called Redruth. They probably moved north to Manchester as the industrial revolution was drawing people from farming the land in the nineteenth century. My mother's family, the Blears, came from Newcastle in the northeast of England. My parents grew up in Salford, which was a poor district with small houses, "two up, two down," a marker of the industrial revolution on the west side of Manchester. I was born in the north of England on September 19, 1957, the first of three sons. When I was a child, people would ask my name and I would say, "Mark," but they wanted to know my surname. I would resist because invariably they could never pronounce it correctly.

My parents married in the Church of England, but neither was a committed Christian. But like many parents, they thought it a good idea if their children attended the local church. So in due course, I was baptized in the local parish of St. Mary Magdalene in Winton.

I wasn't particularly happy growing up in the family. I preferred being outside than being in the house. I think from the beginning there was a great bond between myself and my mother. As the family grew, I gravitated naturally toward my mum and my brothers gravitated toward my dad. They were his golden boys; I was not. In those days, working-class families took the view that if a child was naughty, then a good hitting would not do any harm. I was a naughty child, taking risks, not conforming, and trying to push boundaries, so I got a fair dose of that. I was often frightened, rejected, and alone. The house was comfortable, but not beautiful. My parents had enough money to raise a family, but they did not have money to buy works of art. They were thrifty, fair, and committed to doing their best.

Some people look back on childhood as an idyllic world filled with laughter and familial comfort; that was not my experience. On reflection, I don't blame my parents. I was the first child and I think it's like being the prototype. If things go wrong with the first, you can modify your actions with the future children.

During one of my adventures out of the house, I came across an old lady who lived in the same terrace of houses as my family, just three doors down. I don't know how we first connected. She may have been working on her garden, and I, being inquisitive, went to ask questions. Her name was Gertrude Saunders Bates, and she was in her seventies. Her father had been a builder and had built a number of streets in the local area. She had married a journalist who worked for Reuters. During the Second World War he had been assigned to work in

China. After the war, they both returned to England and managed to inherit the properties her father had built.

Meeting Mrs. Bates opened up the first of what I call "special doors," in which I was able to experience a new way of seeing. Her home was like stepping into another world, overflowing with profound beauty. The house was filled with Chinese works of art, porcelain statues of the Buddha, Tibetan rugs, bronze incense burners, tea sets with swirling dragon motifs in solid silver, and cloisonné bowls on small tables. Books, paintings, copies of *National Geographic* magazine were everywhere. In suitcases were traditional Chinese wedding garments of silk, kimonos in wonderful silk, and marble statues of Chinese lions. After that first visit, Mrs. Bates took great delight in bringing me to visit art galleries and museums and on day trips to other towns, all without my parents ever knowing. If I had ever told my parents about my Saturday routine, I suspect it would have been brought to a swift conclusion.

Mrs. Bates had a great and positive influence on me. She opened my eyes to other worlds, visions of beauty encapsulated in works of art. As time went by, the tables turned, and I was able to help her. I guided her as she grew old and feeble. I would make her bed, prepare her meals, clean the house, help in intimate ways, and wash her hair. She had been generous to me, and now it was my chance to return the favor. She was a primary influence on me for good.

It was on one of my Saturday visits to see Mrs. Bates that I happened to cycle past the local church of St. Mary Magdalene. I decided to go in. I don't know exactly how it happened, but I struck up a friendship with the vicar, David Hinge. In retrospect, he was one of the most influential people in my life. I was a teenager and I suppose David represented the good father for whom I was searching. David was married and had a young family. In time, he became my confidant, confessor, friend, and guide. Originally, he had moved from London to take on the parish of Winton. Previous to ordination he had been an architect. He introduced me to the world of architecture, a love of history, a love for buildings, art, Victorian architecture, Arts and Crafts, early-twentieth-century architecture, and books. I don't think he ever realized the influence he had on me, but today it still endures.

I confided in him about my sexuality and it was accepted.

He showed me how to restore furniture and over three summers I cleaned and brought back to life three Stations of the Cross that were from around the seventeenth century and of Flemish origin. They still hang in the church today. It was at that time that I developed a romantic attachment to the monastic ideal and the idea of building up the waste places that had crumbled in the aftermath of the dissolution of the monasteries.

It was the time I developed an attachment to "high" church practices. David described himself as a "Tractarian," Anglican but high church. After a few years, he accepted a post near Durham, which was a big blow to me. He later became a canon of Durham Cathedral.

Sometimes I would cycle down the lanes to visit medieval churches. I would marvel at the beauty of carved monuments, painted and gilded timber, and breathe in the ancient atmosphere as if it were a drug. It was at that time I realized that the Church of England attracted many gay followers. By now I knew I was gay. I loved the beauty of the worship, but a part of me questioned it because it had a seam running through it that suggested more theater than

substance. It was like playing at being a Roman Catholic, while being fundamentally Protestant. For me, it seemed like a game. It was simply not genuine. Trying to make sense of this tension was all the more difficult because woven into the very fabric of high Anglicanism was this gay thread. Trying to reconcile the desire to be religious and at the same time feel and recognize my personal desires was at times a torment. The threads of guilt and remorse, coupled with the sense of being different and fearing rejection, did not make for a happy adolescence. Who we are and who we become is something so baffling. I had an image in my head of a large ball of wool that at some point had gotten knotted. If I could unravel the ball and undo the knot, then all would be well. I would become straight.

In time I would reflect on my life and recognize that being gay was not a choice, but a given. I had no choice in the matter. What was important was that I use it in a good and positive way.

At the age of sixteen, I left school. It was the happiest school day of my life, as I ran home through the fields in the full knowledge that I would never have to return. I managed to get a place in a sixth form called Eccles College. It was there that I met my first contemporary gay friends: Geoffrey Bridges, Denis Shaw, and Carl Baybut. At that time, society was not kind to gay people. Maybe people thought it was contagious and would mark them. The age of consent was twenty-one, and many gay people lived in fear that their private lives would be revealed, or they would be blackmailed.

The worst thing was the negative view taken by society that was often absorbed by gay people to further enhance their feelings of isolation and their sense of being the outsider. Those three friends were victims of this, and all, at different times, took their own lives.

At age seventeen, I was a regular in Manchester gay bars. I met a man at one point whom I knew through friends. He was a teacher and after a few meetings, he invited me to spend the weekend with him in his cottage on the moors north of Manchester. I told my parents I was going to spend it with a girlfriend from college.

The cottage was accessed by a steep dirt track. From the back windows at night, the lights over the hills sparkled like stars. On Sunday morning after breakfast, the telephone rang. Frank answered it and after a moment said, "It's your dad." I spoke to my dad, who said, "When you come home today, we need to have a chat." I knew this "chat" was the big one, because I never chatted with my dad.

I arrived back home on Sunday evening. My mum was sitting in a chair, relaxed and knitting, and my dad was sitting on the sofa watching TV. As I entered the sitting room, his head swiveled toward me. He then barked out, "Who is this Frank you're knocking about with?" Tired of being careful with the truth, I said, "Frank is my boyfriend. I am what you call a homosexual." My dad, surprisingly, looked shocked. He then asked my mum if she knew anything about this. My mum continued to knit and simply said, "I've known for a long time." My dad said I should sit down and talk about it. He then went through my friends, asking if they were queer. When he came to Denis, he said that he didn't need to ask; it was obvious.

The following morning, he came into my bedroom and said my news was a shock to him and my mum. My response was that he often called me queer, so I assumed that was what he was implying. He asked how strong the feelings were and I responded by saying they were very strong, and I was not going to visit any doctor. He then said he and my mum needed time to come to terms with it.

After leaving school, I went to work for Bowes & Bowes, a book chain. Eventually, in 1979, I got promoted and went to work in Bath. This proved to be another major turning point in my life. It was a very different world, a wealthy part of the country, full of Georgian architecture and surrounded by wonderful countryside, villages, and beauty. I had recently made the acquaintance of a university student called Robert Byrne. He had arranged to visit one of his old school friends, called Harry Hicks, who was a monk of Prinknash Abbey in Gloucestershire, doing studies at Downside Abbey in Somerset.

Moving to a new town, having new experiences, forging new friendships, and developing new survival skills all take time, and I was open to new beginnings. I was looking to find a place of worship, but not sure if I wanted to remain in the Church of England. I was introduced to Harry and at the same time to Downside Abbey. Through Harry, I had an introduction to members of the community. Downside Abbey followed *The Rule of Saint Benedict,*

and the monastery was part of the EBC, the English Benedictine Community. It was regarded by some as the premier monastery in England. It was grand, sophisticated, intellectual, beautiful, superior, and snobbish. The abbey was built in the style of Gothic Revival by some of the most famous nineteenth-century architects of the day. It was unapologetic and it proclaimed Catholicism and monasticism were back to shape society.

As it happened, a large number of the monks had been converts from Anglicanism, and in an earlier period it was not unusual for boys in the school to join the monastery. For my part, I was young, impressionable, and searching. I did not fit the mold of a typical Downside monk. For a start, I was a working-class kid from the back streets of Manchester, gay and uneducated. Someone once described me as the "token peasant."

The abbot was Dom John Roberts. He was the "good" father, and I had an immense love for him. He was a holy man, grounded, honest, and realistic. Many monks found him taciturn and difficult to engage with, but for some reason there was no silence between us when we had our regular meetings. He was protective of me, and I think that fueled jealousy and resentment toward me. I had always been honest with him, and he admitted to not understanding the gay dimension.

Downside was the real thing; it was not fake and, to all intents and purposes, it looked like any other Anglican cathedral church. Worship was simple, but it was Roman Catholic, and for me that seemed a path to follow. It was decided that I would go for instruction each week to one of the monks with a view to being received into the Church. The date set was February 21, 1981. I was received into the Church in the Lady Chapel at Downside. In the following months, I visited a number of monasteries with a view to joining one of them. Eventually it was decided I would test my vocation at Downside. The following year, I entered the novitiate and took the name Dom Edmund Brokenshire. I could not use my name, Mark, because one of the monks was already called Mark (Dom Mark Pontifex).

I was often questioned by friends as to why I had chosen the monastic life as a gay man. Some people think the two—being a monk and gay—are incompatible. But I did not want to waste my life constantly searching for the man who did not exist. For me, monastic life, teaching, and priesthood presented the perfect way forward: chaste, committed, and honest. To many people, it is a life beyond reason. In a conversation about being gay with a previous abbot, one of the monks was told that it was like being a bird "with a broken wing." For me, there was nothing broken or deficient, there was no abnormality, only the need to acknowledge the fact that I was gay. As one monk once said to me, "Facts are friendly." The greatest danger to a successful life as a gay and celibate person was being dishonest. Secrets have a way of turning things bad, corrupting what was essentially good into a negative stream, infecting every aspect of life.

I once remember praying inside the abbey church with my eyes focused on the ceiling and

the intersecting arches. My first thought was that it was like being in a huge womb and hopefully one day it would give birth to someone shaped, molded, and healed by monastic living. Downside did bring about a new birth for me; its generosity meant I had the skills to leave the community and be successful.

In the summer of 1982, walking along the avenue lined with old lime trees, I was talking with Dom Sebastian Moore, a monk of Downside. He said there was a great scandal about to break in the American church, which would bankrupt it. I asked the reason and he said, "Pedophilia." It was the first time I had heard the word, and I found it hard to believe. Years later, it would emerge at Downside and bring the edifice crashing to the ground. That revelation later aided in my departure from the monastery.

After initial studies within the monastery, it was decided I should go to Oxford and study for my BA in theology.

In October 1985, I went to live at St. Benet's Hall and live my monastic life in term time there. At the end of the term, I was to return to Downside. Oxford was not an easy place to be. Many of the students regarded themselves as God's gift to the world. It was a privileged world; many of the undergraduates came from private schools with parents who were supportive and well educated. They were informed and had an eagerness to reap the benefits of

Oxford life. Being a monk and an undergraduate at the same time was not easy. The degree was challenging, and part of the course demanded coming to grips with New Testament Greek.

Those three years at Oxford were the unhappiest years of my life. I was like a fish out of water. Fortunately, I had good friends with the monks of Belmont Abbey who were studying at St. Benet's.

It occurred to me that I could arrange to find a psychotherapist and resolve some of my inner conflicts. I returned to Downside and talked to the abbot. He listened carefully, and it was agreed that I could see a psychotherapist each week. It was arranged that I should see a Dominican priest called Piers Linley. That was the beginning of a psychotherapeutic dimension to my life, which continued off and on with various therapists for years. In the initial sessions, I remember lying on a couch, filled with so much anger and frustration that I could not speak. The only thought running through my brain was that the monastery was paying for this and all I could do was remain mute with rage. Slowly things began to change, but I always had a profound sense of not being worthy, of not being good enough.

When I eventually left Downside, it was not my disillusionment with the monastic life, but rather that sense of being unworthy. Priesthood was fundamentally about walking in freedom—to be happy in who I was and being equipped to create a life that was whole, holy, and creative. I dreaded the idea that I might become a stumbling block along the way to other people if I stayed.

After Oxford, I returned to live at Downside and did a small amount of teaching in the school; studies for ordination were ongoing and it was suggested that I should be ordained as a deacon. But I declined because I had now started on the road of psychotherapy and I did not know what the end result would be, so to be ordained while on this journey did not seem the way forward. I do believe that the Holy Spirit led me into the monastic life as I also believe that same Holy Spirit led me out of it. Eventually, I decided that monastic life was not for me. It was not an easy decision and it was one that caused me immense guilt. I had reneged on my monastic vows. For the next ten years, I had frequent nightmares about the monastery. It was only on the death of my abbot, John Roberts, that I decided to return and attend his funeral, though I didn't know how I would be received. As it happened, I was warmly welcomed. Talking with my contemporaries that day felt like I had never left. For me, returning was like lancing a boil. After that, I returned each year to spend time there.

A few months after the funeral I found myself living with my best friend, Aidan, in Walthamstow. Within a year we bought a flat in Dalston, in northeast London. It was small, but we created a lovely home. I decided to become a teacher and, with my academic background, decided to train to teach religious education. I was offered a place at the Institute of Education, University of London.

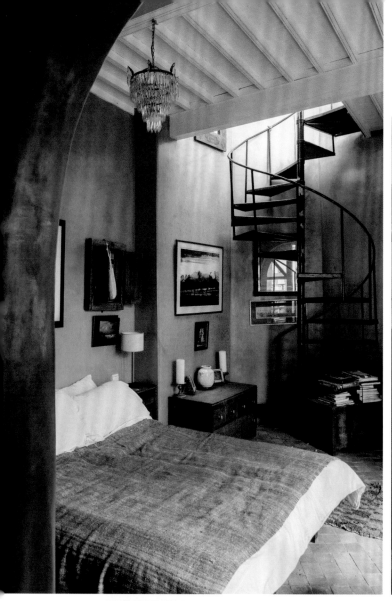

When I retired from teaching in Hackney, I decided to sell my London home and move to France, where Aidan was already living, to a sleepy village called Roquemaure. I later moved to Arles, a beautiful town originally founded by Julius Caesar. After three years, I decided to sell and move to Morocco, where I finally settled in Essaouira, which is known as the "Windy City" because it is situated on the Atlantic Ocean. The town is a UNESCO World Heritage Site and has a population of about sixty-five thousand. It has a vibrant artistic community and boasts sunshine most days. I found a *riad*, which had been restored by a German woman, in the medina. She had lived in it for twenty years before finally selling it to me. Now Riad El Rahala welcomes guests and offers people a quiet haven where they can find refreshment and inspiration.

If you had one pivotal point that changed the direction of your life,
what would that be?

MARK: It was a traumatic incident that happened in Oxford, where I was able to turn an event not advantageous to me around and embark on the psychotherapeutic process. I was full of so much anger, and I think psychotherapy was a very good thing. I learned to live with myself and come to terms with who I am. I didn't have a very good relationship with my dad as a child. It was diabolical. He was violent. If I was naughty, if I did silly things, I'd get a good thrashing. My father wouldn't think twice about it. And I think my mum was scared of him, so she wouldn't intervene. I think there was a lot of damage there. And I sometimes think I made choices simply to annoy him. I wonder if I chose to become a Catholic or a monk because I knew it would piss him off. Through psychotherapy, I was able to come to terms with what my dad had done and what I had experienced, and I learned to forgive him. I don't know when it happened, but I just woke up one morning, and there wasn't any anger there anymore.

When my mom died, I was still living in Arles, so I wrote to my dad. I said, "I just want to thank you for what you did for my mum."

When I went back to England for the funeral, I was sitting down with my dad and I said, "Did you get the letter?"

"I got the letter," he said. "It was a wonderful letter. It should be displayed and put in a church." And then he said, "You know, I've condemned myself many times over the years for how I've treated you, and I'm very sorry."

I said, "Well, I forgive you anyway." I know it was the psychotherapy that helped me to forgive him because I didn't want to mention all of the terrible things he had done to me, and stick the knife in. I have a wonderful relationship with my dad now, and I phone him every week. I think he was probably happy when I left the monastery, and he's probably happy that I became a teacher.

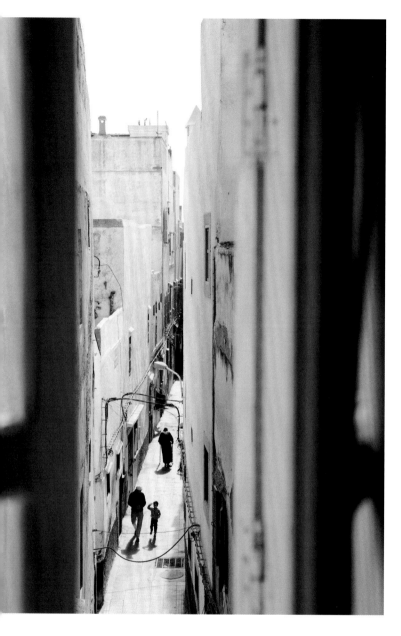

"This sitting room is one of my favorite spaces, right here. I don't have a particular space because the whole house feels like I can sit anywhere and be at peace."

CARLEY: Total redemption of a relationship.

MARK: Yes, it was a complete turnaround. I could never tell him about the psychotherapy because it would make him feel guilty, and I don't want to do him any harm.

CARLEY: I love that you've come to a place in your life where you're sixty-four and he's ninety-one, and there's total restoration of something that was broken. It's a very hopeful story for other people.

How are your trials and victories represented in your home?

MARK: I suppose growing up in a home that I didn't feel happy in was pretty grim. I always wanted to be out, and I would only come back inside to eat. If I sat at the table and

made a noise, my dad would hit me or close my mouth. If he got angry, he'd go upstairs and play his guitar, and there'd be tension in the house all the time. He was very moody, and if he wasn't moody, then he only needed some slight incident to spark off and he'd hit me or kick me. He didn't want me to go to church, but I would go anyway, because church was a safe place for me.

My trial was not having a safe home growing up. And the victory is now having a home and creating a space I love. This house is a safe haven; it's like a lighthouse. I also like to see it as a place where people can come if they are in difficulty, and I can try to help them. Like Mosen, who was washing the pots this morning. He slept in my bed last night while I slept in the blue room because he's having problems with his family and his parents kicked him out. But I have to be careful because if the neighbors see him coming into my house, they're not thinking, *Oh, that kind European.* They will think negative things, which does worry me. And

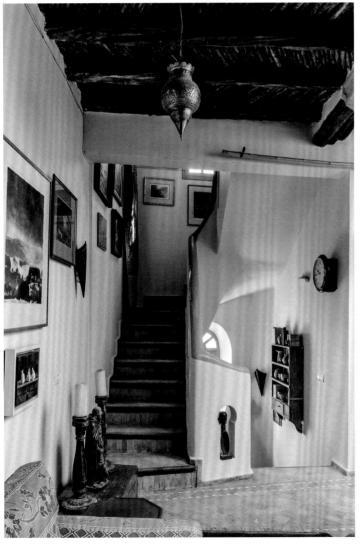
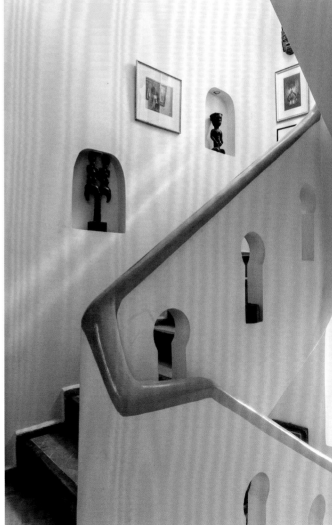

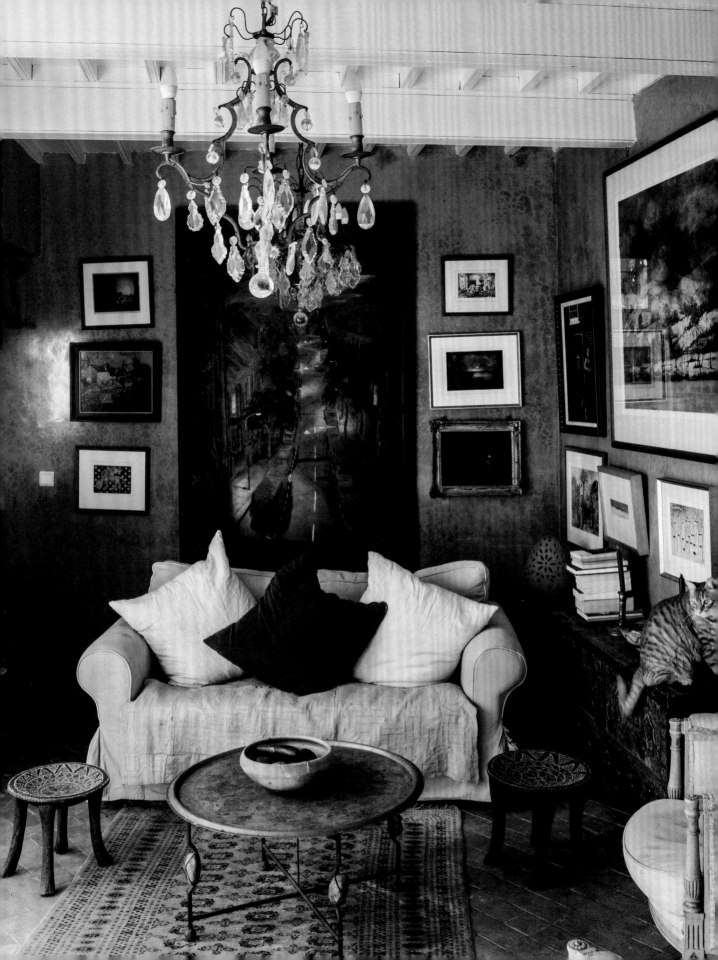

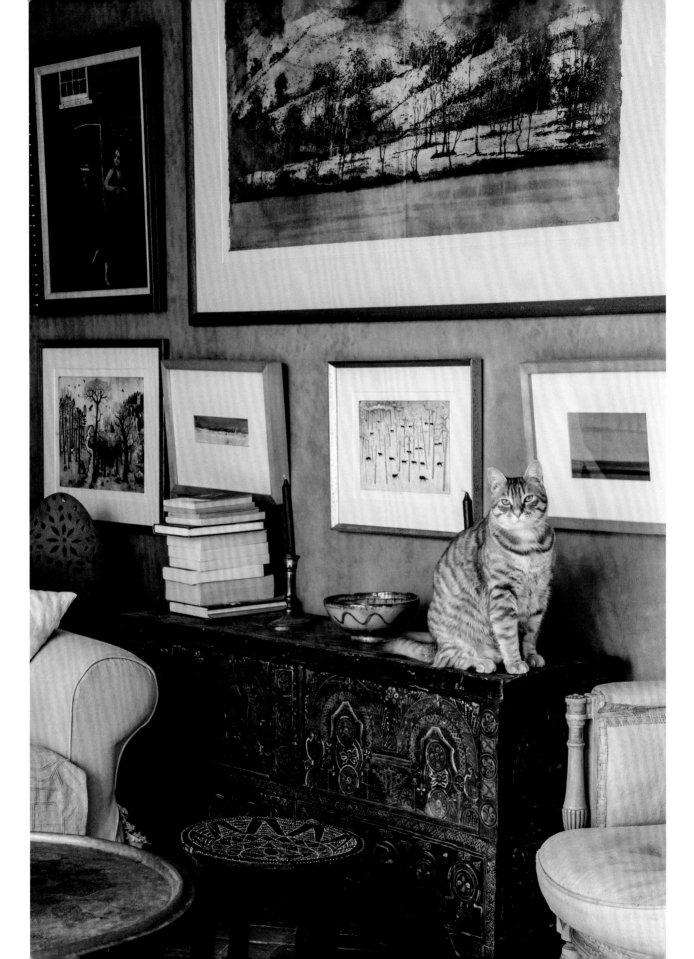

when the boys are working here, I sometimes like to stand outside when they do the cleaning, so the neighbors know I'm not in the house with them. I try to help the boys and give them some money because they've done some good work.

CARLEY: It really is beautiful, creating a safe haven for other people. You like caring for other people.

MARK: It's always been part of my being, to care for and protect people if I can.

What does freedom *mean in the setting of your home?*

MARK: Well, I'm the one who determines how the house looks. One of the first prints I ever bought was called *The Magic of the West Indies*. And I remember my dad saying, "Why did you buy that? He can't even paint a clock properly." When I left Manchester, he took it off the

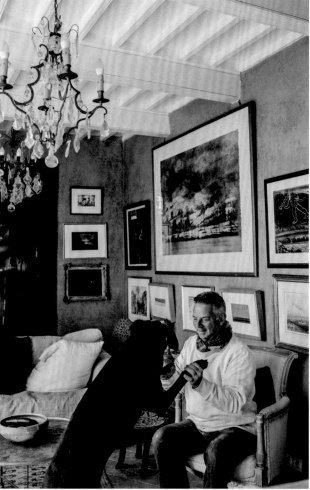

wall and hid it behind the cupboard. When I went back, I asked where the print was and he said, "Oh, it's behind the cupboard, which is where it belongs." He was always very critical about art or pictures or furniture. He'd always pooh-pooh it. Whereas now, if something catches my eye and it's beautiful, then I'll buy it and put it in the house and hope that when people come here, they see the beauty in it and maybe it will give them a little inspiration.

CARLEY: It does for me. And now you not only have the freedom to decorate, but nothing is hidden behind a cupboard; it's in plain sight. It's the freedom to be exactly who you are.

MARK: It's to be honest, isn't it? When I became a monk, I told the abbot straightaway that I was gay. I wasn't going to be a practicing gay man in the monastery, obviously, but it's such a big part of my life. You have to be honest with yourself and with other people, because if you're not honest, then your life will take a dark turn. I think it's important to live a life of integrity—be honest with yourself, be honest with other people, and don't tell lies.

Where is your sacred space in your home, the place you find the most peace?

MARK: This sitting room is one of my favorite spaces, right here. I don't have a particular space because the whole house feels like I can sit anywhere and be at peace. I like to think this house is very quiet, and if you come from outside or you've been in the medina when it's hectic and noisy, you can come in here, close the door, and find peace. I want it to feel like you've walked into a sanctuary. And it's there for other people to enjoy as well.

What does your personal meditation or quiet time in your home look like?
How do you get away from the worries of the world?

MARK: Normally, in the morning, the first thing I do is walk the dog. Then I like to sit on the beach and watch the waves. I find that relaxing and also spiritual, seeing creation in action. Then when I come back, I like to read some verses or the chapters in the Gospels, and work through the Gospels each day, one chapter at a time, then reflect on it. I especially like the story of the woman caught in adultery in John 8. I've always found that story inspiring, realizing that it's very easy to point out the faults of other people, but you need to look at yourself first. If you haven't got the guts to look at yourself, then stop pointing the finger at other people.

If there is one part of your story that you think would set another free,
what is it?

MARK: Believe that, no matter what you go through, transformation is possible. You might have the worst experience, but you've got to trust that it can be changed. You can't change the drama, or what happened in the past, but you can believe that from that bad experience something good can come. It doesn't have to continue to be negative. Your life may feel like a dark, cold winter, but you need to believe that spring will soon come. Transformation is always possible.

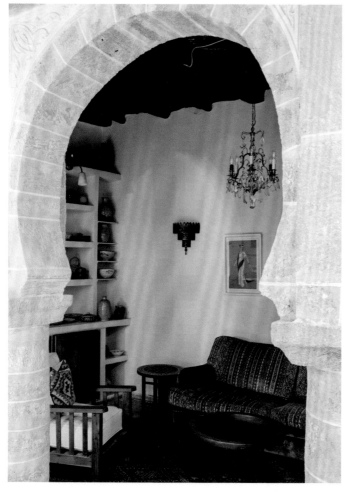

"Trying to reconcile the desire to be religious and at the same time feel and recognize my personal desires was at times a torment."

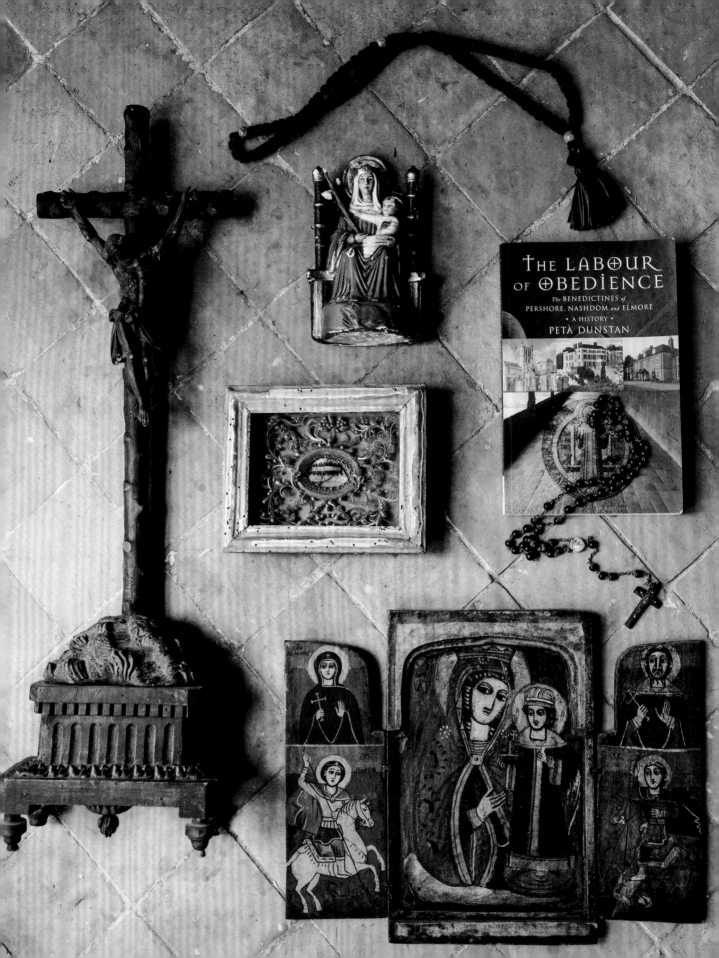

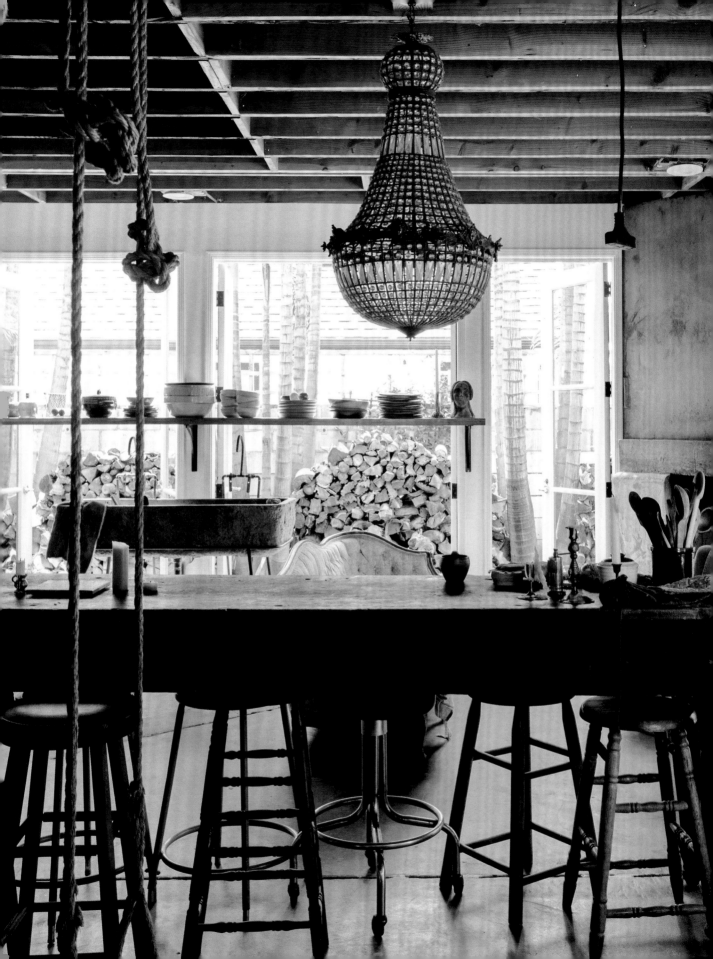

THE SERVANT'S HOME

STORIES FROM

BETSY GINN AND KAREN EMILE,

WHO USE THEIR HOMES AS A VESSEL,

DEDICATING THEIR LIVES TO GIVE AND

TO SERVE THOSE AROUND THEM.

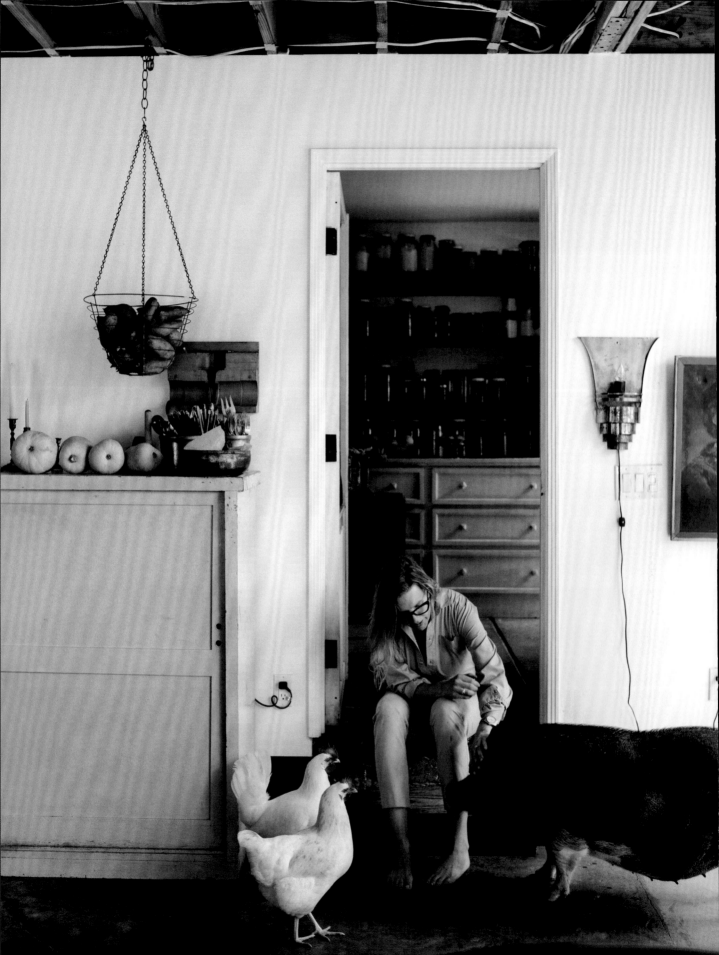

BETSY GINN

BETSY GINN HAS BUILT A FORTRESS AND SAFE HAVEN FOR HER FAMILY IN Encinitas, California, that has not only healed them, but has created a new way of living. Betsy started her career in the pharmaceutical industry, and later followed her passion of interior design, building a successful business. After her youngest child, Paxton, was diagnosed with a severe form of asthma, Betsy dedicated her life to healing her son with gut-healthy foods. Betsy and her husband, Stewart, intentionally designed their home around the kitchen as they implemented the GAPS diet, which requires extensive planning and preparation. Cooking three meals each day from scratch, Betsy sacrifices daily for her family and lays down her own ambition and life to constantly serve them. She inspired me with her heart, her design, and her cooking. I left with the fullest heart and belly! Her home is like nothing I have ever seen before, and honestly it was hard to leave. My time with her and her family made me feel like I was always welcome at her table and her home. I have never been served quite like I was at Betsy's. I left feeling like I had gained a sister and friend for life. I hope you see the incredible spirit and heart behind these photos and her story, as I did.

Your story . . . Go!

BETSY: I grew up in South Carolina. We have a big family and I had eleven cousins. Many of our weekends were spent at my grandparents' house. It's my favorite of my childhood

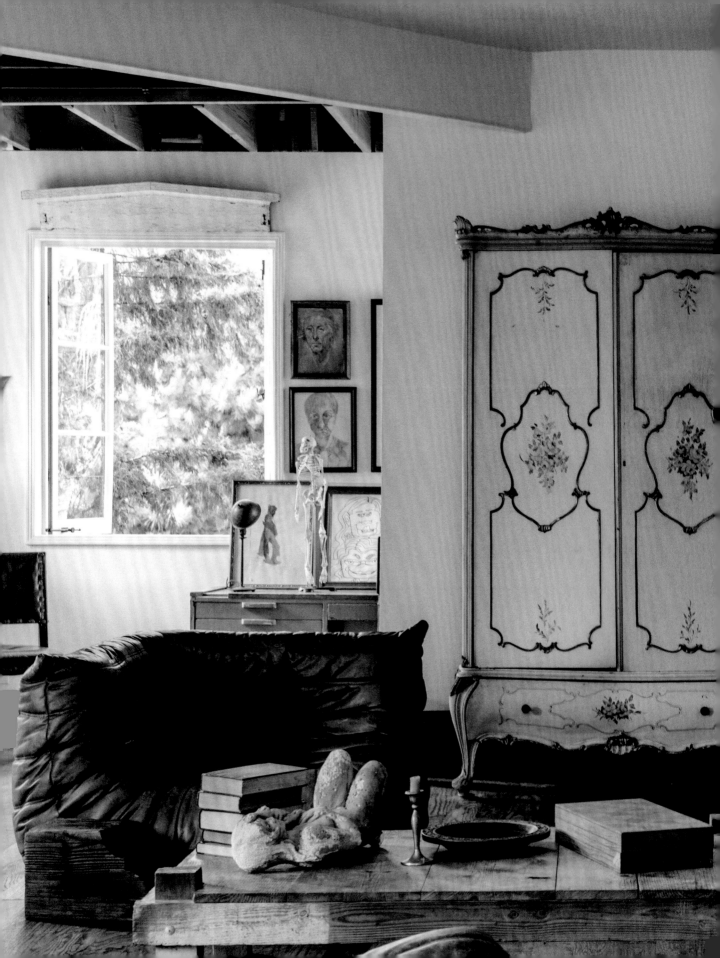

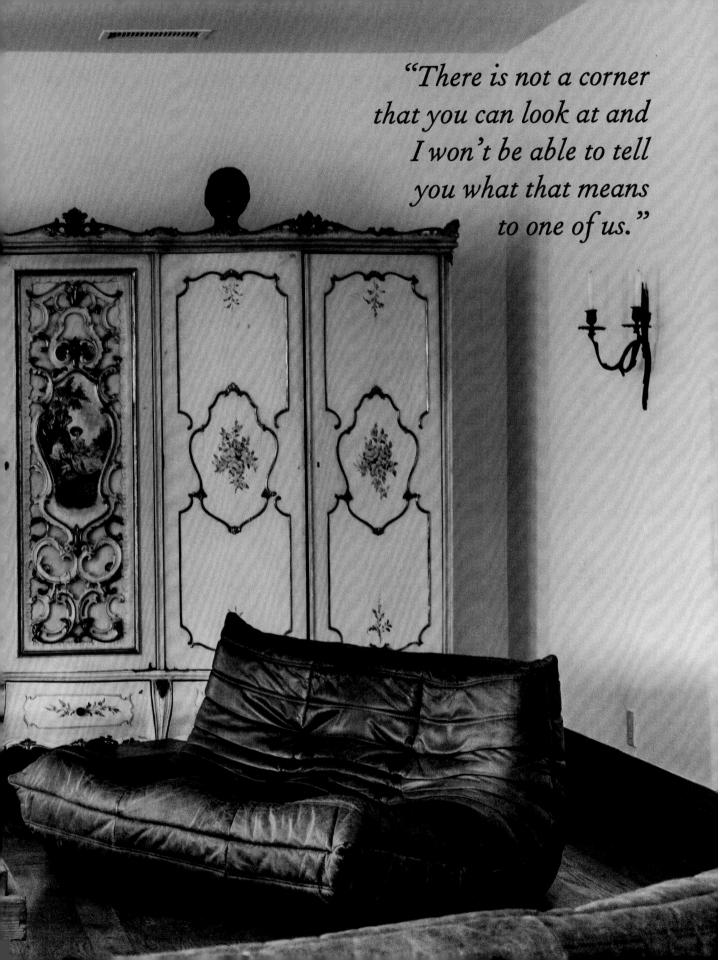

"There is not a corner that you can look at and I won't be able to tell you what that means to one of us."

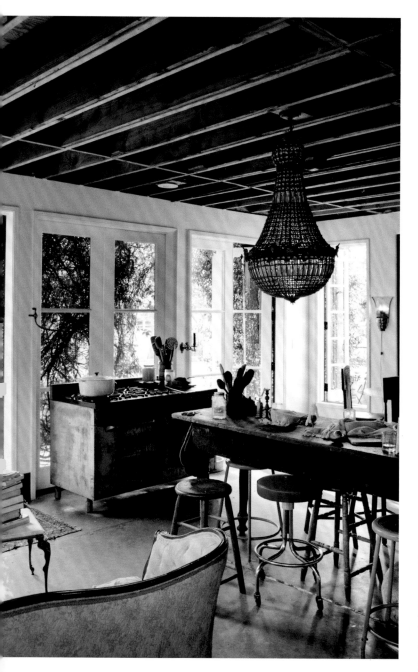

memories. It's not that it was a perfectly magical childhood by any means, but it certainly felt that way when all of us kids were together, playing in the ditch at Grandma and Granddad's. We went outside in the morning and didn't come back inside until a meal was being served. We got dirty from head to toe and didn't have a care in the world. We were all able to be kids and have fun. I can still close my eyes and see the fig tree we climbed and the ditch we thought was massive. I can hear the cooking in my grandmother's kitchen and all the different sounds: Granddad snoring, kids laughing, dishes clanging. Their house was sacred to me as a kid. It was comfortable and felt like home.

Although I loved my childhood in the South, I saw myself as different, unique, pushing the envelope a little—maybe not your typical Southern belle. The older I got, the more I wanted to break away from Southern culture, not appreciating its value. My family and my upbringing were wonderful, yet I still felt I needed more. I felt there were many closed minds living in South Carolina. There was a perceived way you should look and act, and I didn't want to conform to that. I wanted to express my own uniqueness. I craved more art, culture, freedom of expression, and the vibrant streets of New York City. I wanted to be in the creative world in some way, but that had not come to fruition yet. I just wanted to get to New York and figure everything else out after.

It wasn't until much later that I was able to fully appreciate my childhood, the beauty of

Southern culture, and the foundation it gave me. I ended up craving everything I had as a child and more for my own kids.

I was also raised Christian. It was a big part of my family's life. No matter how tired we were or what we had on our plates, we went to church every Sunday. I'm very grateful for that foundation now, even though it felt very ritualized at the time. It is what brought me back when I went calling for help at a time when things felt very dark in my life.

CARLEY: I remember you telling me that you wandered.

BETSY: Yes. I knew God existed, but I didn't have a relationship with Him. I didn't have an appreciation for what that even meant. I didn't think about God. He felt very far away and was on the back burner of my life. It wasn't until later that I found him again and realized he can and will connect with you where you are.

I was itching to break away as soon as I graduated from college. I was dating Stewart, my husband, at the time, and he was supportive and excited about moving to New York. We lived there for about seven years and loved it. We had all these amazing experiences, living with sophisticated, creative people all around us. I was exposed to culture from all over the

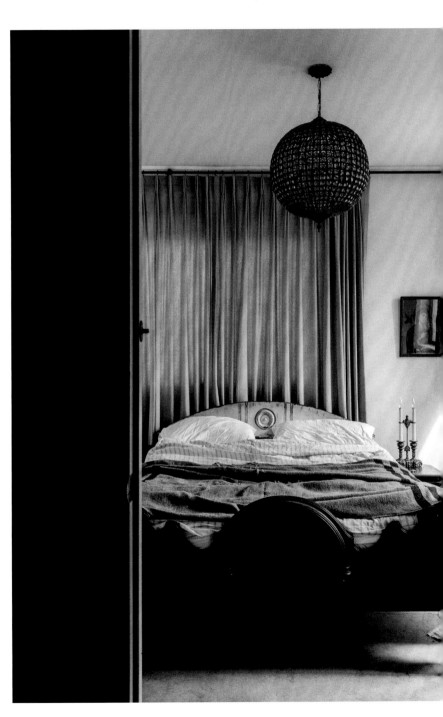

world, which was fascinating. I was influenced by that vibe of keeping things fresh and experimental. I just had fun with it and made a lot of mistakes. I didn't end up working in design while in New York. I worked for a pharmaceutical company and was a drug salesman.

We moved to Encinitas, California, in 2004 because I took a promotion with my company, planning to stay for only a couple of years. When we bought this house, we had plans to flip it in those two years. We brought more of a New York City loft style with us to California. Our kitchen was upstairs and the bedrooms were downstairs. Keeping the house layout made sense, as we had not planned to have kids and wanted to get back to New York quickly. I was on the corporate track and wanted to be a CEO of a major company one day.

It took a little while to come around to staying in California. Actually, it took having kids to start looking in a different direction. And then I did a one-eighty with my life when my son, Paxton, became really sick. I went from working in the pharmaceutical industry pushing drugs, to starting an interior design company (my original love), which in hindsight was a necessary step as a transition to taking this journey of [holistic] healing.

Paxton got really, really sick. He was diagnosed with severe asthma. When he caught the common cold, he would turn on a dime, his oxygen levels would go into the seventies. We would race to the hospital, which was not a onetime occurrence. It was the darkest time of our life because he was in and out of the hospital so often. In fact, he had the second-worst case of pneumonia at Rady Children's Hospital.

Coming from this pharmaceutical background (I am not antipharmaceutical), I believe medicine is there for a reason. In fact, it saved my son a number of times. But I believe medicine is best reserved for when you have no other option.

Paxton was prescribed nine different medications when we were discharged the last time from the hospital. He had gotten so sick that any type of environment trigger—like dust, mold, pollen, or dog hair—would send him back. The doctors told us that we had to keep an air purifier in every room, he couldn't have stuffed animals, couldn't keep clothes in his closet. We needed to keep his room door closed, and to change his sheets every day. We had to keep all our doors and windows to the house closed and check the pollen count before he went outside. We had dogs at that time, and they told us that we should consider getting rid of them. We were devastated. I just wanted to give Paxton the most normal life that he could have, and it was really hard to achieve. He couldn't run because he couldn't breathe. He couldn't play because he couldn't keep up. We were in a vicious cycle. I sat there that night with all the medications around me on the bed and prayed, "God, if you exist, please help me figure this out, because he can't live like this." We were going to have a bubble boy, and I couldn't do that, because he couldn't be a kid like that.

Then my friend, with divine intervention and timing, told me about ancestral cuisine and about a protocol called GAPS. She wanted me to take a course on it. It sounded like a cooking

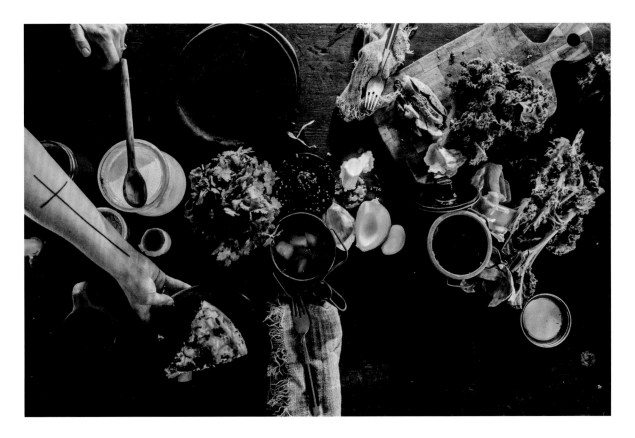

class. I cannot even tell you how frustrating it was to be hearing about another thing I should try when I was at my wit's end. We were eating organic at the time and were on the gluten-free trend. I felt like we were doing everything we could.

In New York, we went out to brunch all the time, which was part of the fun of living in a city, so I was not a good cook! We were still living like that here, in Encinitas, with our children. As I learned about the GAPS protocol and way of eating, I quickly realized I would have to start cooking everything from scratch, which is how we got to where we are now, with the design and layout of our kitchen. The turning point for me was realizing how much time I would need to spend cooking. I was literally going to be living in my kitchen, because I was cooking stocks, bone broths every day, braising, fermenting my own vegetables, culturing our dairy, making our own ketchup, mustard, et cetera.

CARLEY: I've seen it.

BETSY: You've been eating our food! Everything's from scratch. We don't just run out and buy packaged foods, and when we're tired, we don't go out to eat. We'll splurge occasionally now, since we've been on the protocol for six years.

C A R L E Y : You said something to me in an earlier conversation that the friend who called you kept bugging you about this class and you said, "I'm not going. Stop bothering me." So what clicked?

B E T S Y : Well, she got sort of aggressive with me and basically told me that I didn't have a choice, saying, "Just take the class!" And she said that, after the first day, if I didn't feel moved or pushed in that direction, then she wouldn't ever speak to me about it again. She just wanted me to get there. And then I got there. And I cried the entire time in that class, because it all made so much sense to me.

C A R L E Y : Then you started following the GAPS protocol. What did you notice in your son after you started cooking and preparing food this way?

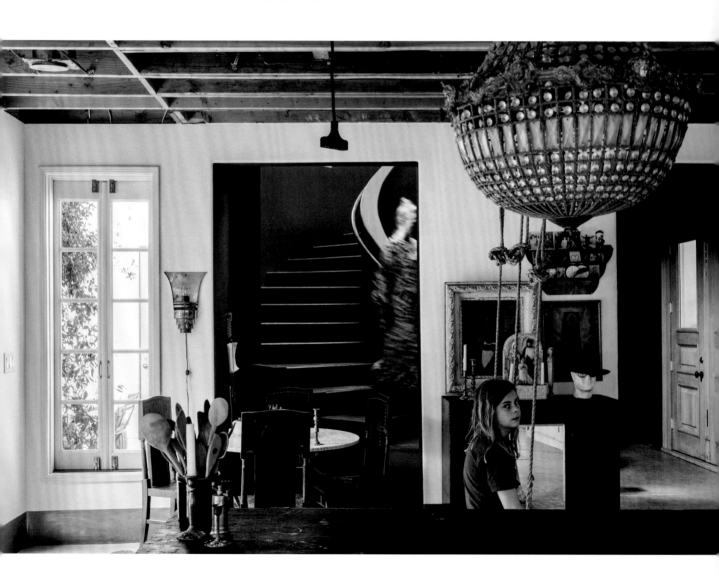

BETSY: Immediate healing. Paxton was allergic to all dairy, eggs, and every single kind of nut. We carried an EpiPen with us everywhere. Doctors were not able to get his asthma con-

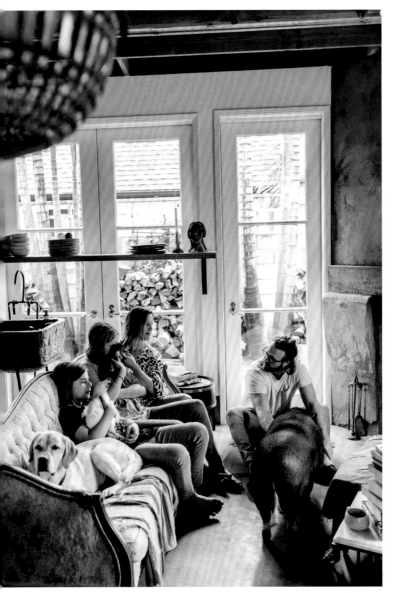

trolled with as many medicines as they had him on. We had been on a process-of-elimination diet for a while to figure out his food sensitivities and triggers. We were running out of things to feed him. Through the class, I learned it was the sourcing and preparation of the food that was creating the problem and that very few things I was feeding him were nutrient-dense. His body wasn't able to use what we were giving him. What was crazy was that I hadn't even started the protocol at that point. I just went back to that foundation of ancestral cuisine, the way people used to prepare food. I started giving him raw milk and bone broth. Within twelve days, he stopped wheezing. We hadn't even started the more stringent protocol! That's when I knew everything was going to have to change.

CARLEY: You knew at that point that convenience was out the window.

BETSY: There's nothing convenient about this. I don't feel restricted in my life though. Rather, I feel it is wide open and I am free to eat so many good foods. I was more restrictive of myself before, eating ancestral cuisine because I was watching calories and concerned with eating fat. But what I learned from this journey is that we need good fats. As long as you're sourcing the food well and it's nutrient-dense fat, your body will fuel and thrive. So now I feel freer from that standpoint, because I lived a lot of years where I eliminated ice cream, steak, and any whole food that I thought was too fatty. I was thinking I was doing the right thing for my body and my children. From a standpoint of convenience, it

[the GAPS protocol] is restrictive, because you can't just whip up a meal, but I'm getting better at being more efficient. There's absolutely nothing convenient about it.

CARLEY: How did what you and Paxton went through impact your husband, Stewart, and your daughter, Charlie?

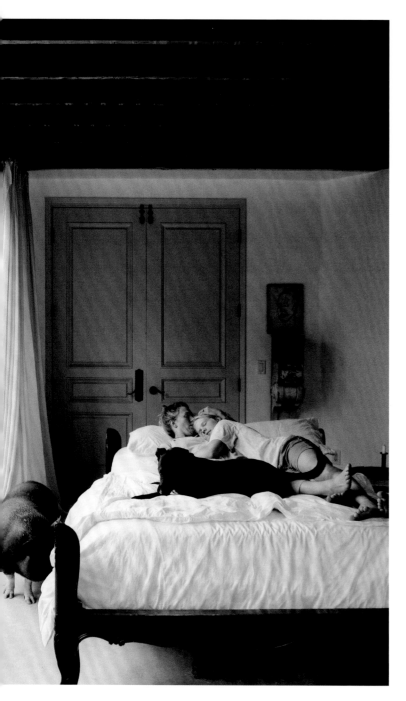

BETSY: It was pretty cool actually and showed me how open a kid's heart and mind can be and how willing my husband was to change everything. A lot more attention was on Paxton because he was so sick. It would be another change we wanted to make for Paxton. We all decided to take this journey as a family because we didn't think it was achievable or fair to say that Paxton had one type of meal and then we all would eat something different, or if we all went out and splurged, and Paxton didn't get to, none of that felt right to me. I remember Charlie saying, "If Pax is going to do it, I'm going to do it with him."

CARLEY: Charlie has a sweet selflessness.

BETSY: Yes, she does, and she loves him. There was no hesitation for her, ever.

CARLEY: It's so amazing to see Paxton now and the miracle that he is.

BETSY: Yeah, he's solid!

CARLEY: I see him run up and down the stairs, and he has the most energy over anybody in this house. Before, he could barely run. It's such a miracle.

BETSY: Right, and within less than six months of eating this way, he was on the running team at school. That was pretty epic, watching him run those laps with a smile on his face.

This whole experience of healing him with food made me realize the time investment I would be spending in my kitchen, and that's really when I thought, *Okay, now more than ever, my house, the way we live, now what's around me is going to really matter.* I've always wanted my designs to be pretty, fun, and tough. But now everything that I've done in my house is connected to our way of life, our way of eating, our faith, our family, and each individual is fully represented in this house. There is not a corner that you can look at and I won't be able to tell you what that means to one of us.

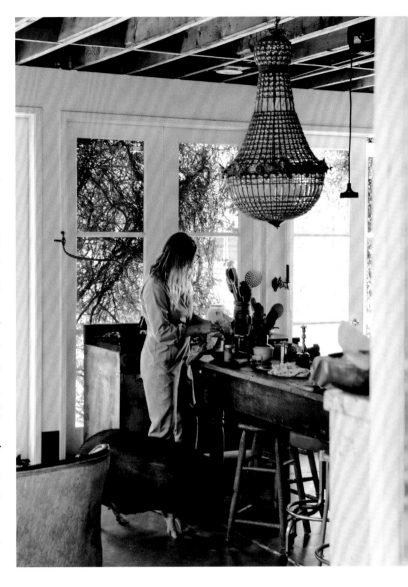

If you had one pivotal point that changed the direction of your life, what would that be?

BETSY: Realizing that the only way to change the direction we were going in Paxton's health and life would be to use the earth the way it was meant to be used and the way God created it. I literally live in this kitchen. I finish breakfast, then I start thinking about lunch, and then I finish lunch and I start thinking about prepping for dinner. I didn't want this to be something that I had to do. I wanted it to be a way of life, a choice to serve my child, to serve my family. I wanted to love it, because it's a lot, it's a lot every day.

If I didn't have this light in my kitchen, and all of these things, the swing where my kids want to swing, the little table where they like to work, the couch where I sit and have my time, it would be harder. My husband naps on this couch and sits and talks with me while I cook. I love having him here and comfortable in this kitchen where we can sit for hours—it's everything to me.

I wanted this to be a place of light, not just for us, but for everyone who comes here. I have doors and windows as my walls. I wanted to be able to see my kids playing outside, to see the animals easily and to feel the sunshine. The beautiful irony of this story is that they told me I couldn't do any of this, and here we are defeating the odds. Praise God.

CARLEY: You're beating the medical prognosis.

BETSY: Yes, yes! We are here and we are living our life to the fullest. I didn't want to look at this as if I was chained to a stove or to a kitchen. I wanted to be open and accepting and invite all of this in, and I think the only way we could have done it is to create a space like this because we're all happy here.

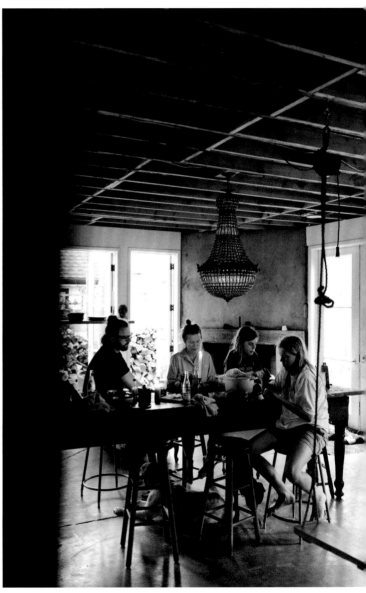

How are your trials and victories represented in your home?

BETSY: My biggest trial is the sourcing, cooking, and feeding my family, because of the fact that food is not a convenience. The way we eat could be a point of contention for us because we can't just go over to someone's house for dinner. The victory is that my kids love the way we eat and feel good eating our food. And

what's even crazier is that their friends love the way we eat. I thought before that a group of thirteen-year-olds could care less about food made from scratch, and would prefer a bag of Doritos. They literally have sat here and said, "I love the way you cook everything from scratch. It's so cool, and I wish we did that." They ask, "Why does your food taste better than everywhere else?" It's incredible that the way we eat has had an impact on other lives.

The other victory is that because of the way our home is, people's minds become open just from walking in and they want to learn more about what we eat and what we're doing. Instead of being critical, they find it incredible. I used to shut down when it first came up in conversation because it's a lot to explain to people and I assumed they wouldn't appreciate our way of living.

CARLEY: Were you living in this house when your son's health started to fail?

BETSY: Yes. It is amazing because this house used to be a place of darkness and oversterilization. Our son was being isolated, and was prescribed the life of a bubble boy. He couldn't sit on the couch, because of the dog hair or whatever might irritate him, and he couldn't live in this house without somebody saying something or being concerned for him or him being concerned for himself for any imminent environmental trigger. We were asked to change our life in a way that would be so restrictive. He wasn't able to be a kid, and so it's beyond a victory

"Food is healing, and God gave us everything we need already."

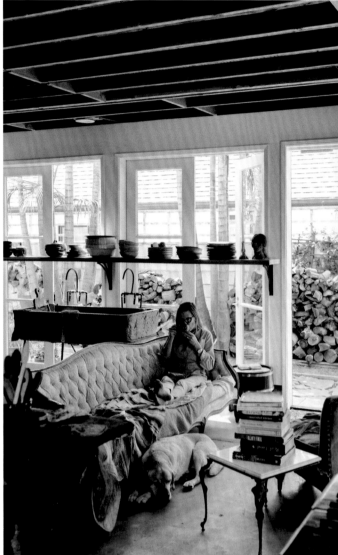

for us. We open all of our doors. We don't have air filters in every room. We have three dogs, two chickens, twenty-five ducks, and a potbellied pig. Paxton helps clean the farm pens and we never check pollen count before we leave. I would have never imagined that we would be here six years ago. He can live and be a kid. That's a huge blessing and victory!

What does freedom *mean in the setting of your home?*

BETSY: It's a number of things. Freedom means that my kids are able to be kids. They are free to skateboard and ride their scooters through the house. They can swing in our kitchen and have a rock band upstairs. Their friends love spending time here.

I wanted our animals to be an intricate part of our family. My kids are experiencing beautiful connections with our animals, and also learning the responsibility of their care. We are able to invite all of these beautiful creatures to be a part of the daily routine. Sometimes our ducks parade right through the house. The chickens love following the kids around; they come in to hang out with the family in the kitchen, and the pig sleeps inside most of the time, waiting for scraps to fall from the table.

I designed our home so no one feels like they need to be cautious. My pieces have all been worn out long before they were placed here. I buy pieces that I'm in love with, of course. Those pieces have character and a story, but they are also pieces that can be used. I want friends and family to be themselves and enjoy time here. I do love a certain level of glamour, but I also think that there needs to be a balance and it has to be able to take a beating. I think I've done pretty well. I feel happy in my home. My husband is happy here. The animals are happy, and all the kids are happy when they are here. To me, all of this is freedom.

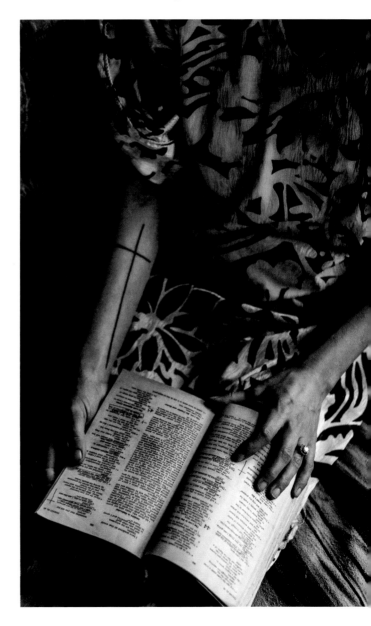

A good example are my baseboards. They're brass because my kids can ram their skateboards into them and the pig can rub her rear end or her nose on them and I can still look at something beautiful and not feel like they need wiping down every five minutes. The best part is that brass continues to get more beautiful with age.

Where is your sacred space in your home, the place you find the most peace?

BETSY: For me, this couch, this kitchen, this is my sacred space. I'm really proud of this space because it used to be a very dark room, both physically and emotionally, so when we had this idea of turning things around in our life, we wanted to bring a lot of light into this room and make it a place where we all felt safe and where we all wanted to be.

CARLEY: This room has been redeemed.

BETSY: Yes. And this couch is where I pray every morning. This is how I take on the day and how I continue to be of service to my family and live my life with gratitude, be a good friend, and appreciate myself. I just pile here on the couch with my dogs while the pig is lying on the rug. Sometimes the chickens come in, and it's almost like they're all joining with me in prayer. It's so cute.

What does your personal meditation or quiet time in your home look like?
How do you get away from the worries of the world?

BETSY: The morning is my time to replenish, be grounded, reset, and spend time with God. I make it a practice to get up around five-thirty A.M. I light candles, because it makes things still for me. I make a cup of coffee, and then I kneel down to pray. I don't check a box. Instead, I invite Him in and let Him do what He wants. I give thanks for everything that I have and for the things that I don't even realize He's doing for me all the time. I pray for others, and sit really still. After I pray, I flip my Bible open and wherever my hand lands, I read. He always answers me. That's what has grown my relationship with God the most, because I know I'm being heard and communicated with.

CARLEY: I think that how you read your Bible by letting your hand land on the page and reading from there is such practical advice for people who are wondering where to begin with reading their Bible.

BETSY: Yes, the Bible can be scary, depending on where you start. I can't believe He has time for me in my tiny little world, especially when He also answers my design questions.

If there is one part of your story you think would set another free, what is it?

BETSY: Food is healing, and God gave us everything we need already. We've gotten too far away from those natural resources. When these types of things [Paxton's illness] are thrown at you, you can take it on, you just have to create that space where you can thrive. I rest a lot in my faith, and I owe everything to Him [God]. I'm so grateful. I feel every direction I've turned in our healing and in design, He showed me exactly what needs to happen. This whole interview has been God speaking through me. I'm grateful for that because it's important to me that I'm not doing this on my own. We've made something beautiful out of

"Although I loved my childhood in the South, I saw myself as different, unique, pushing the envelope a little—maybe not your typical Southern belle."

what could have been seen as a negative/daunting change to our life, and God helped me see how this could be so beautiful. I do not look at our situation as restrictive—to eat this way every day and to prepare all foods traditionally. It is a blessing to have this knowledge. If I don't rest on that, I think it would be a challenge for me to get up and serve all day, every day. It's a lot, and it's okay. I have my moments. I am human, but He's always there reminding me and helping me to shift my perspective, to make it all work.

"After I pray, I flip my Bible open and wherever my hand lands, I read. He always answers me. That's what has grown my relationship with God the most, because I know I'm being heard and communicated with."

KAREN EMILE

K AREN EMILE'S HOME IS TRULY SOMETHING OUT OF A FAIRY TALE. KAREN and her husband, Shawn, have created an oasis for themselves and Karen's three children in a beautiful, family-oriented neighborhood located just outside of Los Angeles. Karen fell in love with design early on and became a successful realtor. Knowing only single motherhood for so long, Karen initially fought her calling to be at home with her children after meeting Shawn, but accepting change has ultimately blessed their lives tremendously. Shawn is a talented craftsman and skillfully brings Karen's designs to life in their home. Karen and Shawn blended their families together and are very intentional about spending time together as a family. Karen incorporates earthy and airy elements into her design, ultimately creating the perfect balance between function and beauty. Spending time with Karen and her family was easy, fun, and life-giving. I hope you see the joy that resounds within the walls of this home.

Your story . . . Go!

KAREN: I grew up with a single mom, since we left my dad when I was very young. We didn't have a lot of money, so my mom was frugal, and she thrifted everything. In those days, I didn't really like to share that with people because it wasn't cool to thrift. But I'll never forget my first project with my mom. She bought a disgusting, ugly table and we sanded it down

"I grew up in the projects, and it was a harsh environment. But even though we didn't have a lot, I loved our home because it was enough."

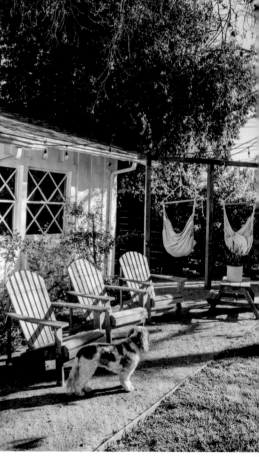

and made it very pretty. It took weeks to remove all the grime and paint from that piece, and all the while I was thinking, *Where's this going?* But when we were done, that

was the first time I remember seeing something that was once ugly made beautiful in our space. That always stuck with me, and I was very fascinated by it. Once it was finished, my mother put it in the living room and arranged flowers in a vase to sit on top of it. At that moment, the lightbulb went off and I thought, *I love this.* So from a young age, I was very influenced by my mom with design even though she was a single mom and worked all the time.

I grew up in the projects, and it was a harsh environment. But even though we didn't have a lot, I loved our home because it was enough. My mother always brought in the warmth; she made every space cozy. Nothing was fancy but it was home, and it was beautiful to me. I remember kids coming to my house saying, "Wow, your house is so clean and pretty."

When I met my first husband, my son Aiden's biological father, he was in construction and was working in big, fancy houses. He would take me to the job sites and my heart would pound just walking into every room. I was extremely intrigued with them and I knew that I had to get involved with design, somehow, some way.

Aiden's father and I were married very young—I was only twenty years old—but I immediately told him that we needed to buy a house and fix it up. My passion for homes started from there and we lived in our first home for two years. Then I said, "Let's go on to something else." At that time, everyone said, "What are you doing? That's crazy. How are you

into this?" But it was just magic from day one. I had to do it because it was in me. And that's how I got into real estate. I would evaluate appraisals and I used to sit there and fall in love with the houses. As time went on, I started following different designers in magazines and would visit different shops. I used to carry a huge book of pictures and would go through magazines and cut pictures out of every magazine. It was my inspiration and allowed me to plan future projects.

We moved into a new house and I fell in love with the whole aesthetic of it, the style, everything. We really made it a home. But as time went on, things happened, and my husband decided that it was time to move on from each other.

At the time it was a very difficult transition for me because everything I knew was disappearing in front of my eyes, and I felt like my passion for homes and design was disappearing along with him and my old life.

I quickly realized that everything I had built could literally disappear within a day. I felt like my life had vanished and I almost hated myself for having my passion for design. I already knew the Lord at that point and I loved Jesus, but I didn't have an intimate relationship with God. But going through that trial brought me to my knees. I really found God through that trial and learned that, no matter what happens, it's all for His glory and purpose. If you would've told me that I was going to get through that difficult time and live a purposeful and happy life, I wouldn't have believed you.

As time passed, I became closer to God, and I found women who could minister to me and who really had a heart for women who were going through divorce. And during that time, I got pregnant with Aiden in the midst of my divorce. At first I thought, *What am I doing getting pregnant with my soon-to-be ex-husband?* But looking back, I can't even describe how much joy Aiden has brought me through one of the darkest times of my entire life. That trial also taught me to listen to other people, because everyone has their own story; everyone goes through hardships. It's not always about what you're going through. I had to rebuild myself. It was time to really start over and break the chains. A Christian counselor told me to write down everything I wanted. Today everything I wrote down has come to pass.

During that time, I also started helping other women who were literally going through the exact same thing I was, who thought they were broken forever. Everyone goes through hardships differently and everything happens in God's timing, but I assured those women it would pass.

I met my husband Shawn not long after that, and he was literally an angel, but I fought the idea of being with him for a long time because he's younger than I am. But again, God was there in the midst of that. Shawn loved Aiden as his own. We started a life together, and I've never looked back. All those promises God made happened in my life.

CARLEY: All things that are lost can be restored. All things.

KAREN: Sometimes, our little minds can't comprehend God's plan for our lives. When Shawn and I bought this house together, Shawn encouraged me to stay home with the kids. But because for so long I was the only one providing as a single mother, I fought the idea of staying home. God really had to speak to me on that subject because all the things that I was so worried about were superficial, like not having enough money to travel or go to nice restaurants. I really had to check myself. God spoke to me and told me that it was time to stay home with the kids, and He just put my worries to rest.

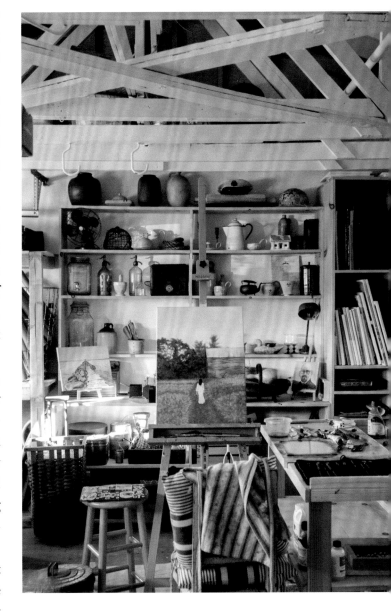

Now I have a beautiful life that I absolutely adore, and I get to spend time with my kids. There's no way that I would have seen my kids flourish if I had chosen the path that I thought was required of me. Aiden is a great example with his art. I had the time to really cultivate his talent and help him foster his art.

When God calls you to do something, you have to get ready to do it. I feel for single parents because I know how difficult it is to care for children and also work hard to provide. I had to learn to be okay with the season God brought me into, and learn to humble myself, while staying home. And it's been nothing but an absolute blessing.

God brought us to this house, and it was a seamless transition. It was like the gates of heaven just opened and we knew this was where we were supposed to be. Shawn flourished in everything. He grew, and I know it's because we just followed his lead. We've been blessed abundantly, and there's no expressing what has happened in these last few years, because it happened so fast.

Shawn has always been such an encouragement to me with my craft and with my art, and when I thought I had lost my passion for design and homes, God restored it tenfold. Through the trials and battles, I've learned to be extremely humble and just thank God for everything He's done. That's my testimony; that's my story.

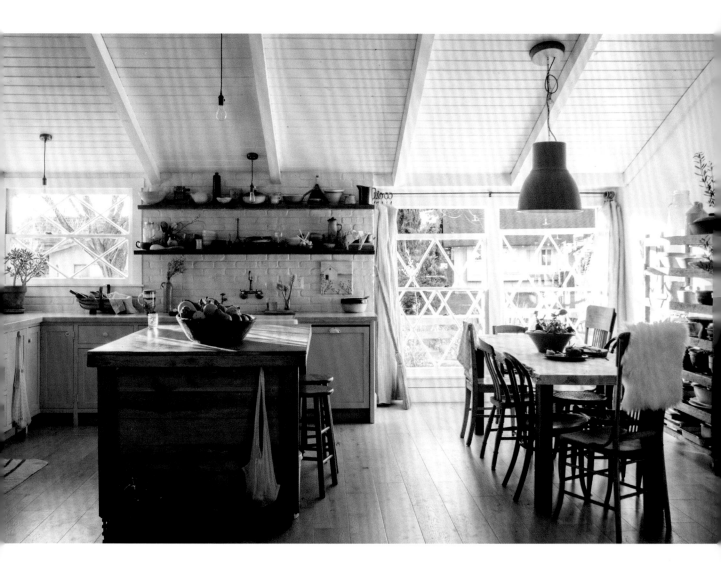

CARLEY: I'm about to cry. I know that God led us here and I know your story is going to bless so many people.

If you had one pivotal point that changed the direction of your life, what would that be?

KAREN: Walking through my trial and finding God through it all truly changed my life. My life used to be shallow. Learning humility also changed my life because you can't get through life without it. You need humility in order to have a purposeful life.

How are your trials and victories represented in your home?

KAREN: Growing up with a lack of money and seeing the things that I saw while living in the projects was extremely difficult, with dealers selling drugs right outside my window. My mom worked so much. She was a nurse and came to this country with nothing, wanting to make a life for us, but it was hard. I had to really step up and I became a big girl very quickly, especially to my younger brother.

A lot was expected of me as far as helping take care of my brother and keeping the household together. I had to take on that role as the woman of the house since my mom was always gone. And so I felt that responsibility at a very young age. And I've carried that through my

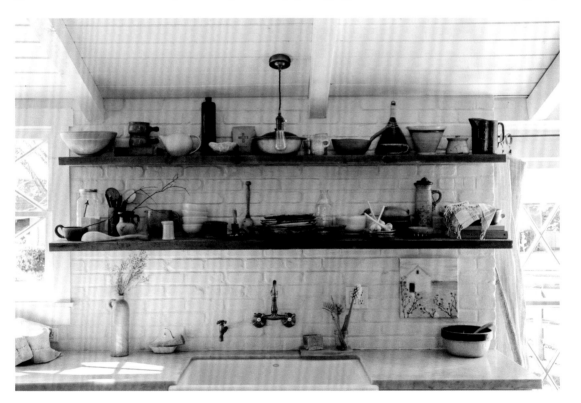

entire life. I count it all as a victory because everything I learned drew me closer to God. I learned to get on my hands and knees, not only during difficult times, but also in moments of pure bliss.

The victory is walking into my home and feeling peace. I always tell my husband that my favorite time is at night when all my babies are in their rooms falling asleep and we're all here in one household. I know that one day they're going to be gone and that's a really hard thing for me to imagine. That's my favorite time of day, aside from cooking for them, when I get to tuck them in and they say their prayers. My heart is full. I didn't grow up with my father, so I didn't know what having a father in the house looked like, but to see my husband here with these kids and how they love him is just amazing. All we knew were strong women: my mother, my aunts—they just made it happen. That's all I ever knew.

Shawn and his fatherhood are a literal representation of how my trials and victories are represented in our home. If God has placed a man in your life, you need to encourage that man, because he's there for a reason. He's there for a purpose. And that's especially true for women with strong personalities like myself. I always felt the need to be in control, but God taught me not to strive for control all the time. We are a complement to them as much as they're a complement to us.

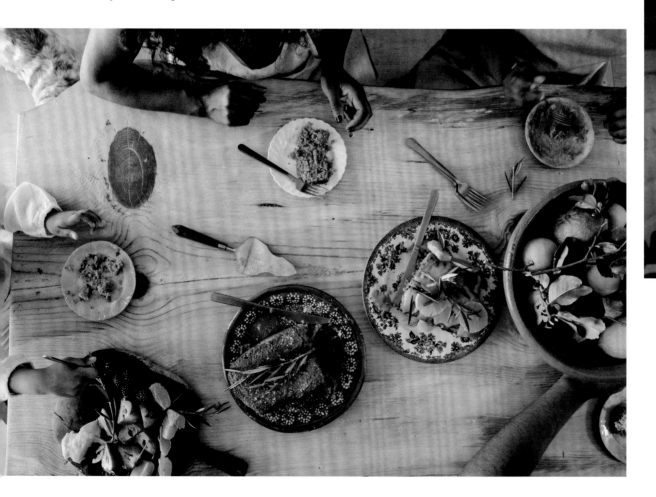

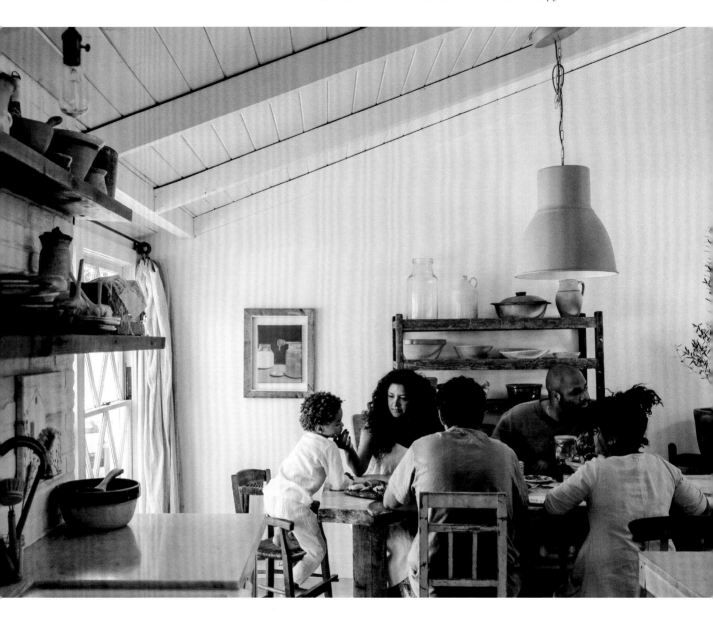

CARLEY: That is a huge victory.

KAREN: Yeah, absolutely. Shawn is a super-gentle spirit, and he is so patient with me. Men like Shawn are a great complement to women like me with strong personalities, but I had to learn to not take advantage of his patience and gentleness.

What does freedom *mean in the setting of your own home?*

KAREN: Freedom is exactly what I said about having my kids here, seeing them flourish, rather than just hearing about it from someone else because I was too busy to witness it. As a mother, witnessing your children flourish and the peace in your home that comes with that is irreplaceable. Freedom in our home also means setting the tone in the house for our children, setting an example to our children of how a husband and wife should be. I love the respect that we con-

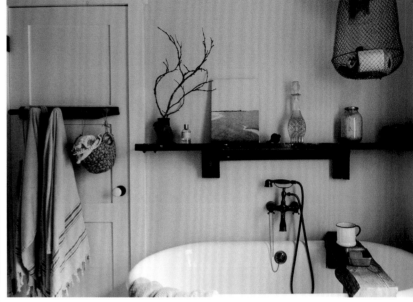

vey to each other as husband and wife, and the kids see it. I want them to learn what a godly marriage is supposed to look like so that they can carry that into their own marriages one day.

The freedom is exemplified through my children and the fact that they have a father, because I had no idea what that looked like. Simply *being* in this house is freedom; it's our haven. My kids don't ever ask to leave the house, because they love it and they feel safe, protected, and free. They love their home, and when you create a space like that for children, it's irreplaceable. I love that we've created a space for them to be free. We try to encourage them in all that they do. There are free little people here, loving the Lord and giving thanks.

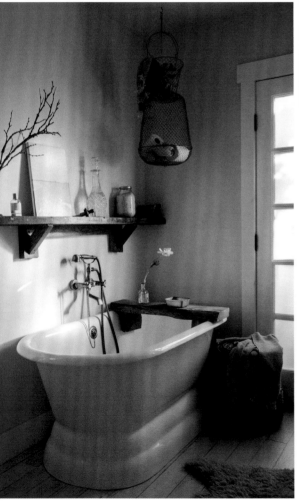

CARLEY: That's what I want for Max, too.

KAREN: Absolutely, you will have that.

Where is your sacred space, the place you find the most peace?

KAREN: My sacred space is the kitchen. I get up early every day, making sure the kids have their breakfast. I'm a nurturer, so I love to cook for them. I like to make them happy, so the kitchen is where I go early in the morning to start preparing for the day.

CARLEY: How do you feel peace in that space? What about your kitchen draws you to that area of your home and provides peace?

KAREN: God obviously always had a plan for me, but I never pictured myself as a mother. As a matter of fact, I was very hard on myself and always thought that I would never be a

good mother. I believed that lie from the devil and I fought with that for a long time. So having this beautiful kitchen has aided in breaking those barriers for me, which is why the kitchen is my sacred space. Having the ability to take care of my family in that way means so much to me. Now I look back and laugh at those thoughts that used to creep in all the time—that I wasn't good enough. God used my children to shatter that lie. God had a different plan for my life, even though I was fearful. He worked it all out.

CARLEY: The area where you didn't have an ounce of peace is now a place where you have the most peace. The exact lies that the devil whispers to us are the complete opposite of what God's truth is for our lives. I was on a path to be a degenerate loser, but I always craved success as a young girl. During my trials, I remember the devil telling me, "You're going to be a loser and a nobody for the rest of your life," but God had a different plan for me.

KAREN: Yes, that's exactly how I feel. That passion that you see on my Instagram is real. It literally pours out of me, and I can't even contain it sometimes. I don't do it to be a show-off; it's not for my glory. I'm just so proud of my children and love sharing that aspect of our lives.

Another sacred space for our family is the dining table, because it's our gathering place.

We are really intentional about eating together and using that time to dive into each other's lives. We love to hear about each other's days, and we want to set that example of intentionality for our kids, especially because Shawn and I didn't have that growing up.

What does your personal meditation or quiet time in your home look like?
How do you get away from the worries of the world?

KAREN: I do a lot of praying, and I do a lot of crying. Crying is part of my devotion because I have energy that I need to release sometimes by crying and thanking God, while giving over my fear and worry. Fear creeps in every single day, and just because you believe in God and live a purposeful life that doesn't mean those fears won't creep in.

We are building a little area in the backyard that will be my little freedom space, where I can just *be* and get close to God and do my reading.

CARLEY: Do you have a space in your house now for that?

KAREN: My kitchen is currently that space for me. I'm an early bird, so I usually come out of my room in the morning and sit there, enjoying the morning light shining in, and then I get ready for the day. I've learned to be thankful right after waking up. First and foremost, I thank God for simply waking me up, and giving me the energy to go on with my day.

CARLEY: It sounds like the kitchen is that temporary space for you, so I love that you're already imagining creating an intentional space for yourself. I think a lot of people can relate to you because they may not have that space just yet, but they are dreaming about creating a sacred space for themselves.

KAREN: When we bought this house, I knew right away that the little corner in the back-yard would be my space for my morning meditation. There are trees that swoop down and I knew I wanted to hear the birds sing in the morning.

> *If there was one part of your story that you think would set another free, what is it?*

KAREN: Don't believe the lies about yourself and don't fall victim to the comparison game. Unless you're extremely strong-willed, you will have fallen victim to the comparison game at some point in your life, which is why I believe social media needs to be put in its place. It's a wonderful feeling to gain recognition and to have people adore your passion, but don't be-lieve the lies about yourself, and don't compare yourself to others. I always tell my kids to be genuine and to always do the right thing, regardless of whether people are watching or not. When my Instagram account was hacked, I remember saying to myself, *Just keep doing what you always do, even if nobody's watching.*

You are uniquely *you,* so don't try to be someone else. I know this sounds cliché, but it's so important to understand it and to implement it into your life. God doesn't ask you to be someone you are not and to compare yourself to other people. Just keep being *you,* because you will fulfill your calling.

THE REDEMPTIVE HOME

STORIES FROM

CARLEY SUMMERS AND ANNA KOVALENKO,

WHO USE THEIR HOMES AS A

PERSONAL REFUGE FROM OUTSIDE FORCES

THAT WOULD OTHERWISE BREAK THEM DOWN.

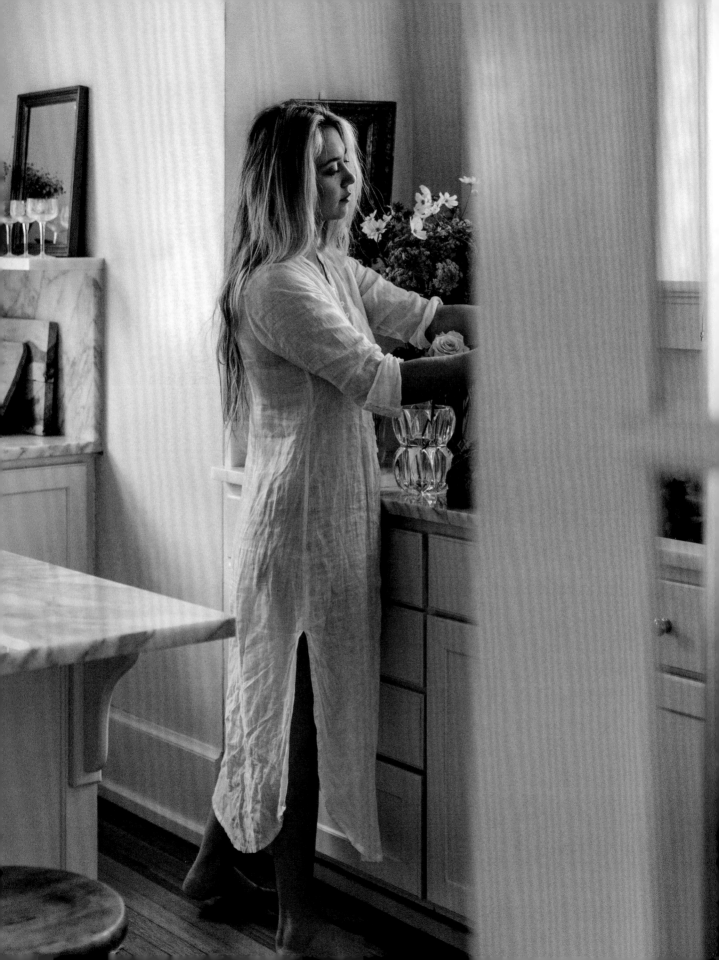

CARLEY SUMMERS

GREENVILLE, NORTH CAROLINA

Your story . . . Go!

CARLEY: Where do I even begin? To be honest, I think I've shared my story hundreds, maybe thousands of times, but every time I share it, it's almost as if I learn something new about myself. A lot of my story is still uncovering. So to begin, I grew up in a very sweet home. My parents are very loving, and my dad worked super hard. But the fact that he worked super hard made it evident that he was absent from our home a lot because he was working so hard for me and my older sister and younger brother. As a young girl, I always had a rebellious spirit; I was always creative, and I think the world took ahold of that. When I got into high school, I started partying and doing drugs. Then when I entered college, my drug use and alcohol use got even heavier because at the age of eighteen, I was a victim of sexual assault. Because of that incident, my self-worth lowered to a place that I could've never imagined. For about five years, I never spoke of it and continued to go down a path of recklessness and worthlessness. I probably moved around thirteen times during my tribulations, which was more than ten years ago. I ended up getting two DUIs, had countless worthless nights where I allowed parts of myself to be taken from me, fell almost thirty feet onto a concrete alleyway where I should have died, and went to rehab twice. It was the second time in rehab where I finally was ready to surrender my life to a higher power. At that point, I can remember knowing that God had so much for me—He had such a promising future for me—but I

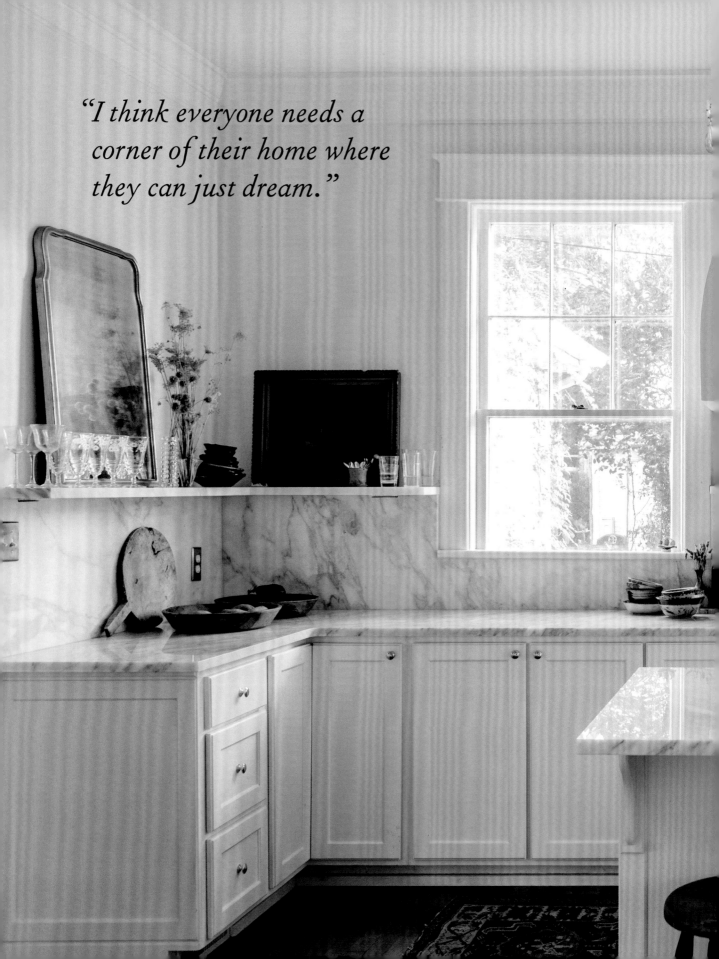

"*I think everyone needs a corner of their home where they can just dream.*"

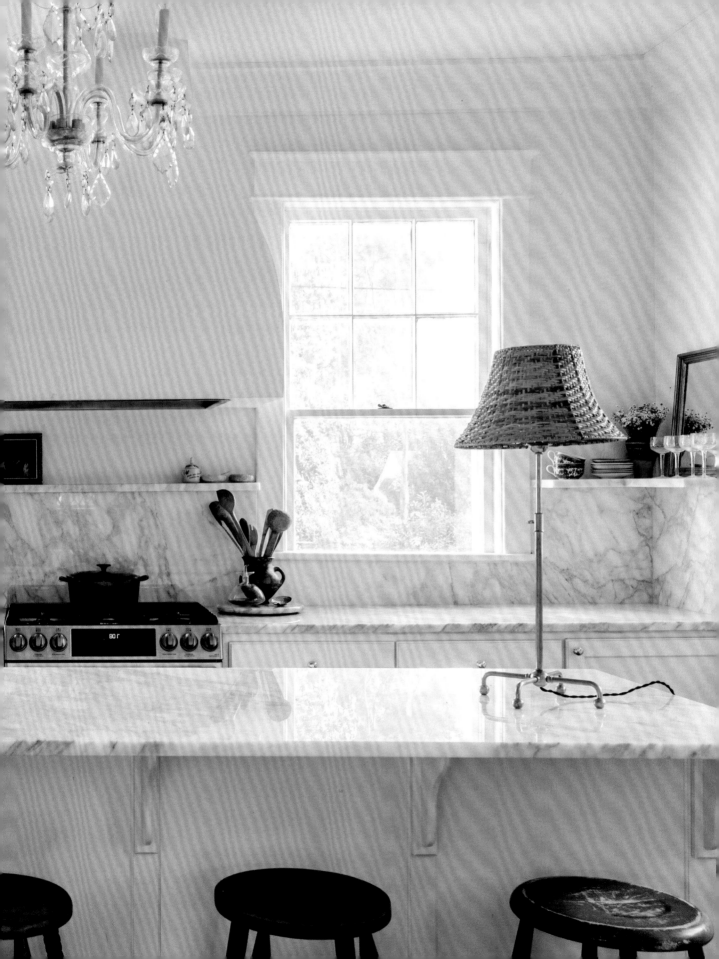

had to take hold of it. After rehab, I lived for half a year in Port-au-Prince, Haiti, as a missionary. I then moved to Florida. And now I live in North Carolina. I've moved around a lot, so the idea of home is really important to me and my heart, leading me to where I am now. I am so lucky to be here.

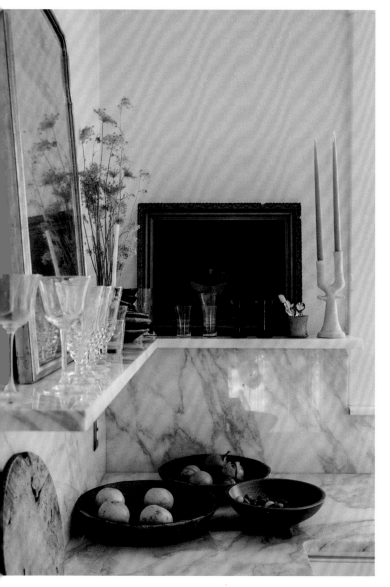

If you had one pivotal point that changed the direction of your life, what would that be?

CARLEY: I think it's hard to pinpoint. I think there were multiple pivotal points that changed the direction of my life. Obviously, I think the assault changed it for the worse. I got my second DUI, which was eye-opening for me, and it made me realize I wanted something different for myself. I think probably my second DUI and going to rehab were the two pivotal points that changed the trajectory of my entire life because I chose to leave my past behind and pick up a new future.

How are your trials and victories represented in your home?

CARLEY: The fact that I am able to live in a beautiful home and inspire other people because of how I have created my space is sometimes baffling. Because I can remember—and it'll make me tear up—not having a place to create. And as an artist that's really hard, to feel an emptiness in the place that's called "home" and yet you can't even design your surroundings to beautifully represent yourself and your art. I think that's where my trials were.

I think my victories mimic the same thing. The fact that I've been able to overcome addiction and alcoholism and be sober for more than ten years coupled with the fact that my

home is such a safe place and I'm alive and able to do what I love—represented in the carefulness and the creativeness in my home—is just so precious to me.

Going back to when I talked about moving more than thirteen times during my rebellion and recklessness, I can remember lying on a mattress on the floor and feeling a cockroach crawling over my hand while I was on the computer. I was living a really low-rent lifestyle and the word *home* produced a lot of anxiety in me. I think those trials have brought me to a place of such gratefulness. For example, in my past, when I would move from place to place, there was such a level of shame associated with packing up my things. Packing up meant that I was a problem and I had to go away. When I was able to unpack at a new location, that meant new excitement and adventures. Even to this day, when I packed up

my old home to move a few blocks away, I cried because I was triggered by the process of packing things away. I had to remind myself that moving into a new home wasn't a result of being unwanted. Now every time I move, it means a new victory for me.

One of the greatest victories I have and share in my home today is my husband, Jon. Because of my past and all of my brokenness, I never thought a man would love me and truly accept me with all I have been through. Jon loves me unconditionally, which is evident to everyone around us, but that love is something I thought I never deserved. On our wedding day, I shared in my vows that God restored all my broken pieces back together, so I could give it to my husband that day. Jon has received me fully as I am, as crazy as I can be, and has helped me create a homelife that is so safe and healing. One of my greatest fears and trials was feeling like I would never be loved, and it turned into one of the greatest victories of my life.

What does freedom *mean in the setting of your home?*

C A R L E Y : [*tearing up*] Why does that make me want to cry? [*laughing*] I'm so weird.

I can remember in my past living environments, before I got sober, I lived a very worthless and dirty lifestyle. My environment was a product of how I truly felt about myself. When I was raped at the age of eighteen, I felt worthless, and my life reflected that—even down to the way I kept my bedding. I felt dirty, so I thought, *Why even wash my sheets?* Now, honestly, my sheets are something I take pride in. I wash them regularly. My clean sheets are a reflection of how God has cleansed me.

Truth be told, white linen bedding is one of my most-suggested items for all of my interior design clients. Who would have thought? The fact is, as an artist, I've been able to create a space that truly reflects me. Not only does it reflect my travel experiences, but it also represents me, my husband, and my family. It is a difficult concept to wrap my mind around, the fact that now I can come home, sit in a special place, or sit anywhere in my house, and feel free to know that I can be one hundred percent who I've been called to be and create one hundred percent of what God has placed inside of me. Being an artist and knowing that I can fully be myself in my own home is the most freeing thing. My home means so much to me because, at one time in my life, I didn't have a place to truly call home. I think I have been able to create spaces that inspire other people because what God placed inside of me has now come to fruition. It's a miracle. I once thought that nothing good could come from my life, but God has done a one-eighty with me, and has not only given me a sacred space, but has allowed me to be an inspiration for others to create their own sacred spaces. It's so redemptive.

That message is just so much a part of this book. Every time I have created my own home,

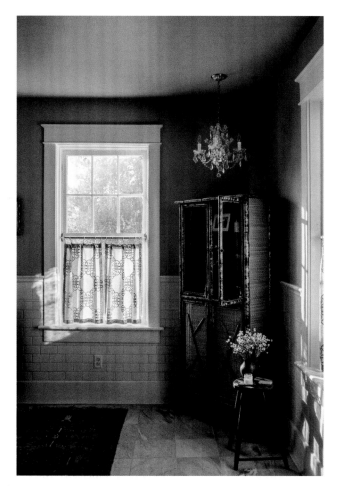

I have created a safe and sacred spot for me to sit and rest and read in and know that as soon as my butt hits that seat, the presence of God will fill me with hope and wonder; it will help me dream again, help rid me of anxieties. I think, especially coming from my background with drugs and alcohol, the fact that I am able to sit and find that place, when before I wasn't, is something so important for me to create in every home.

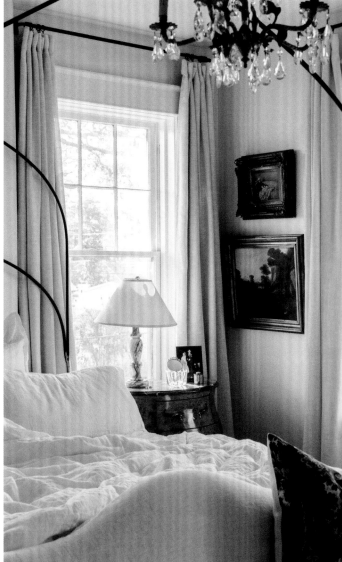

"One of my greatest fears and trials was feeling like I would never be loved, and it turned into one of the greatest victories of my life."

Where is your sacred space in your home, the place you find the most peace?

CARLEY: What first comes to mind is my green chaise lounge. It is honestly my favorite corner of my home, aesthetically and by the way it feels. Every Wednesday morning, I prepare a Bible study to teach that night for the girls I lead and encourage. When I sit down, I feel like God meets me there in that seat. I am immediately able to focus and find peace there. It's as if, as soon as I sit down, He begins to speak to me and tell me to drop all of my worries and anxieties and rest in Him. I have also been finding a lot of joy in my sunroom, which has recently been completed. It's a little bit offset and private from the rest of the house, and it's very cozy. I can look outside, where I can see the sun early in the morning, and it feels quiet and peaceful. It's been a place for me lately where I'll journal and cry out to God with different insecurities that I have going on throughout the day. I sit there and write down things that are weighing on me, reflect, and release it in that space. When I get up from that space I think, *It's staying here in the journal. I'm not carrying it with me.* I read scripture and take tidbits of it that speak to my heart in a sweet way. Even this morning I read, "To take all thoughts captive." That means I'm not going to let my mind run wild. But I don't think I would have been able to sit down and find that meditative space if I had not found a quiet and peaceful space that I've created in my own home. Jon and I also gravitate toward that room on weekends. We let the light stream in on our faces and we dream together. We talk about what all God has in store for us and what it will be like to bring our son, Max, into this world. I think everyone needs a corner of their home where they can just dream.

What does your personal meditation or quiet time in your home look like?
How do you get away from the worries of the world?

CARLEY: Every morning I have the same mindset of what I want to accomplish in my meditation and in my prayer time. I know that I will go to my sacred space. I will open myself up to prayer and listen to God first. A lot of times the weight of the world and my life, and even my past, will surface and rest heavily on my shoulders, and I feel like I can't carry it any longer. What's really neat is that I have so many rugs from different cultures, and I'll usually lay out a rug in my sacred space, which becomes my prayer mat. I have taken that concept from different places I've traveled to. I will get on my knees, or sometimes on my face. I always say, "The best place is on your face." And I will surrender all those burdens over to God because He promises me that He will take them and carry them for me. So that's probably one of the biggest, hands-on practices that I do with my meditation. Then, I journal. I have journaled my entire life. I have journal entries about when I was in rehab, my DUIs, my first boyfriend, everything, and so I think journaling, even something as simple as where I'm at

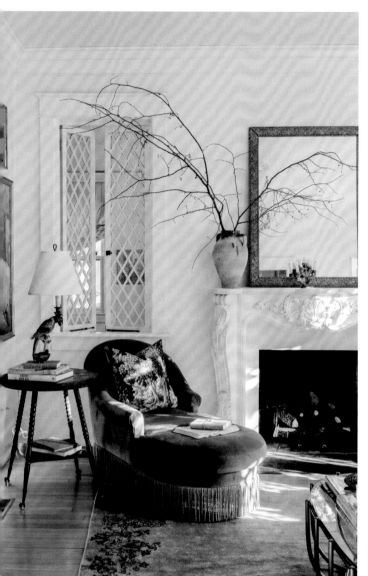
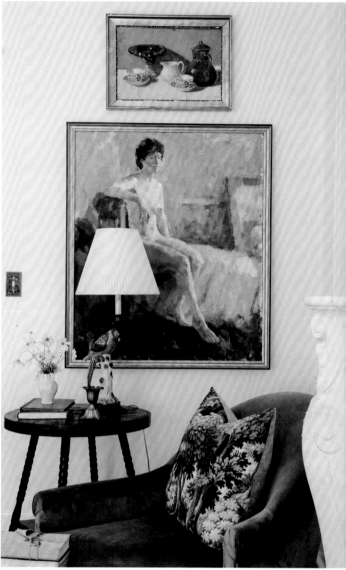

that day, and releasing it over to the Lord and allowing him to be the center, is super important with my meditative state.

If there is one part of your story that you think would set another free, what is it?

CARLEY: Your past does not define you, but it refines you. Walking through this journey of recovery, and even with my business, I've realized that a lot of times, my past comes up and I am able to look at it with a different eye and allow it to *refine* me, instead of allowing it to *define*

me. I think if I hadn't gone through what I've gone through, I wouldn't be the person I am today.

Your story had a purpose for a time, and you have so much purpose in your refinement, beyond your story. I would also say that when the world calls you "broken" and "unworthy" like I felt for so many years, you are actually the opposite of that. My life verse is 2 Corinthians 5:17: "Therefore if anyone is in Christ, this person is a new creation; the old things passed away; behold, new things have come." In the world's standards and according to my past, I should be broken, but instead, I have used my story as a battleground not only to fight for myself, but for others, too. God uses our brokenness to heal others and share hope, and I am so grateful to be a part of that good work.

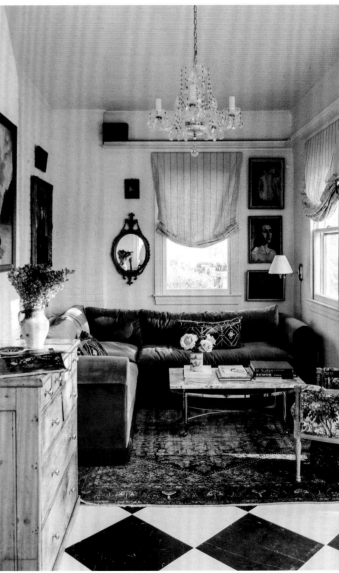

For so long after the sexual assault, I thought, *How could this ever be used to help someone? How could my story ever be used for a purpose? It's just a worthless, horrible act.* Not everyone has the same experiences as I had, but when I realized that my story could be used to help another person find freedom in what they have walked through in life, I realized that my life and the things I had gone through were not for nothing; they had a purpose. I used to be so angry at God. *How could you allow me to go through something so horrible?* He had to remind me that He gave human beings free will. The person who did that to me had free will to make a horrible choice, but I now have the free will to use a horrible experience to help set others free, to know they're not alone. The fact that I get to hold other young women's hands who have gone through the same thing and say to them, "You have a purpose. This does not define you. You are not worthless; you have worth," is so powerful because I've been able to help other women figure that out.

I now live in a home where I probably partied ten, twelve, fifteen years ago, so I live literally among my past, but in a redemptive state. I never thought I would live in my hometown, in this neighborhood, where I felt the most broken, but I literally live in the middle of it. I embrace my neighbors now and I'm able to help other women in the neighborhood who are younger than I am, who are in college, doing the same things that I was doing, but giving them a safe place to come and work things out.

"The fact that I've been able to overcome addiction and alcoholism and be sober for more than ten years coupled with the fact that my home is such a safe place and I'm alive and able to do what I love—represented in the carefulness and the creativeness in my home—is just so precious to me."

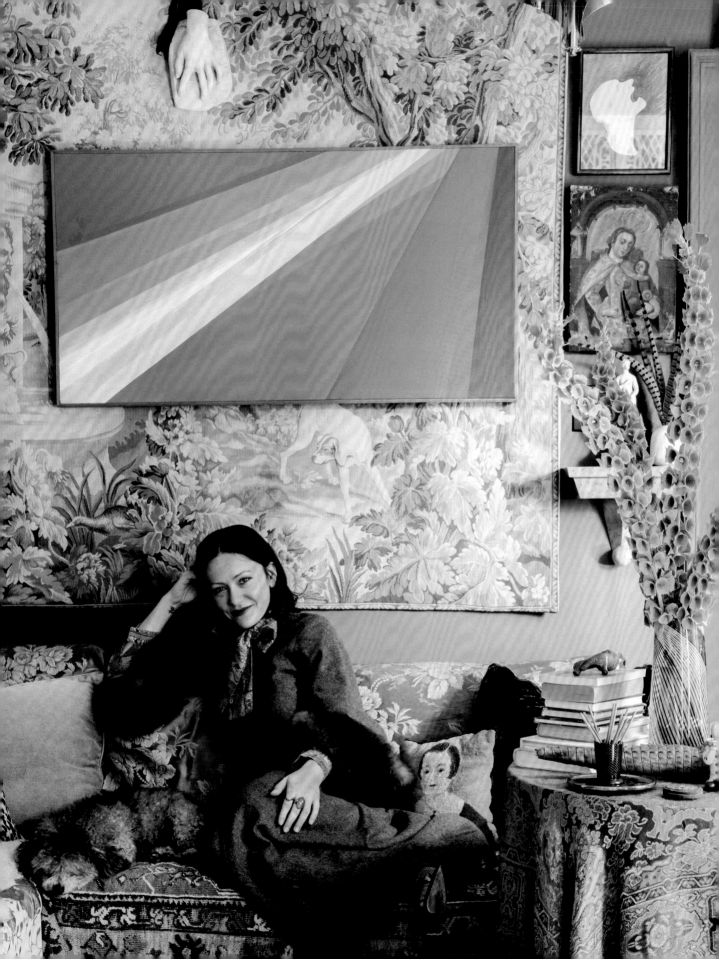

ANNA KOVALENKO

When I stumbled upon Anna Kovalenko's home, located near Hudson, New York, I immediately saw something so rich and full of life. I promptly reached out to her, and as we connected on the phone, we both opened up to each other in such a free way. She poured her heart out to me, as she shared her life struggles, and the victories she has experienced in this home with her husband. Originally from Russia, Anna struggled to find her footing in her new American life. Her home is a full expression of who she is and all the layers that make her uniquely Anna. I was so at home in her space, and I felt like I could share anything with her. I left with a deep connection to her that I will take with me throughout my life. She is creative, free, and full of passion for life, despite the hardships she has faced. Anna unashamedly expresses herself through interior design, and holds nothing back, filling her home with pieces of her Russian history, antique treasures, and fashion-inspired layers. I know you will see this as well throughout her home and story as you flip through the pages and witness the expression of who Anna is.

Your story . . . Go!

ANNA: My story can be described as a series of beautiful and ugly moments, of loss and gain, of great highs and tremendous lows, full of diversity and contradictions. I can describe my life as a series of putting back the broken pieces. Family tragedies, immigrating to a new country,

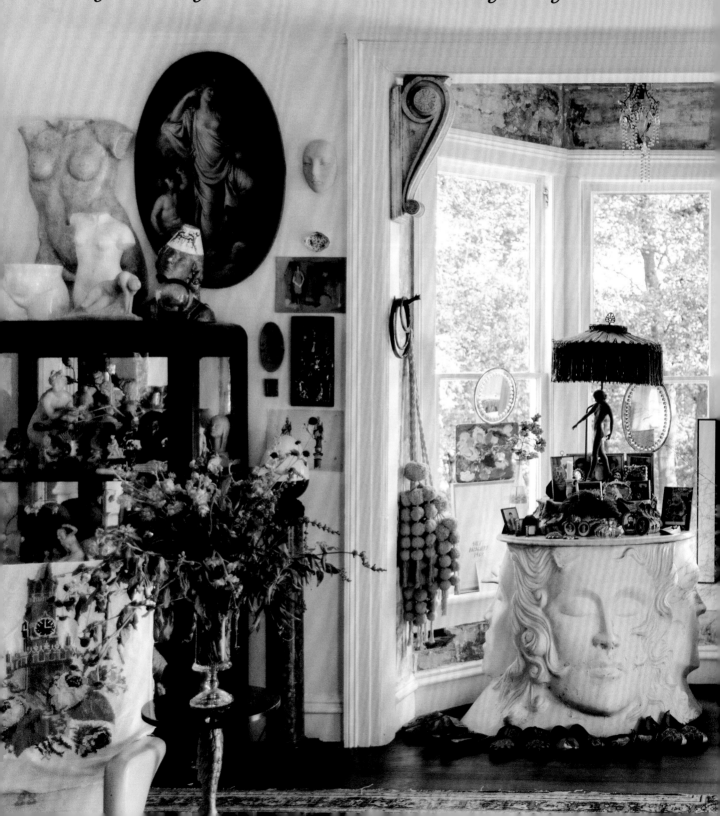

"*The trials and victories are woven deep into the fabric of my home. When trying to understand my home, you have to understand my story.*"

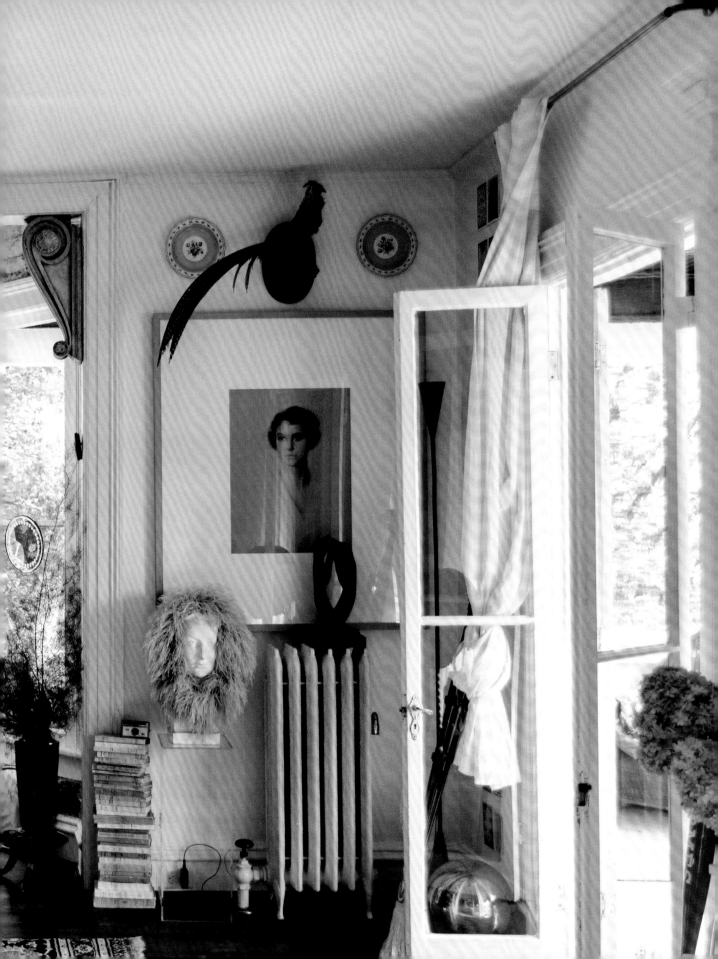

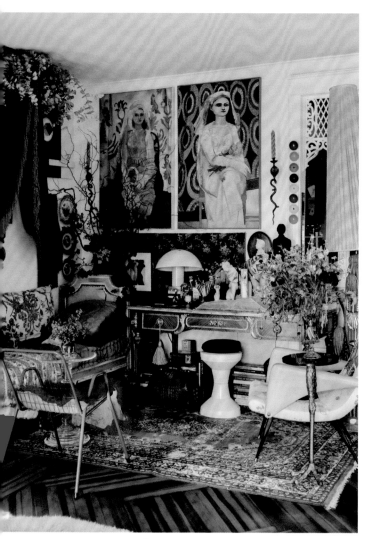

"My story can be described as a series of beautiful and ugly moments, of loss and gain, of great highs and tremendous lows, full of diversity and contradictions. I can describe my life as a series of putting back the broken pieces."

becoming a young mother, and finding my way out of abusive relationships have left a gaping crater that I have endlessly tried to fill. I made it through the hard times, have a successful business, and raised a beautiful daughter, but I have always suffered from feeling like I'm not good enough. Overall, I feel incredibly blessed and my life has been generously full, but my story has been marked by immense loss, grief, addiction, and abuse, which makes me feel like a builder of sorts. Building and rebuilding have be-

come a perfected craft. There were plenty of times when I could not see beyond tomorrow, and it has been a constant struggle to be strong and let the beauty of life persevere and win over the darkness of it all.

I moved here from Russia when I was ten years old because my father is Jewish and there was a lot of anti-Semitism in Russia at that time. He had difficulties at work and did not have the freedom to practice his religion. I remember one time he took us to the synagogue and my mom almost had a meltdown because she was so scared that something bad would happen to us. He also moved because he was seeking freedom and opportunity for his family, as most immigrants do when they come to this country. My mom, on the other hand, was really reluctant because she was really connected to her home, and to her family.

CARLEY: Wow. And then when you moved to the United States, your brother became addicted to drugs and was murdered. That affected you and your family greatly and your homelife, I'm sure.

ANNA: Yes, after we moved here my parents had to work incessantly to keep a roof over our heads. My brother and I were pretty much left to our own devices. We were teenagers and it was hard on us to be in a new country and to adjust without regular parental guidance. Unfortunately, my brother started running with a bad crowd and was introduced to drugs. After he died, our home fell apart. Life as I knew it was shattered. My mom started drinking soon after he died, and my dad left. I think he couldn't cope; it was just all too much for him to have to deal with the death of my brother and to have to deal with my mom's drinking. They put the house on the market, and I felt like no place was safe. Growing up, I had a lot of anxiety, especially social anxiety, but I had always felt like my home was the only place where I was safe. In a way, putting our house on the market ended my childhood; for the first time I realized I had to make a home of my own.

CARLEY: Wow, that makes me want to cry thinking about what you and your family walked through during that season. I can't imagine going through that and then having to leave your home. You told me previously that you didn't grow up with a lot of wealth and your parents were both engineers. They did pretty well for themselves in Russia with that type of education, but then moving here as immigrants, it was a different story. You didn't have a lot of money. One thing that you said stuck out for me—that you and your mom would thrift together.

ANNA: Well, it just so happened that when we first arrived in the States we were taken to a temporary home for immigrants, which was located next to a church. Our first morning here

happened to be on a Sunday, so my mom and I decided to go to church. It was there that we met a lovely, generous Southern woman. She had porcelain skin and apricot hair and would later introduce us to American thrift stores. As far back as I can remember I had two loves in my life: fashion and interiors. So there I was, ten years old, knowing only a wardrobe of handmade and hand-me-down clothes, and suddenly discovering the world of treasure hunting, unaware that this new adventure would eventually play a big role in my life. I loved thrifting and was instantly great at it. It was there that I could lose myself, and it was the first time I heard someone say I had a "good eye." Now, years later, I have a very successful business with the same name.

After tragically losing my brother and, in a way, my family, I have always felt that safety was out of reach, that it was for someone else, in someone else's home. My entire life I have struggled to create a feeling of safety and a sense of security for myself. When I had my daughter, it was no longer just for myself. I had to find a way to do it for her as well. My marriage with her father wasn't abusive; we were just very different people. I married him because my brother had died, and he was my brother's best friend. I got married when I was seventeen and my parents had to sign papers giving me permission to marry because I wasn't of age. I was taking night classes because I was working full-time, trying to provide for my family. At some point, I remember my husband saying, "Listen, we are hardly making ends meet, so you're going to have to leave school. Why don't you become a stripper?" It was another moment when my whole idea of safety and home and a wholesome family was shattered. Ultimately, our marriage didn't last.

CARLEY: What do you think about the juxtaposition of that past relationship, and the home you have now and the relationship you have with your husband Korey?

ANNA: Oh, it's night and day. This life, this home, and this relationship is what I have yearned for all along. It is the definition of that white picket fence I thought I could see only in wholesome movies or through the windows of someone else's home.

> *If you had one pivotal point that changed the direction of your life, what would that be?*

ANNA: This is a hard one. It is impossible to name just one. I had at least three pivotal moments that changed my life completely: the move, the loss, and the birth.

The move—when I was ten years old, my immediate family and I moved from Moscow to Florida, which was a complete shock. I mean, really, in every sense! Immigration is huge. It changes people forever. To this day, I have moments of doubt, like maybe my parents shouldn't have left Russia. We left our beautiful home with only the clothes on our backs. It

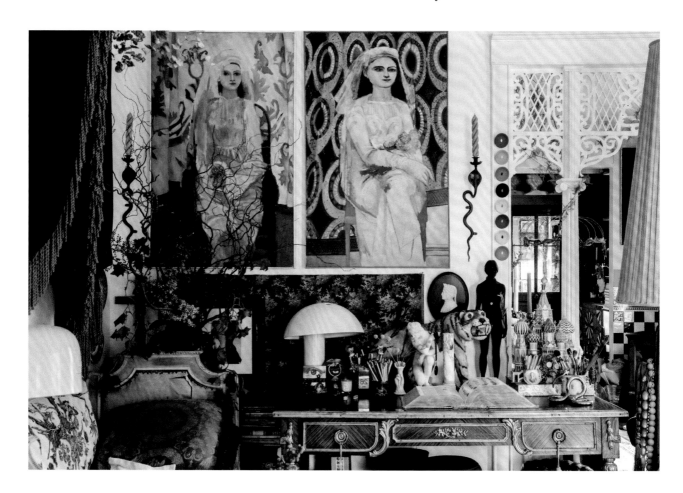

was an experience that overnight and permanently made me feel like an outsider. I will never feel fully American. And when I travel back "home," I realize it's gone. It's not the same, I'm not the same, and we will never belong together again, my motherland and I. When I started school here, the feeling of being different, an outsider, was crushing. It ate away at me, and it was and still is very hard to be strong and maintain my authenticity and individuality. I am sure immigration is easier for some, but I have always been a terribly nostalgic person. Leaving my country, home, friends, and family behind has left a deep, permanent scar. Still today there is certain music I just cannot listen to or when the air smells like the village of my maternal grandparents, it just all gets to be too much.

The loss—when I was sixteen and my brother was eighteen, he was shot and killed. It has been twenty-four years, and to say that out loud still gives me physical pain. This tragedy opened the door to the darkest, ugliest time of my life. My parents divorced, my mother became addicted to alcohol, I dropped out of high school and married my brother's best friend at the age of seventeen.

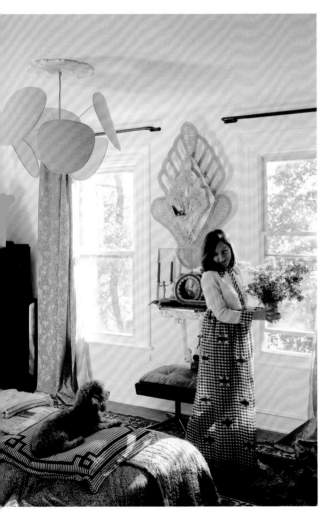

The birth—when I was just shy of my nineteenth birthday, my daughter, Sasha, was born. Talk about a life-changing moment! As beautiful and monumental as it was, I really don't want to sugarcoat that experience. For the sake of all the mothers out there, that shit was hard! I mean, I was eighteen, I had no money, no education, and most importantly no home, at least not of my own. At the time of her birth, I was living with my in-laws.

How are your trials and victories represented in your home?

ANNA: My home is my story! The trials and victories are woven deep into the fabric of my home. When trying to understand my home, you have to understand my story. The two are inseparable. You have to understand that my story is equally full of joy as it is of sorrow, of dreams as it is of nightmares. I am very nostalgic and sensitive, but life has definitely hardened me over the years. I am a self-proclaimed "tender punk" and my home is an accurate reflection. Not everything is beautiful, not

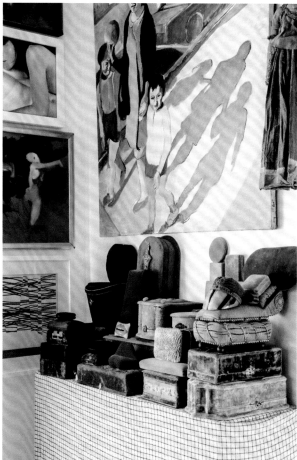

everyone one will love it. There is a Russian saying that life is like a zebra; you don't get the light stripes without the dark.

I still remember being a happy child, picking wildflowers and berries in my grandmother's garden one moment and fainting at my brother's funeral the next. One day I am a straight-A student in a great school in Moscow and the next I'm a young mother and my husband is asking me to quit my night classes at the community college so that I can be a stripper and make extra money instead. I vividly recall my mom painting murals on our walls and finding her in our kitchen lovingly baking elaborate birthday cakes and then in the blink of an eye I found her alone in the middle of the night screaming on my brother's grave.

And so my home is a mix. There is high and low, modern and old, gaudy and folky, it is all a reflection of my experiences, my trials, and my victories. My memories, just like the objects in my home, are different—some are bright and shiny while others are crude and broken. Life has taught me to see beauty in imperfection, to see beauty in complicated layers, to see beauty in decay.

In addition to my experiences, the women in my life are a great part of me and my story. They have made a huge impact on me and therefore on my home. I come from a diverse up-bringing. My mother's family is working-class. They came from the country and worked with their hands. My father's family is very sophisticated, where everyone is well educated and has a much higher, refined way of living. Growing up this way, with such different families, I learned at a young age the beauty and importance of diversity. I learned to love and appreciate raw, handmade linen just as much as precious silk and velvet. I spent a lot of time with one grandmother visiting operas, galleries, and museums, then mending old dresses, listening to folklore and fairy tales, and pickling vegetables with the other. From my childhood on, my whole life was constantly marked with contradiction. I have lost so much, yet I feel victorious. This sentiment, experience, and knowledge can all be found in my home.

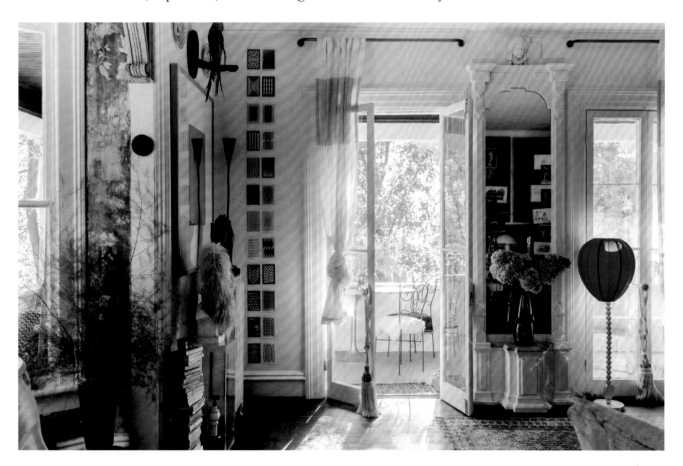

It's definitely the personality that I think life molded me into. I refer to myself as a "tender punk." And I feel like my house is a tender punk as well. It's as if you are looking at a girl who is elegant, pretty, and soft-spoken, but she's also got tattoos, scars, and layers. My home is very much like that. She's pretty and she's sweet and tender, but she's rough around the

edges. The floors are about two hundred years old and have gouges and scratches and scars. I was telling Korey the other day that I don't want to redo the floors. Both this house and I have scars, and they're beautiful.

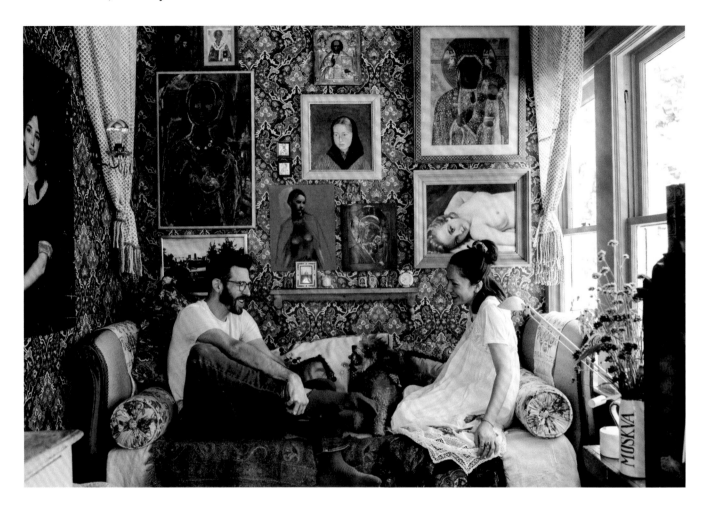

What does freedom *mean in the setting of your home?*

ANNA: I guess what it really boils down to is the freedom of doing what I want. The freedom to express myself without hesitation or being motivated by the approval of others. I mean, freedom is incredibly valuable so it's sad to think that people fall into the trap of following trends and pleasing others, even in the privacy of their own homes. Social media has made it so difficult for creatives to stay true to themselves. Don't get me wrong. It really bothers me at times, where I'll think, *Why does that person get two thousand likes for posting a bowl of lemons, while I pour my soul into redoing a room and no one gives a shit?* There is so much pressure, so much competition. It feels like a huge, vibrant world out there with so many tal-

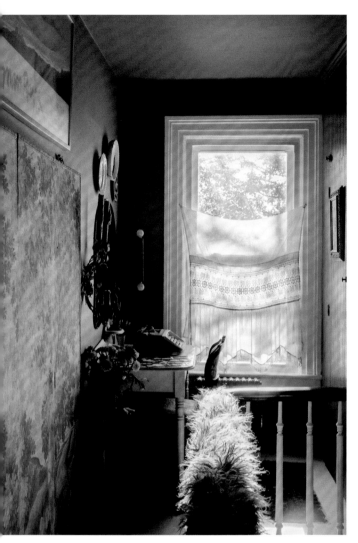

ented, important people and you find yourself thinking that you want to be important, too, you want to be seen and recognized. It's too easy to start using others' responses to what you're doing as a compass, and I really don't want that. I need a home that reminds me of my grandmothers, that inspires me, that fuels my creativity and stays interesting. That is my freedom, and it is so much more important to me than the approval of others. I don't need Mary from Nebraska to approve of my wallpaper. If that wallpaper makes me think of some of the best poetry in Russian literature, I don't care if others approve or not.

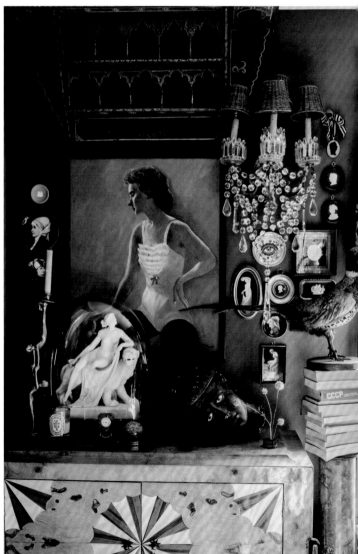

My home is my identity. So if you don't like my home—if you think it's too loud or if you think it's too crowded—well, it's me.

Where is your sacred space in your home, the place where you find the most peace?

ANNA: That's a really hard question for me, because of the way I design. Basically, I design a series of sacred spaces. And I

think people feel that when they're in my house. That's the whole point: it has to be peaceful. It has to inspire me and it has to be interesting. Which makes it kind of difficult to choose. But if I really have to choose, the sunroom is my sacred space. It's covered in Russian wallpaper with Russian icons and with my grandmother's needlepoints. I'm so connected to what is going on in here that this room has become my sacred space. The beauty of cultivating a home with love is that it becomes sacred.

What does your personal meditation or quiet time in your home look like?
How do you get away from the worries of the world?

ANNA: I think about not only a routine, but something that I catch myself doing over and over when I feel stressed or when I feel out of control. I think it goes back to my childhood of looking inside others' homes. I'm telling you, it's like a borderline obsession: not only homes, but other people's homes. I have a ton of interior design books, which are not only for inspiration; they bring me peace. When I look at books of warmly curated homes, I can feel the tranquility from those homes; I can feel the peace that those people have created and cultivated, and it gives me peace in return.

That's my go-to. When I'm feeling super stressed or out of control or like I'm losing that safety, I will sit with a book and a cup of coffee and immediately feel better. Korey, my husband, will notice a difference in me after just ten minutes with those books. I can be in tears but after looking at an interior design book I'll say, "I'm okay. I'm fine. Now let's move some furniture around."

CARLEY: Is there a certain place in the house where you sit?

ANNA: It depends. If I want to be more in the center of the home to feel more grounded, I'll sit by the fireplace. If I am in the mood for a cup of tea, I can be in the kitchen surrounded by my collection of old copper, and feel nourished and comforted. When I'm in the mood for a good read, I can go into the sunroom with the Pushkin wallpaper and feel inspired and transported. If I want to enjoy my solitude, I can go into the upstairs nook, sit by the window overlooking the waterfall, and write a letter to a friend or even to myself.

That's why it's so exciting for me to not only be in a design book, but a book that is so much more than just about design.

If there is one part of your story that you think would set another free, what is it?

ANNA: Don't give up. Try your best to find the beauty and the light in the darkest of places. There's always some of it there, no matter how unrealistic that seems. Grasp onto every little

thread of light, because at the end of the day, we all have an inner strength. It's ours alone, and no one can take it away from us. And the more you pull at that thread and the more you crawl out of that hole and the more you cultivate that love and light, the more you'll see it's there. Sometimes it seems unbearable and unrealistic to get out, and sometimes it seems like there's just no tomorrow for you, but there is. The greatest strength we have is to begin again. I had to learn that truth over and over again. With every difficult, ugly moment that was thrown at me, I had to go through the process of figuring out how I could get from "I can't" to "I can, and I will."

When life is chaotic, when everything is falling apart, don't forget that you can re-create your life again and again. Set your heart and your energy toward the most beautiful outcome and it will be. You will see.

*"Don't give up.
Try your best to
find the beauty
and the light in
the darkest of
places."*

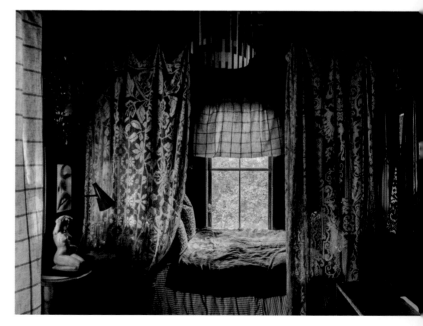

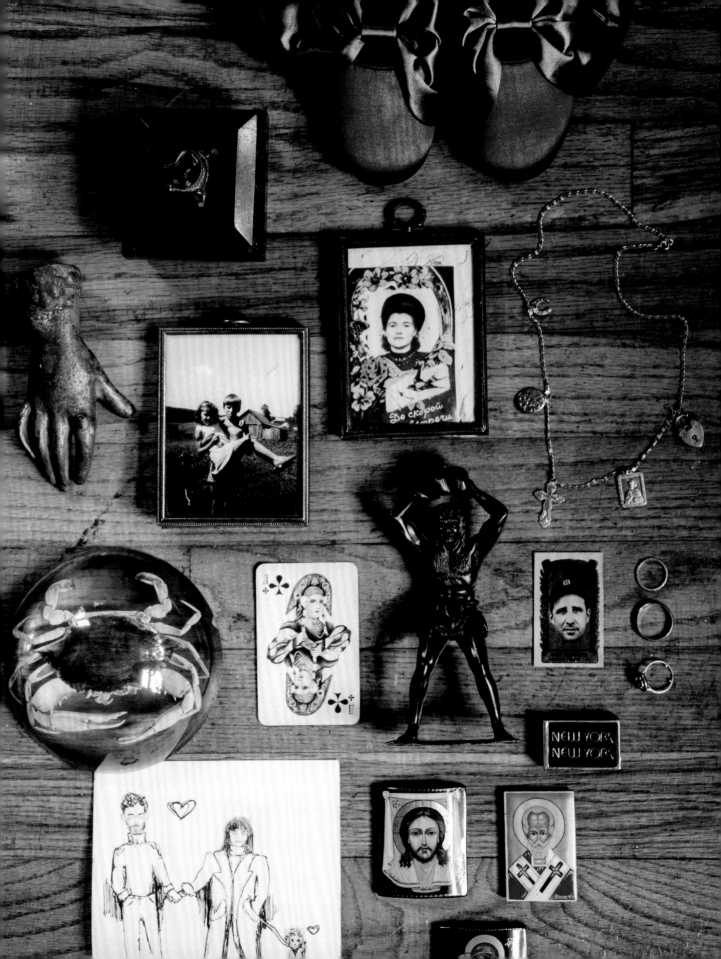

ACKNOWLEDGMENTS

FIRST AND FOREMOST, THIS BOOK WOULD NOT BE POSSIBLE WITHOUT THE INCREDible people who graced the pages. They spilled their hearts and shared their stories and homes to help others find hope and freedom, and I am eternally grateful.

The process of writing this book would not have been easy without my precious husband, who took a major role in coordinating the travel and editing this book. His knowledge and heart for this project has helped beyond measure.

A huge heartfelt thanks to Darby Hubbell, who spent countless hours on the proposal, and whose dedication to this project turned this dream into a reality.

My family and friends have been such a source of encouragement throughout this process, especially my parents, Mike and Page Aman, who have pushed me to be all I can be in this life. I am not sure how I would have made it through without them.

Thank you to my amazing agent, Alison Fargis, who believed in me from the first phone call, and who constantly cheers me on.

And to my amazing publishing team at Penguin Random House; none of this would be possible without your drive and belief in this book.

I was blessed to travel to the featured homes while carrying my firstborn son, Max. I hope he knows how much his momma loves him and that this legacy is for him.

Finally, thank you to my savior, Jesus, who breathed inspiration into me and allowed this book to be brought to life. This book is possible because of how much He believes in me.

ABOUT THE AUTHOR

CARLEY SUMMERS is an interior designer and photographer from Greenville, North Carolina. After spending time as a missionary in Port-au-Prince, Haiti, a place of healing from addiction to drugs and alcohol, Summers pursued a career in photography and design. She now resides in her hometown with her husband, Jon, and baby son, Max, born in June 2022. Summers runs an interior design and photography business, where she takes on clients from around the world. Her passion for life and faith is what drives her to be all she can be in this life. Her greatest hope is to leave a meaningful mark on this world that shows others you can hit rock bottom and still find freedom, healing, and purpose.

Follow her on Instagram @carlaypage and find out more at carleysummers.com.

.

A B O U T T H E
T Y P E

This book was set in Fournier, a typeface named for Pierre-Simon Fournier (1712–68), the youngest son of a French printing family. He started out engraving woodblocks and large capitals, then moved on to fonts of type. In 1736 he began his own foundry and made several important contributions in the field of type design; he is said to have cut 147 alphabets of his own creation. Fournier is probably best remembered as the designer of St. Augustine Ordinaire, a face that served as the model for the Monotype Corporation's Fournier, which was released in 1925.

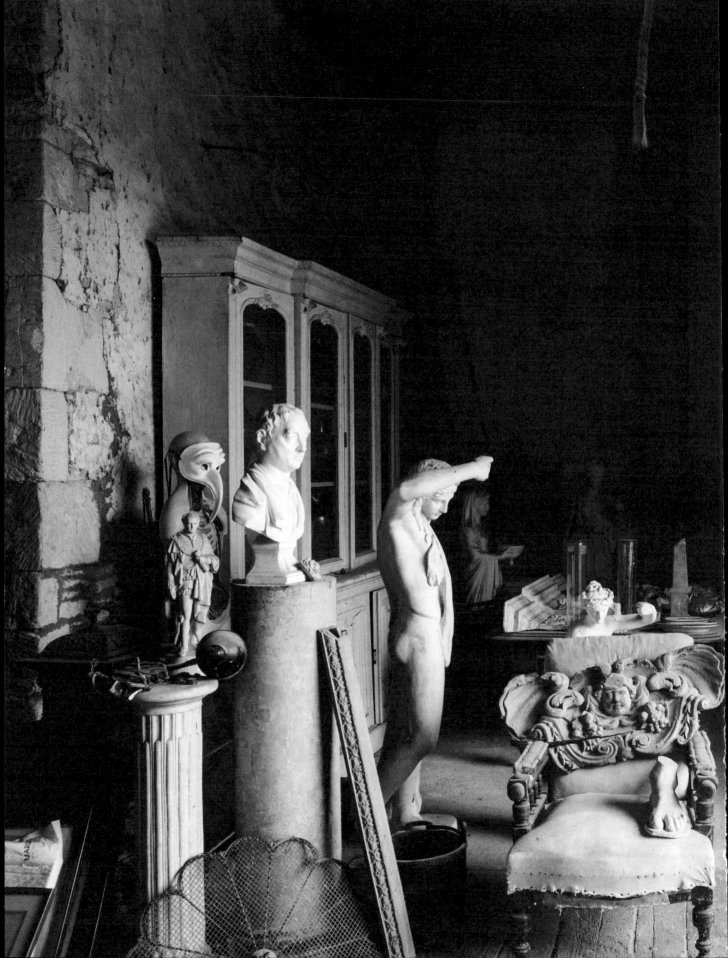